ARTISTS

IN

REPRESENTING
CREATORS OF
KOREA

Supervised by pixiv

KOREA

Editor:
Hank Kanalz

Book Design:
Robbie Robbins
Jung Yeong Gil

Book Production:
Emily Kanalz

Cover Art:
Tiv

Translation:
Kurtis Findlay

Clover Press offices: 8820 Kenamar Dr. #501, San Diego, Ca. 92121

Special Thank You to Beth Kawasaki, David Hyde, Stephanie Borria, Hanna Bahedry.

ISBN: 978-1-951038-82-3

June 2023. First printing.

4 3 2 1 23 24 25 26

Printed in China

pixiv:
Shingo Kunieda, CEO
Takahiko Kato, CIO and General Manager, Creators Division
Reina Hamayoshi, Senior Manager
Liyu Wang

Media Do International, Inc.:
Daihei Shiohama, President and CEO
Beth Kawasaki, Executive Director of Content and Marketing

Clover Press:
Matt Ruzicka, President
Robbie Robbins, Vice President/Art Director
Hank Kanalz, Publisher
Ted Adams, Factotum

Clover Press Founders:
Ted Adams, Elaine LaRosa, Nate Murray, Robbie Robbins

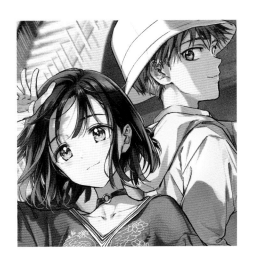

ARTISTS IN KOREA

Artists Introduction

ACCO

Language: Korean, English, Japanese

E-mail: accorshu@gmail.com

twitter.com/accor_s2

pixiv ID : 19351772

Art by Acco ©Crypton Future Media, INC. www.piapro.net piapro

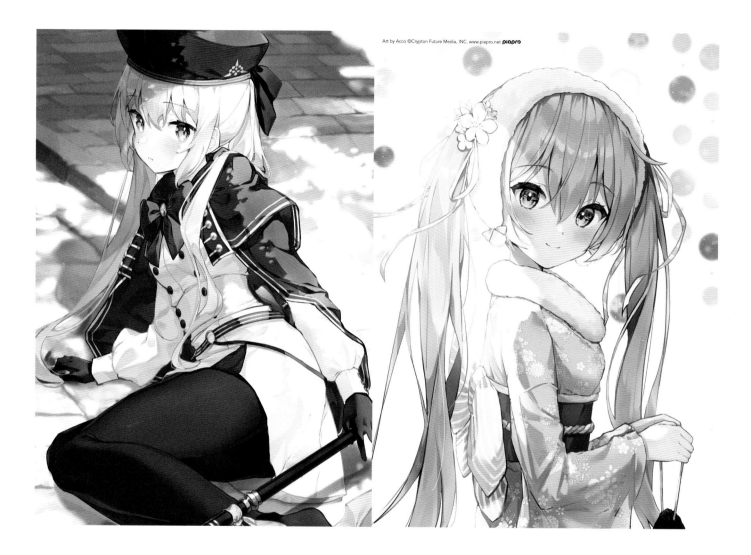

PROFILE
I love drawing cute women, both new creations and fan illustrations. My main focus is on the character design, with the characters simply standing and showing off my concepts. I was a prize winner for the Fate/Grand Order and AFK Arena illustration contests.

1 2 3

1. Altria Caster/2020
2. Miku/2021
3. MOMO/2021

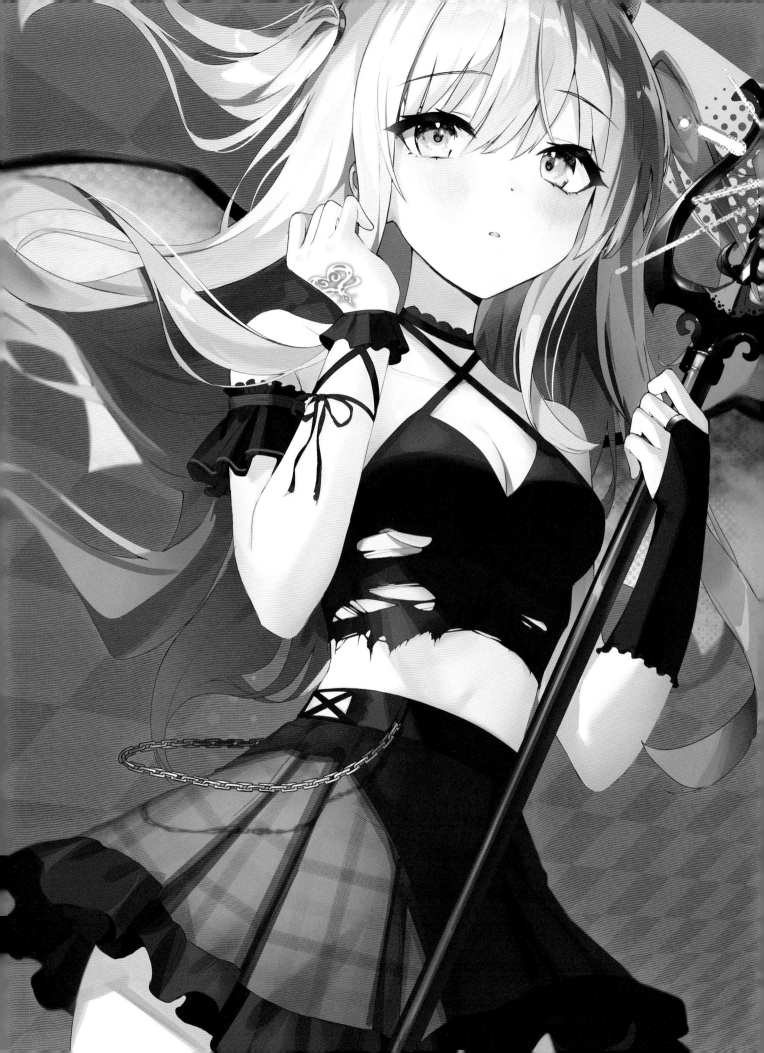

Anmi

Language: Korean, English, Japanese

E-mail: ahnanmi@gmail.com

http://twitter.com/Anmi_

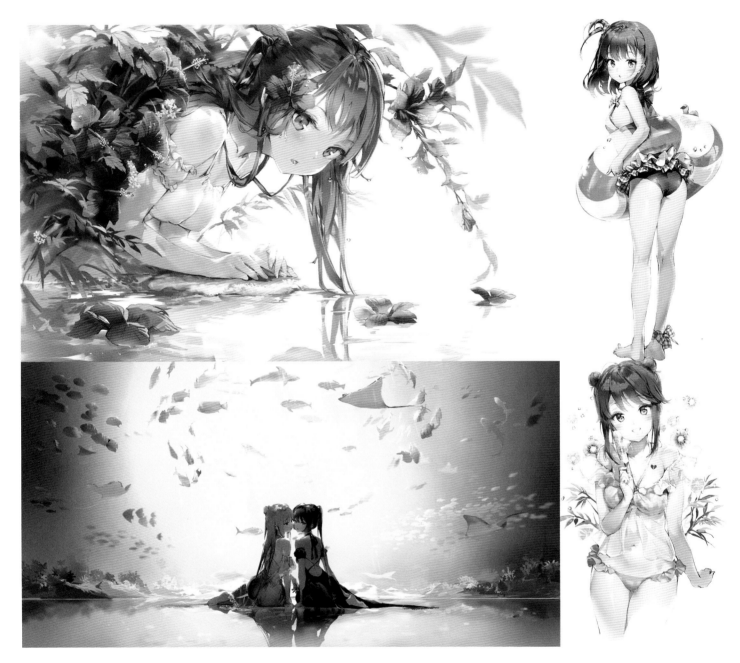

PROFILE

Anmi is an illustrator from South Korea whose art features lively women. She is a widely active character designer for anime, video games and books, and has fans worldwide. His work includes character designs for the *Fantasista Doll* anime, *After-School Pleiades* web-series, and *Girls Frontline* mobile game.

1	3	5
2	4	6

1. Hybiscus/2018
2. Aquarium love/2020
3. Swimsuit/2018
4. Kiwi Swimsuit/2017
5. Flamingo Ballet Company/2018
6. Anemone/2016

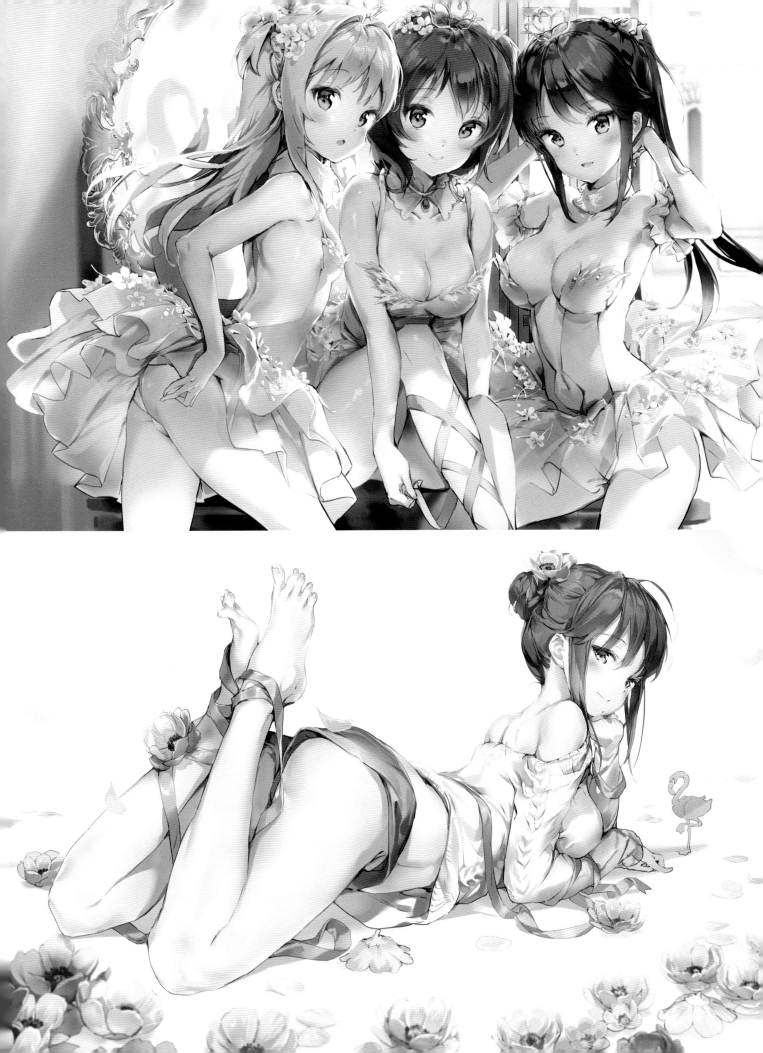

Ciel

Language: Korean, English, Japanese
E-mail: rlacofls0162@naver.com
www.artstation.com/chearin

pixiv ID : 7960381

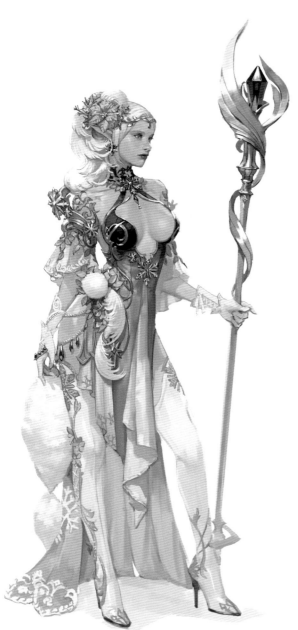

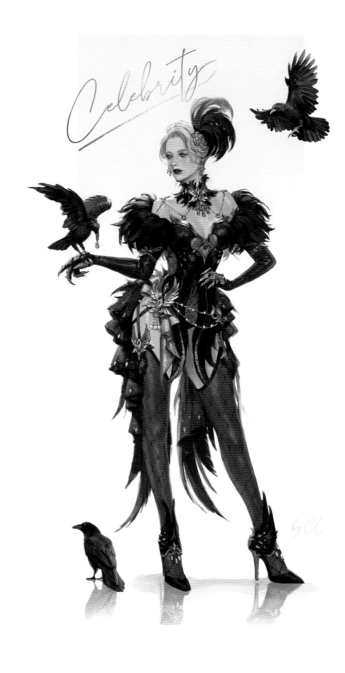

PROFILE
Ciel is a video game character concept artist who majored in western-style painting. His work can be found in Netmarble's *The King of Fighters All Star* and Nexon's *V4*. His artwork is primarily based on original video game character concepts.

1	2	3		
		4	5	6

1. Snow Queen/2021
2. Celebrity/2021
3. Circubus Queen/2019
4. Yashahime/2020
5. Astrologist/2019
6. Rapier/2019

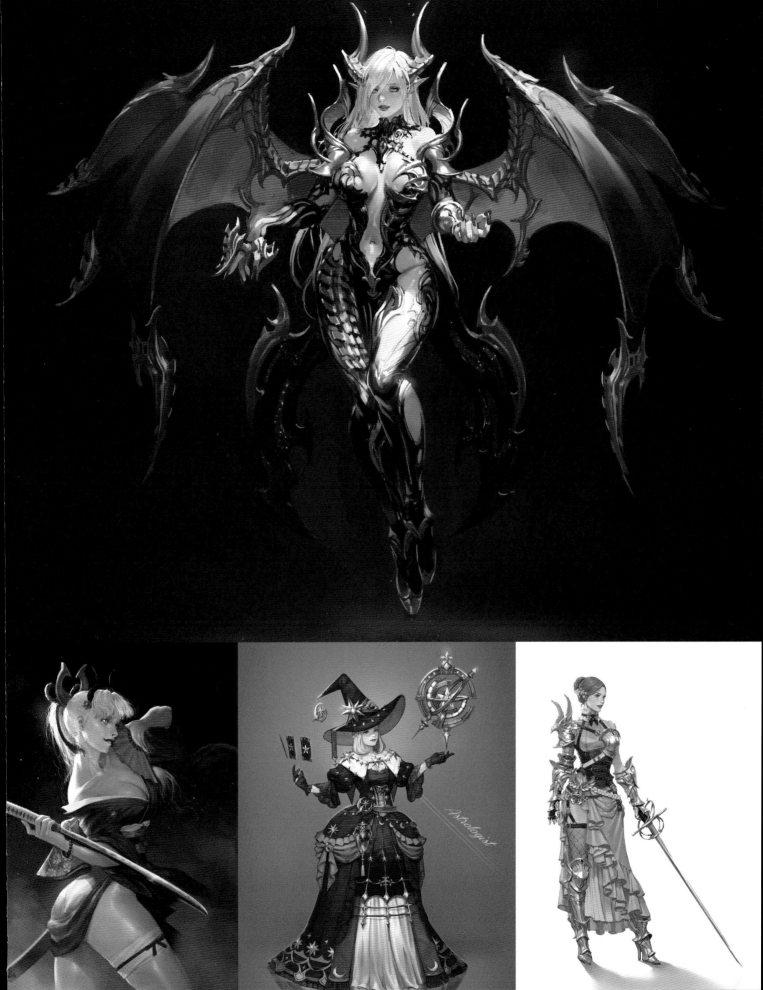

COSMOS

Language: Korean, English, Japanese
E-mail: zd3454@gmail.com
www.artstation.com/namyongkim

pixiv ID : 58836501

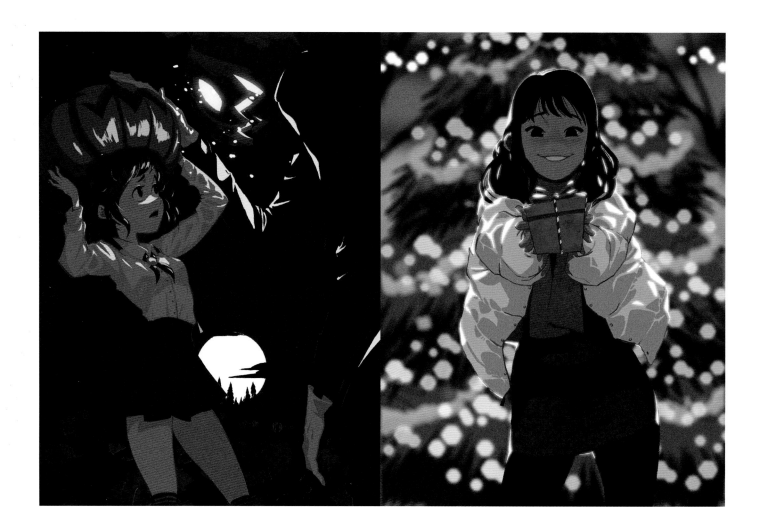

PROFILE
I am an illustrator born in 1993. I am a character designer, background painter and concept artist for video games, anime and movies. I love to create sentimental works using color to evoke emotion.

1. Who are You?/2019
2. Merry Christmas./2019
3. Summer Sunset/2020
4. I'll drive this Time!/2017
5. On Top of an Alfa Romeo/2020

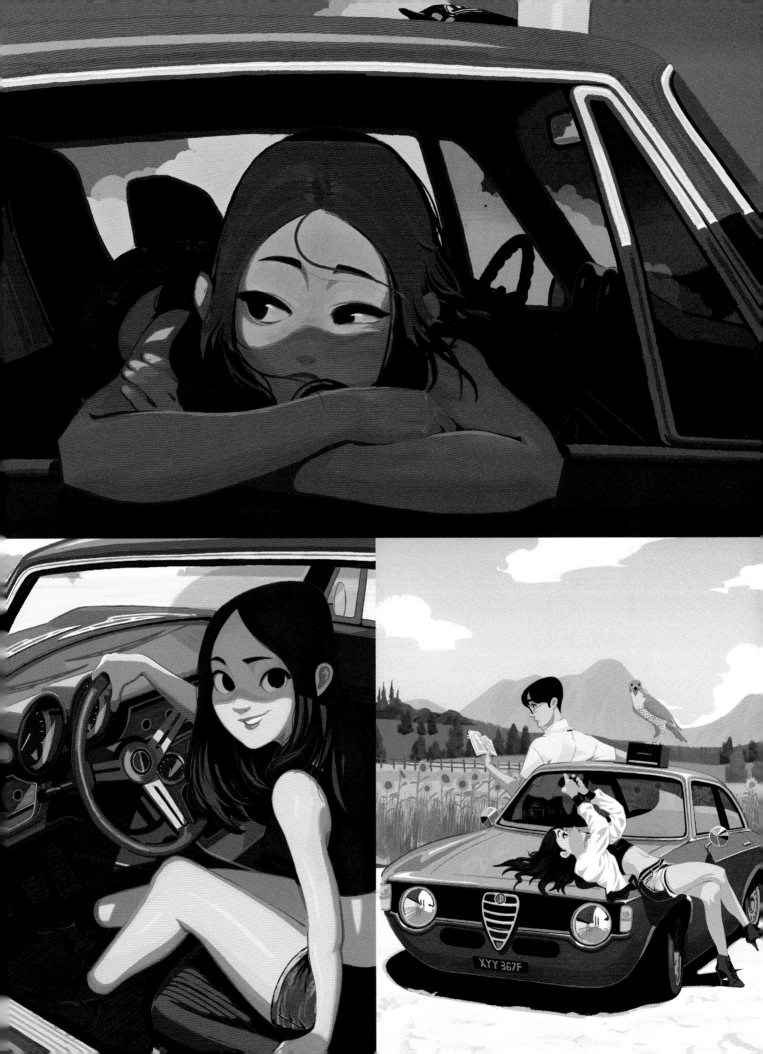

CUTEG

Language: Korean, English, Japanese

E-mail: yoonji.km@gmail.com

twitter.com/CUTEG_rakugaki

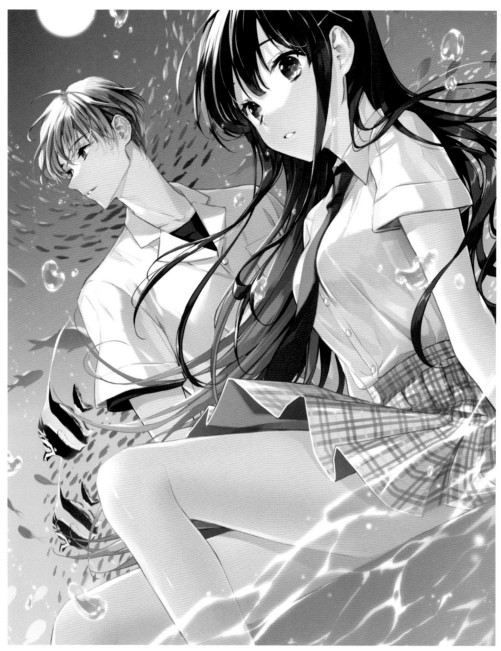

PROFILE

CUTEG is a manga artist for *One of Them Has a Younger Sister!* (MF Bunko J) and *If Her Flag is Broken*, (Kodansha). Other work includes character designs for the *Magic Academy Grimoire* mobile game (Applibot) and the fictional anime band Hinabita♪ (Konami).

1. Summer's End/2021
2. Spring/2021
3. The Year of the Ox/2021
4. Flower Dance/2021

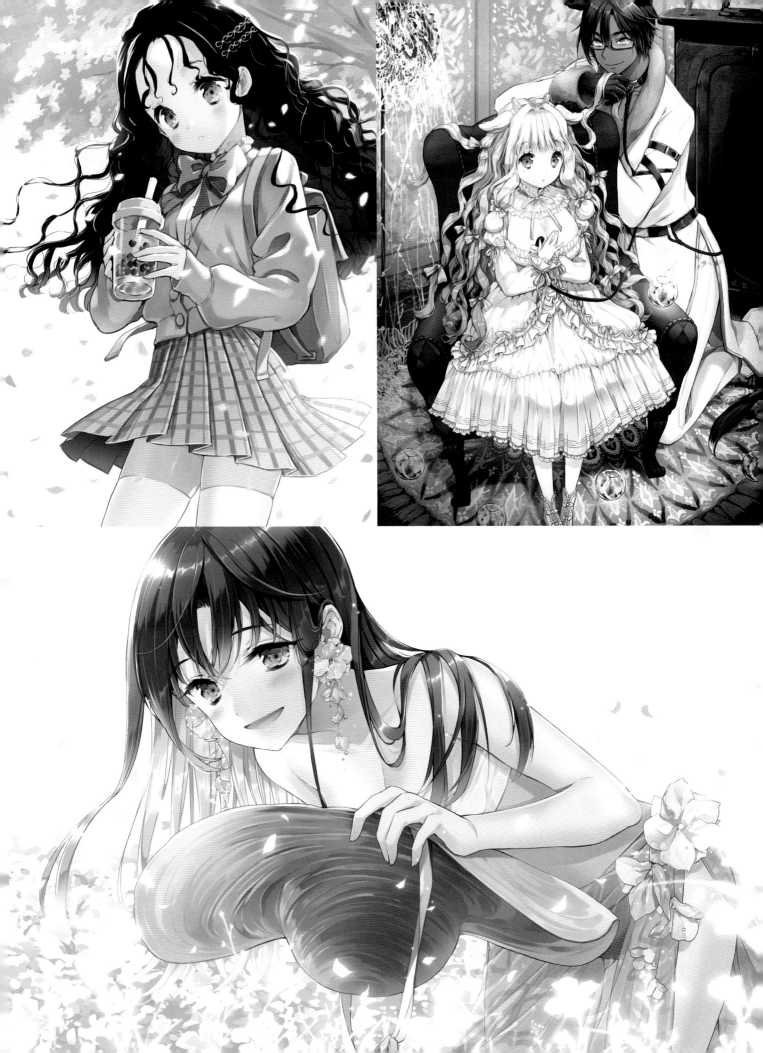

DangMyo

Language: Korean, English, Japanese

E-mail: dangmyo914@gmail.com

twitter.com/dangmyo

pixiv ID : 33718285

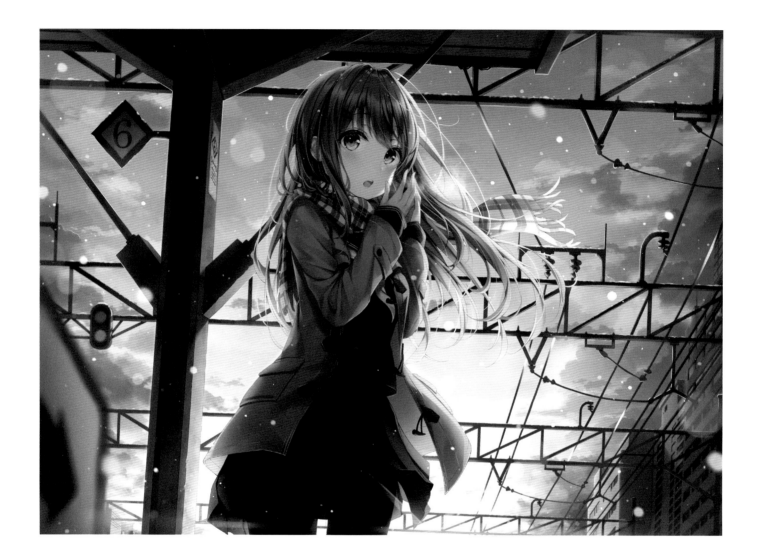

PROFILE
I created illustrations for the launch of the video game *Honkai Impact 3rd* (miHoYo). I love to create anime-inspired backgrounds and character designs. My hobby is drawing the virtual singer Hatsune Miku.

1 2

1.Winter Station/2020

2. Spectre of Daylight/2020

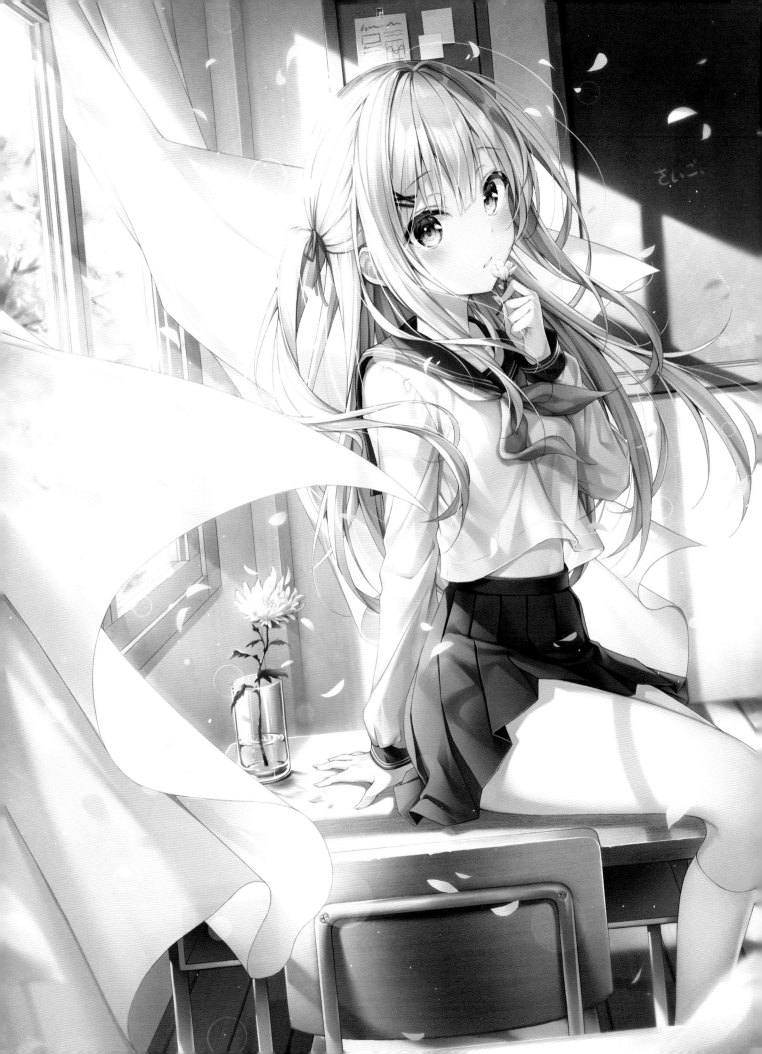

DAVI

Language: Korean, English

E-mail: daviline000@gmail.com

www.daviline.com

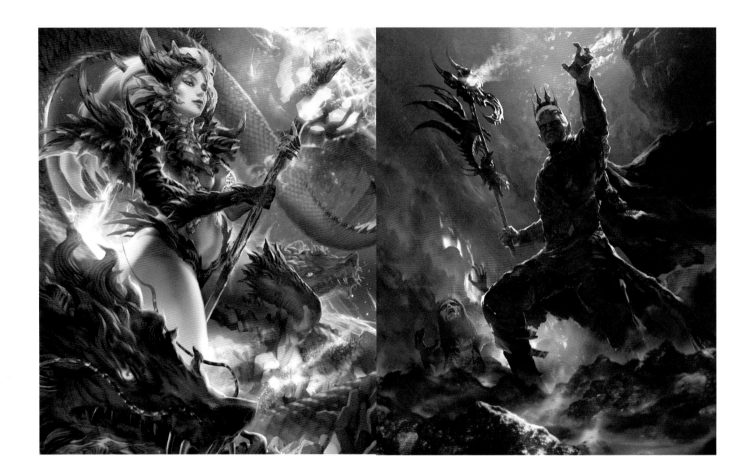

PROFILE

DAVI works as a concept artist and art director for a variety of projects from video games to movies. His personal work explores the themes of the existence and destruction of surrealism. He lives in California, United States.

1	2	3	4
		5	6

1. Kingdom Hunter - Ruler/2021
2. Kingdom Hunter - Sorcerer/2021
3. Kingdom Hunter - Succubus/2021
4. Kingdom Hunter - Hunter/2021
5. Kingdom Hunter - Trainer/2021
6. Kingdom Hunter - Witch/2021

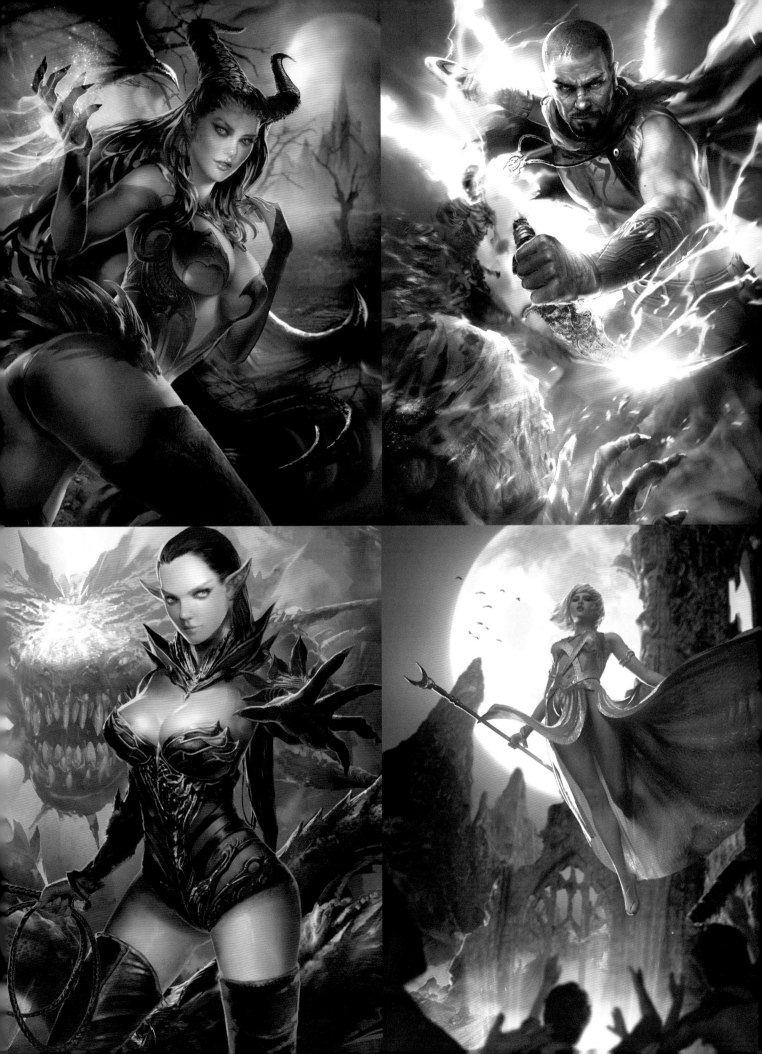

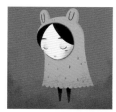

Domino

Language: Korean, English
E-mail: ccillustration@naver.com
www.instagram.com/ccillust/

pixiv ID : 72560010

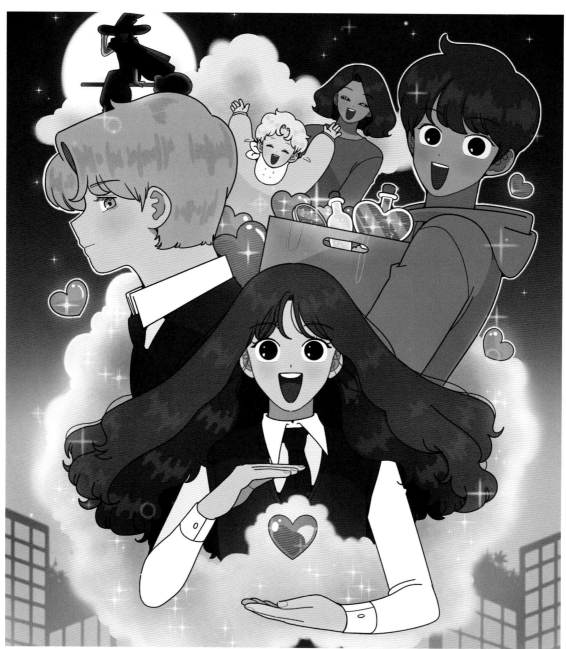

©Elegant Brothers_Kaleidosc

PROFILE

I am a creator born in 1996 who likes a little fantasy and romance in everyday life.

1 2

1. Frog Princess 1/2019
2. Frog Princess 2/2019

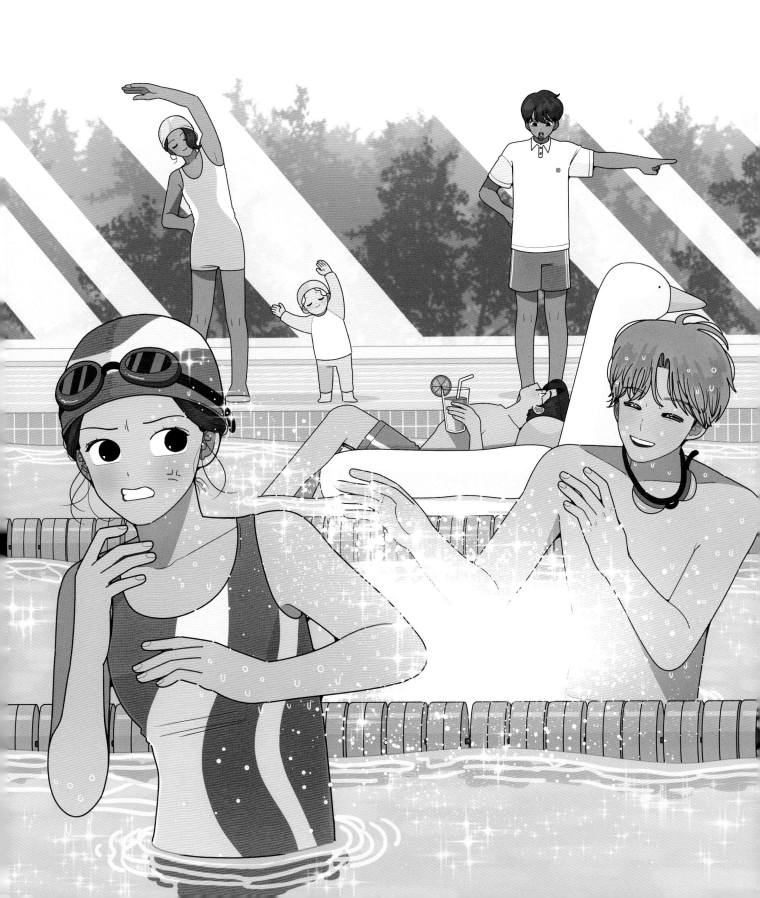

DSmile

Language: Korean, English, Japanese

E-mail: mkt.dsmile@gmail.com

twitter.com/DSmile9

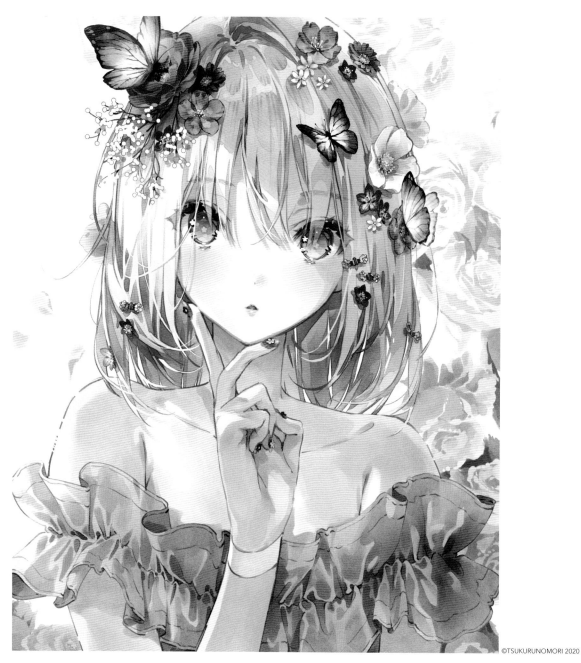

©TSUKURUNOMORI 2020

PROFILE

Credits include the art book *Let's Make Character CG Illustration Technique Vol. 10*, the manga series *My Little Kitties* from Novel Engine, and the character design of mobile game *Girls' Frontline*.

1. Romantic Butterfly from DSmile
 first solo Exhibition "Tomorrow, Komorebi"
2. Embracing the Seasons
3. Season Tinged with Yellow
4. Midsummer Encounter

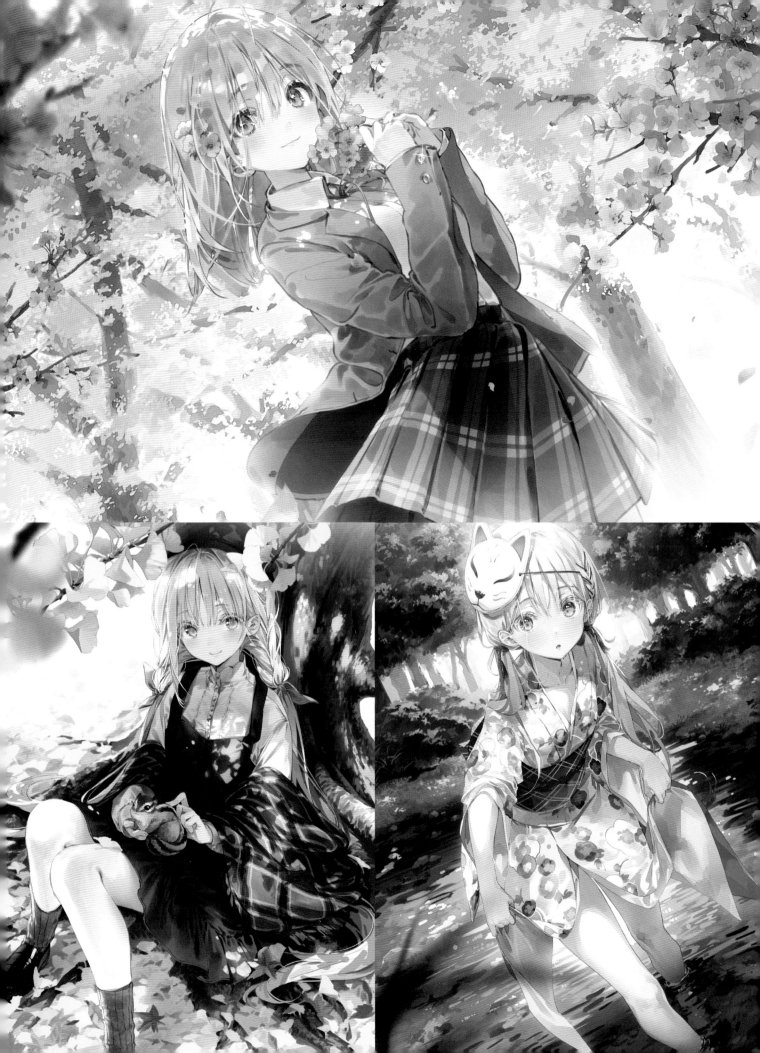

EB10

Language: Korean, English, Japanese

E-mail: limobok@naver.com

twitter.com/ebkim00

pixiv ID : 2345928

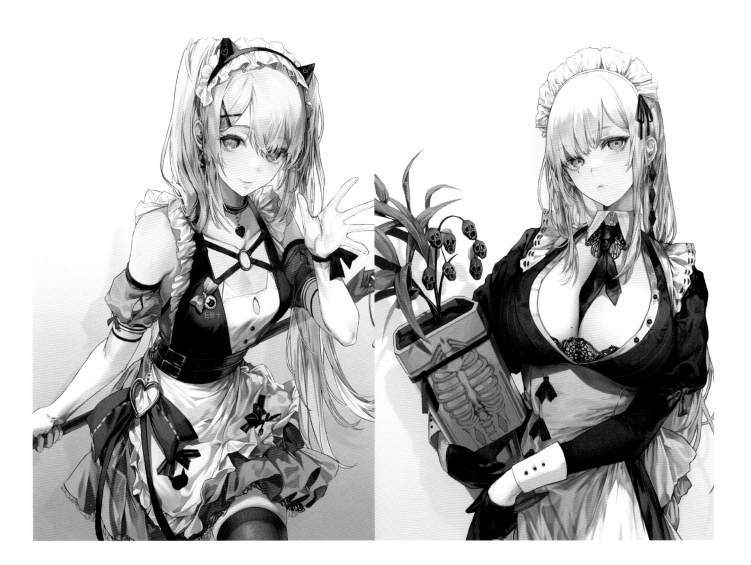

PROFILE
EB10 is a freelance illustrator specializing in beautiful women whose work has appeared in various games such as *Astro and Girls*, *Destiny Child*, *Punishing Gray Raven* and *Guardian Tales*.

1. Maid 2/2021
2. Maid 1/2021
3. Ms. Detective/2021

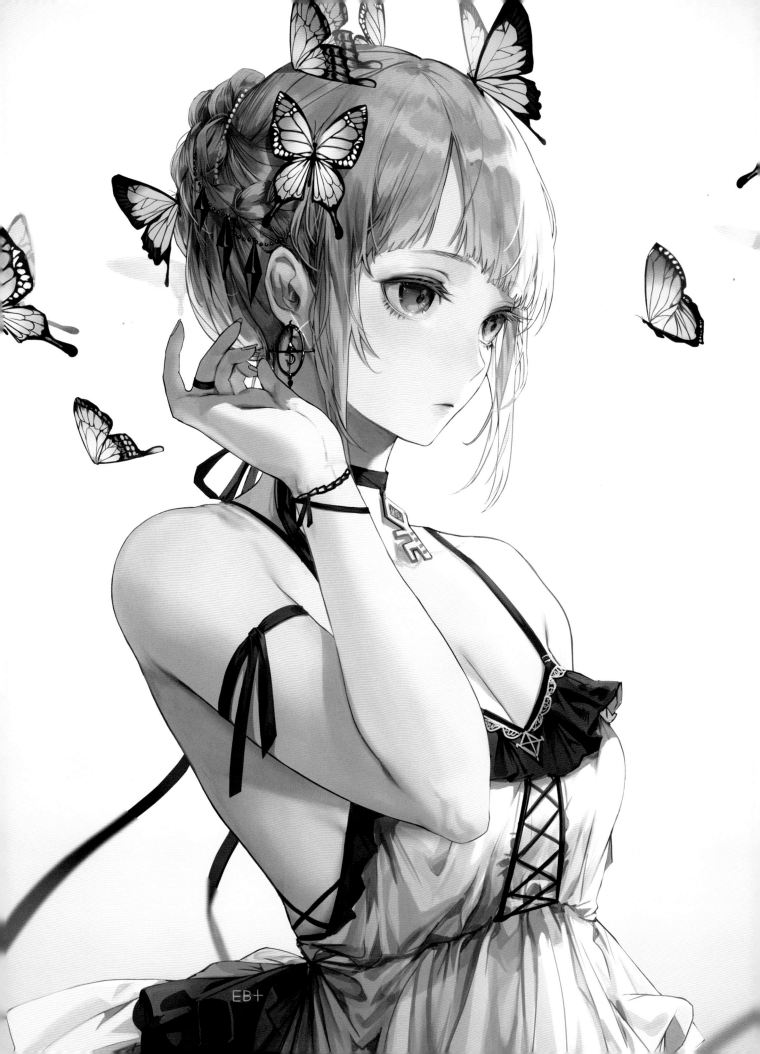

F.K

Language: Korean, English, Japanese

E-mail: hs225kr@naver.com

twitter.com/FK_workid

pixiv ID : 4935406

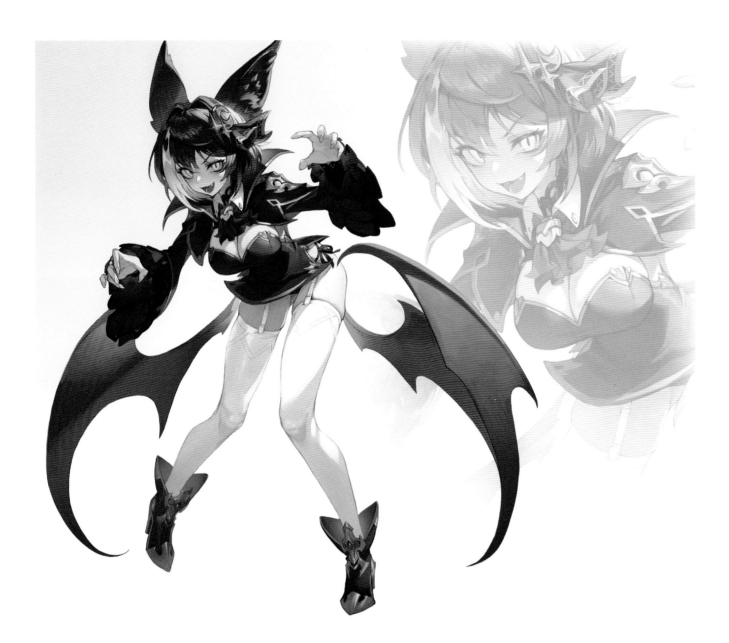

PROFILE
Born in 1999. Trying out various styles and genres, but currently exploring the pretty woman casual style.

1 2

1. Scarlett/2021
2. Under of the Tree at Sunset/2018

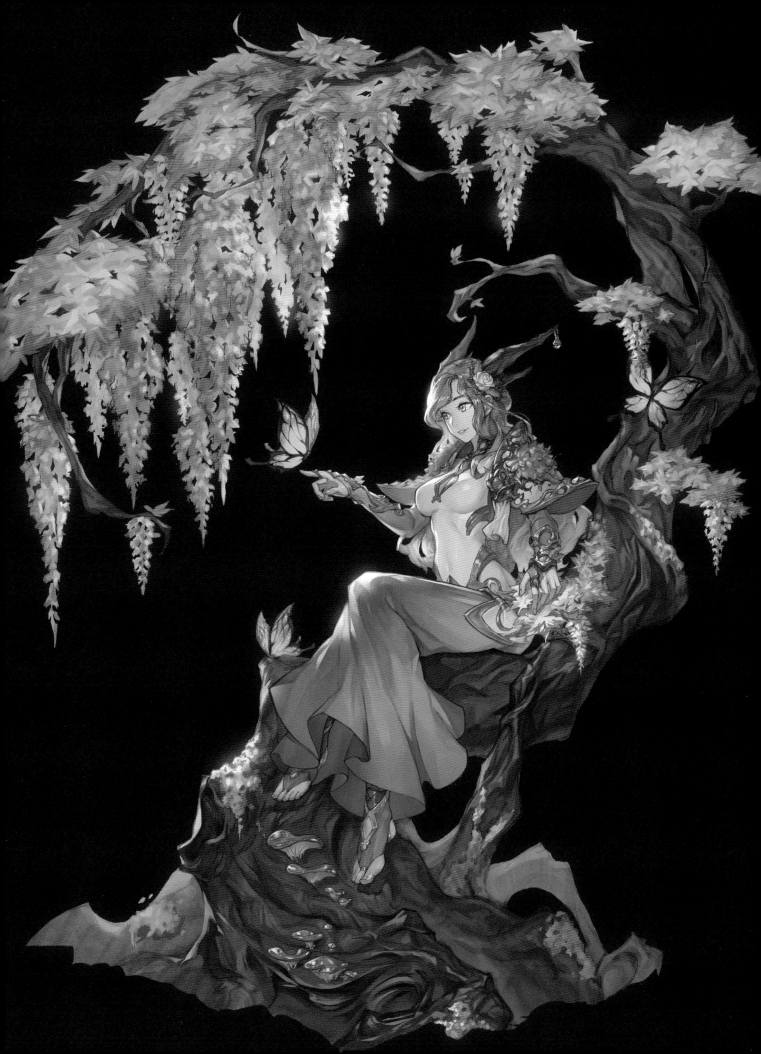

Free style

Language: Korean, English

E-mail: yohan1754@naver.com

twitter.com/yohan1754

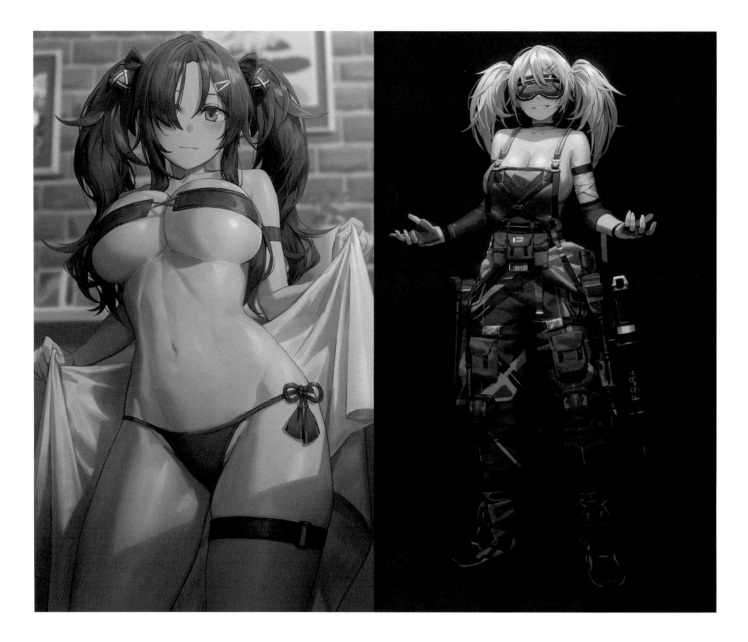

PROFILE

Free Style is a freelance teaching instructor for PIXWAVE. He is active as an artist focusing on male-oriented illustration.

1 2 3

1. The Robe/2018
2. Engineer/2021
3. Samurai/2021

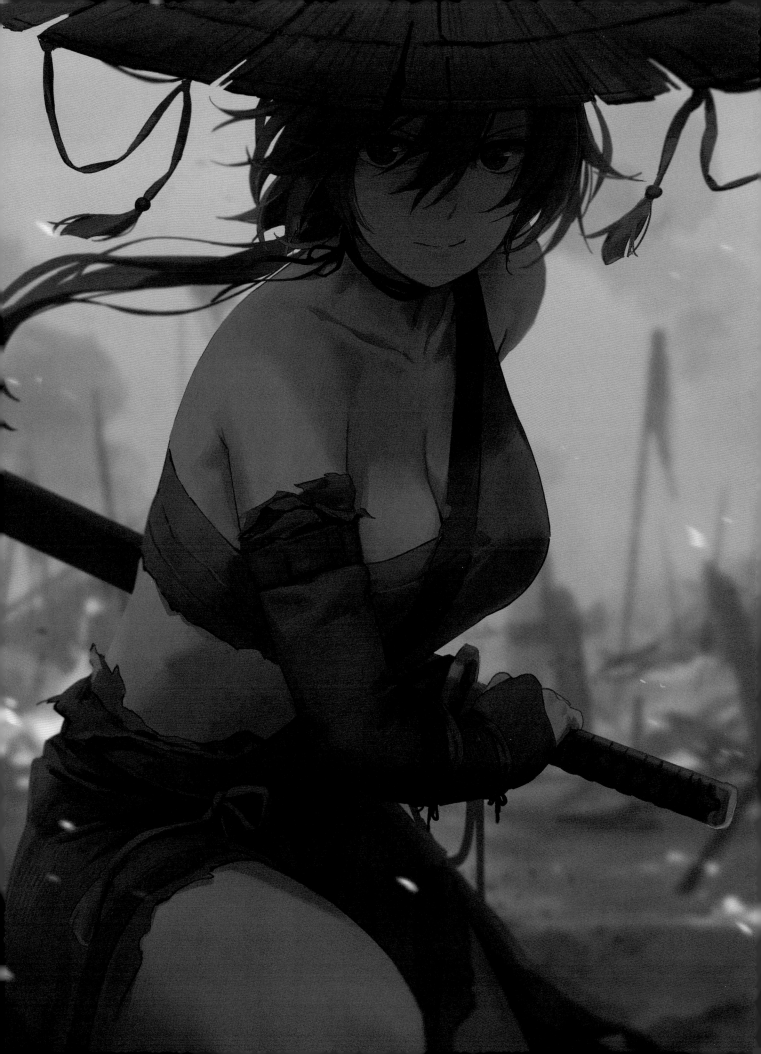

freng

Language: Korean, English, Japanese

E-mail: gkdms111222@gmail.com

twitter.com/frengchiano2

pixiv ID : 3975343

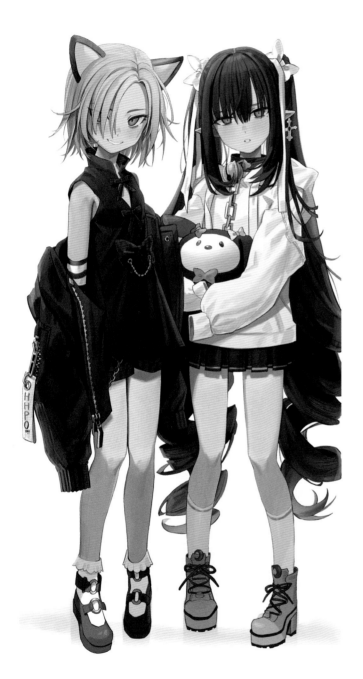

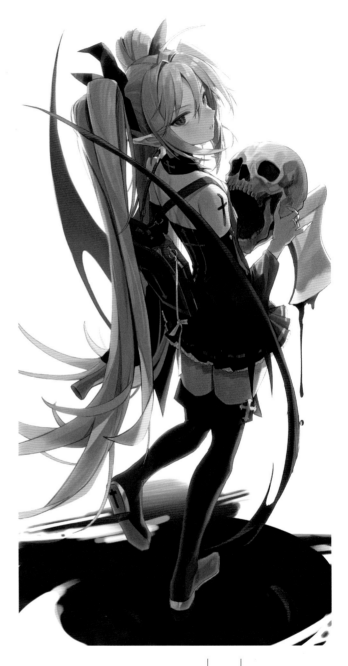

PROFILE

Born in 1996 and living in Seoul. I love creating incredibly dense and detailed drawings, but lately I've been working on finding the balance between detail and speed.

1 2 3

1. Dolls/2020
2. untitled 1/2021
3. Rose Witch/2021

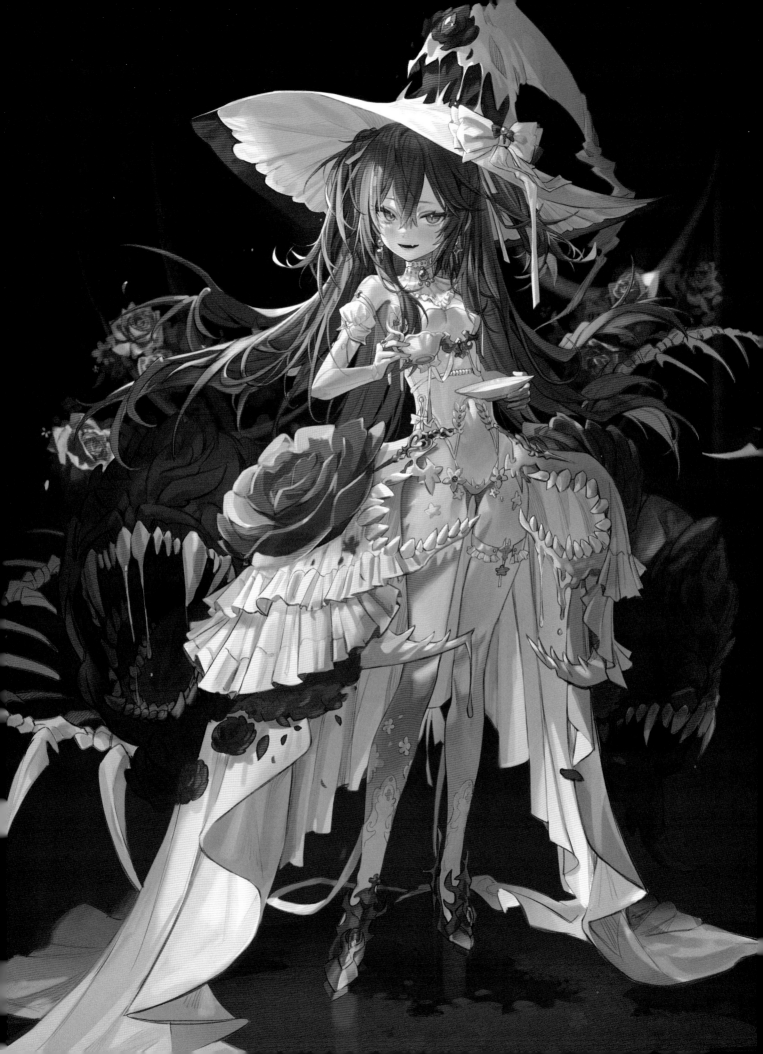

Gearous

Language: Korean, English

E-mail: gearous@gmail.com

twitter.com/GEAROUS

pixiv ID : 658632

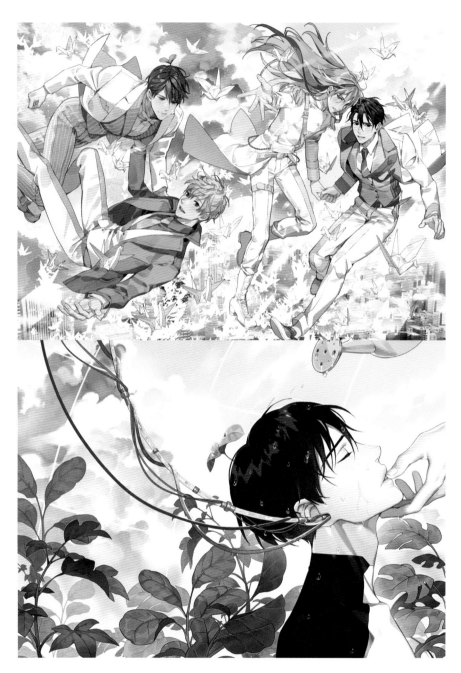

PROFILE

Gearous has creates illustrations for the Japanese audio drama series *Grandmaster of Demonic Cultivation* and a bonus illustration for a new edition of the original Chinese novel. They have also illustrated for NetEase Games and other companies. Gearous create original manga, focusing on a male cast of characters.

	1	
		3
	2	

1. Flare/2019
2. Sexaroid/2018
3. Original Character Ryurell/2021

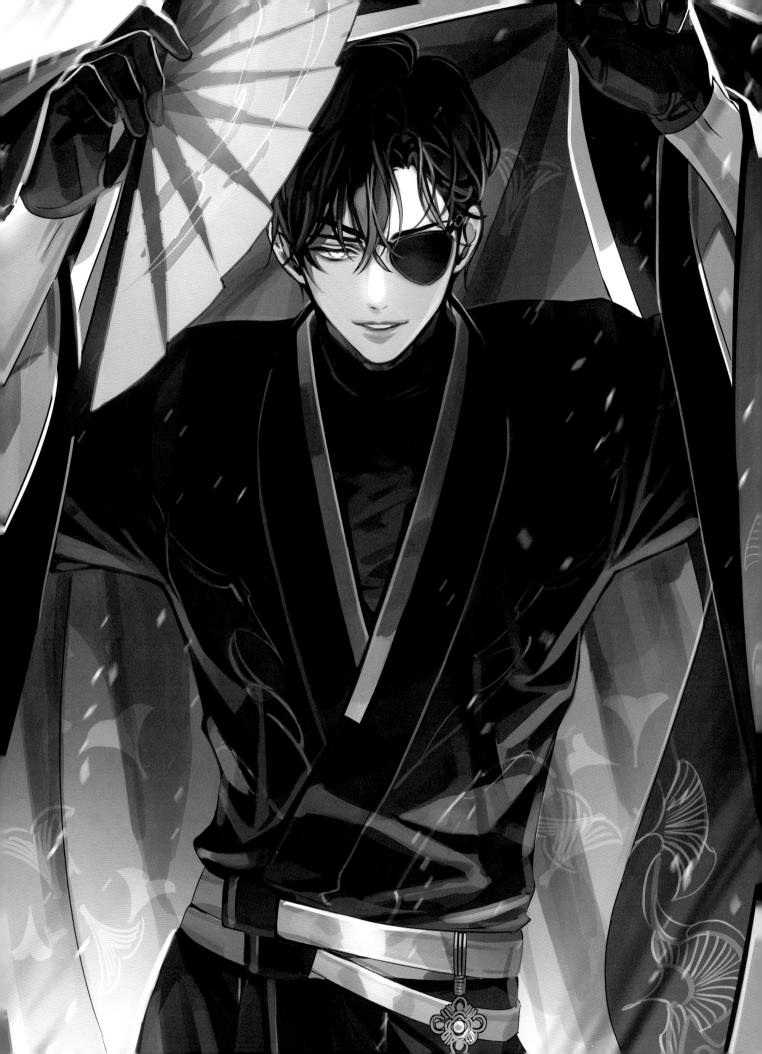

Gilse

Language: Korean, English, Japanese
E-mail: gilse1024@gmail.com
twitter.com/Gilse1024

pixiv ID : 702789

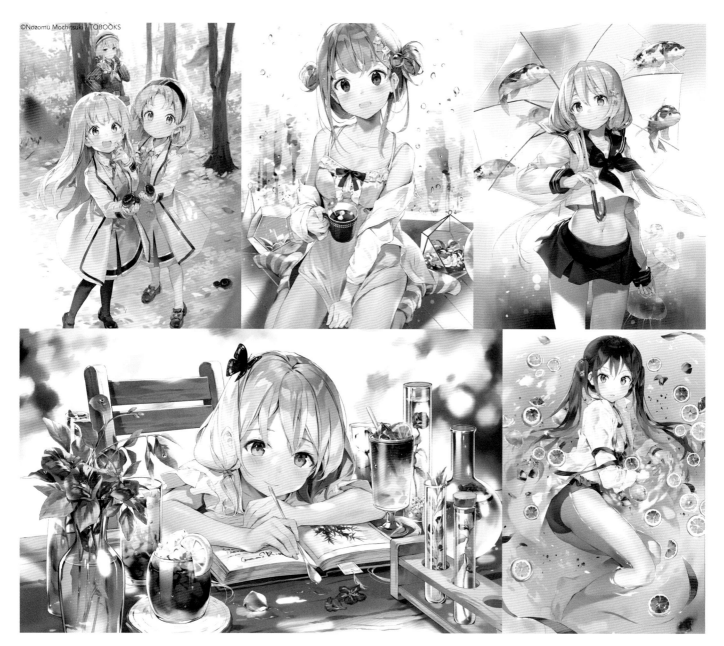

©Nozomu Mochitsuki / TOBOOKS

PROFILE
I am an illustrator born in Seoul who loves shiny things, octopus dishes, and good vibes. I am currently an illustrator for video games and publications.

1	2	3	
4		5	6

1. Tearmoon Empire Vol. 6 Cover Art/TO BOOKS
 Illustrated by Gilse/2020
2. Raining day 2/2019
3. Raining day/2018
4. butterfly-pea/2019
5. Citrus bath/2018
6. Tearmoon Empire Vol. 1 Cover Art/TO BOOKS
 Illustrated by Gilse/2019

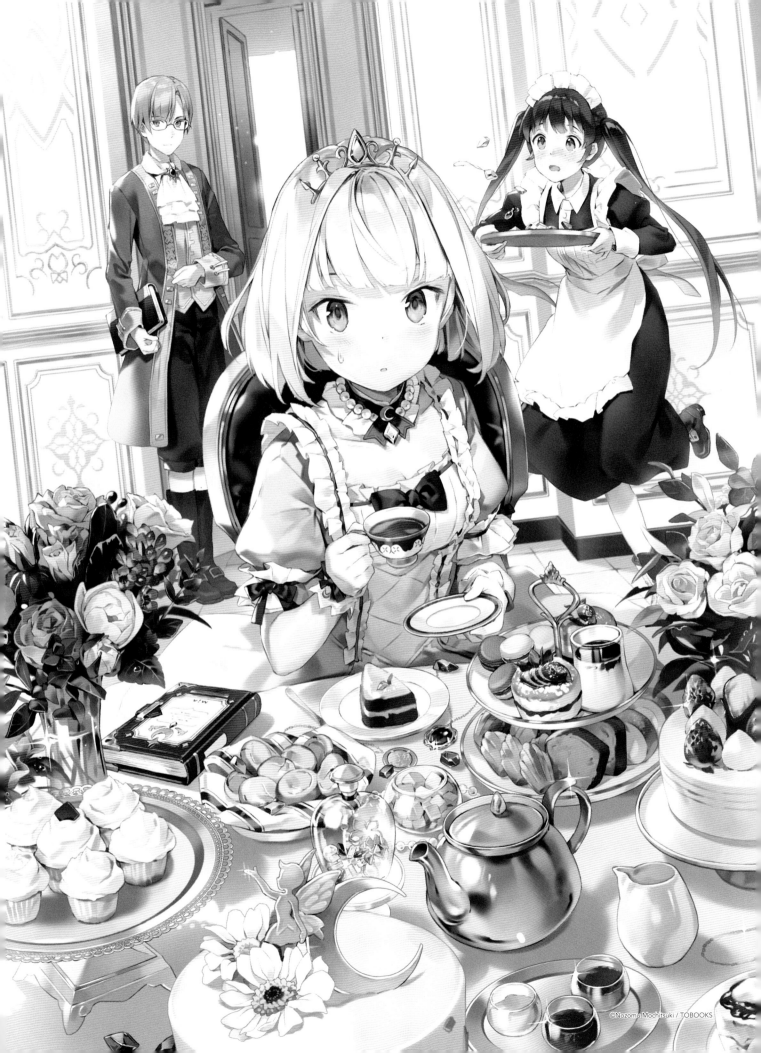

hakusai

Language: Korean, English, Japanese

E-mail: hakusai_hiro@nave.com

twitter.com/hakusai_hiro

pixiv ID : 1589657

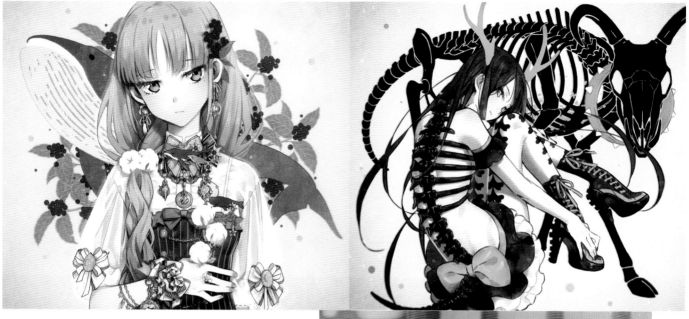

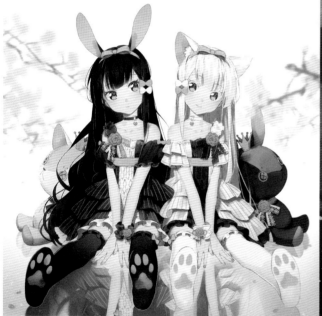

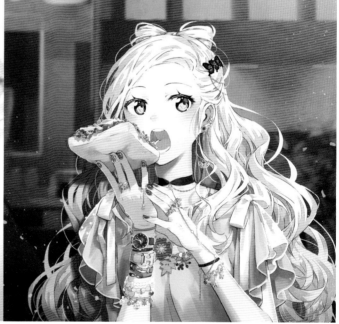

PROFILE
None.

1	2	5
3	4	6

1. Fish/2018
2. untiled/2018
3. untiled /2017
4. untiled/2017
5. untiled/2018
6. untiled/2018

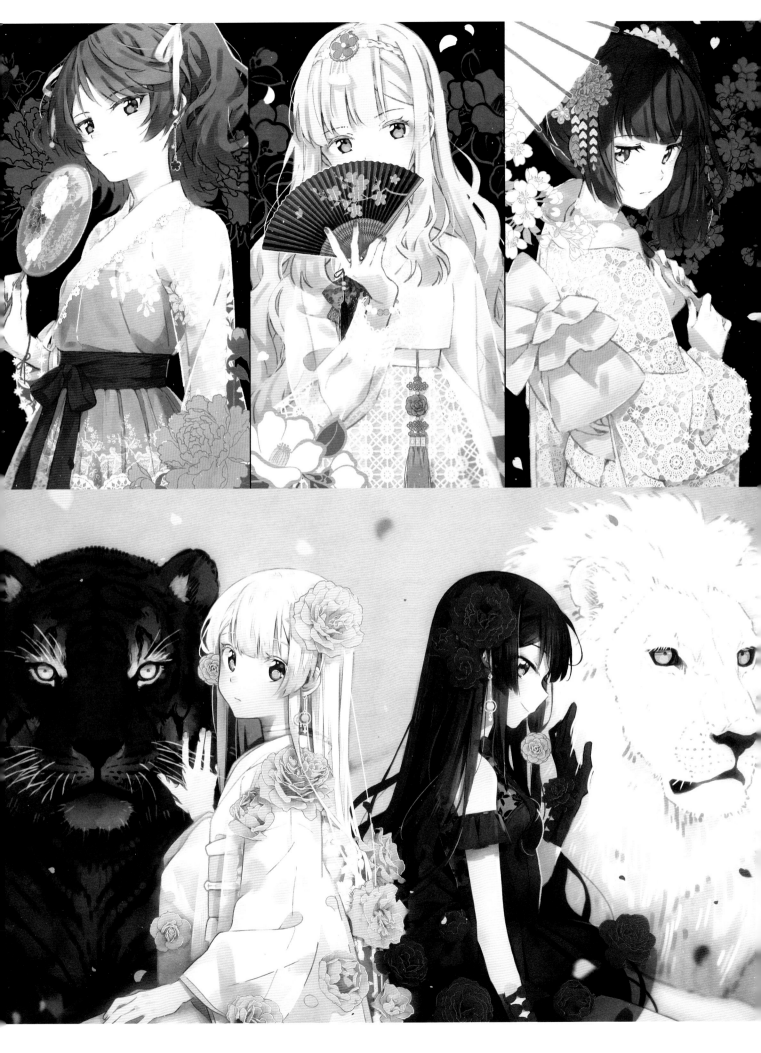

Hinaki

Language: Korean, English, Japanese

E-mail: hinaki010203@gmail.com

twitter.com/Hinaki0102

pixiv ID : 33778959

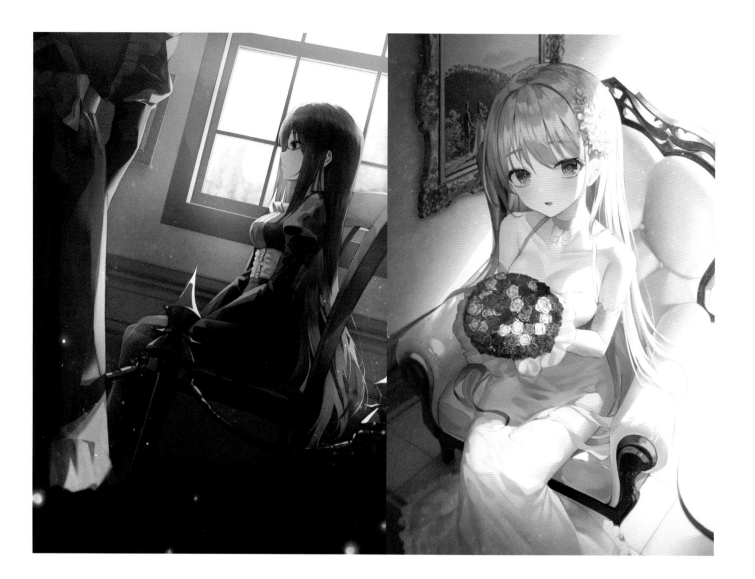

PROFILE

Hello, I'm Hinaki! I draw adorable women, but would like to branch out to other things. I am always trying to improve my art and I hope you will look forward to seeing my growth!

1 2 3

1. Noble/2021
2. Wedding/2020
3. Autumn Leaves/2020

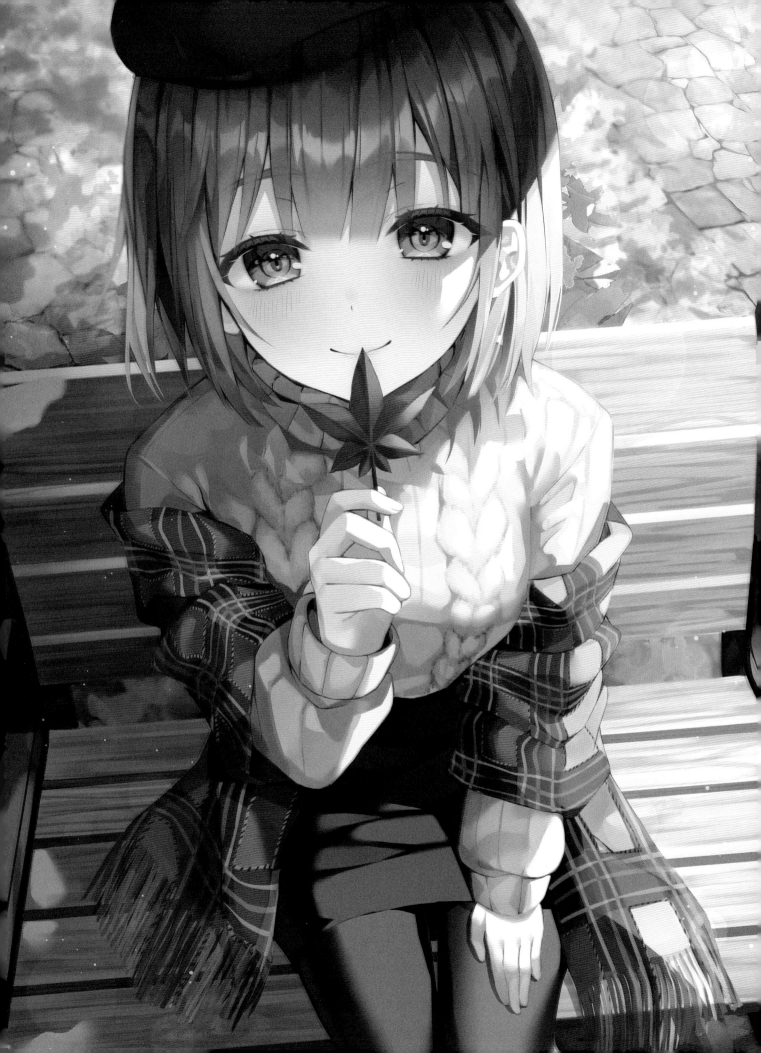

HOLDEEN

Language: Korean, English, Japanese
E-mail: holdeen@naver.com
www.holdeen.com

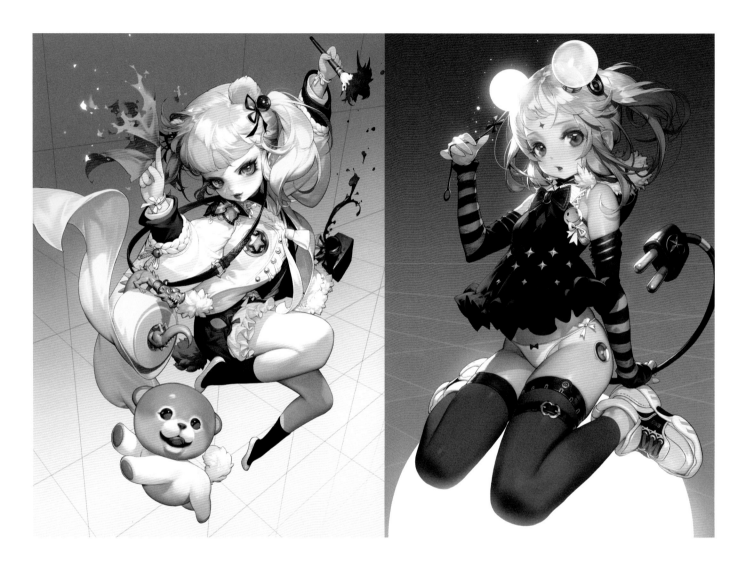

PROFILE
Illustration work includes *Chaos Online* and *Grand Three Kingdoms.*

1 2 3

1. Spell Girl/2018
2. Electric Ball Girl/2018
3. White Wizard/2017

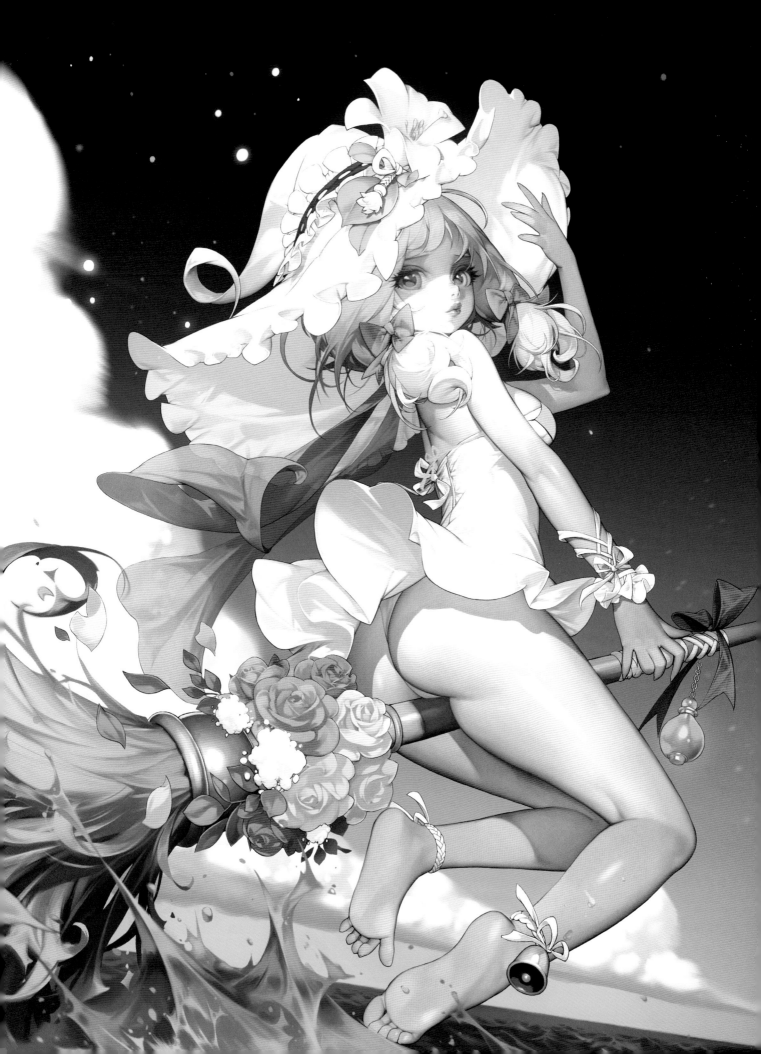

HYONEE

Language: Korean, English, Japanese

E-mail: hyonee929@gmail.com

twitter.com/JinHyeon929

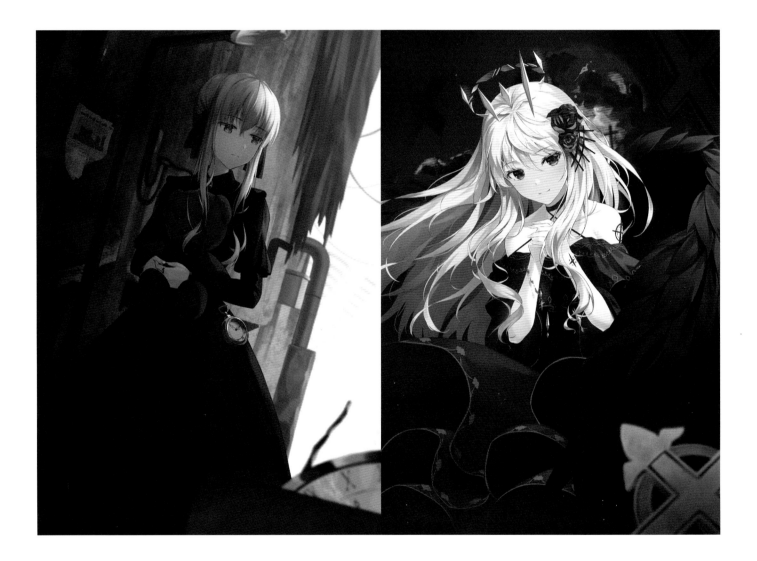

PROFILE

Currently working as an instructor at EGOArts Academy, HYONEE's smooth lines depict life, both in the real world and the fantasy one. His character designs can be found in Nicely Game's *Infinite Neglect Story*.

1 2 3

1. Ruins and Girl/2021
2. Red Moon and Angel/2021
3. Summer Festival of that Day/2020

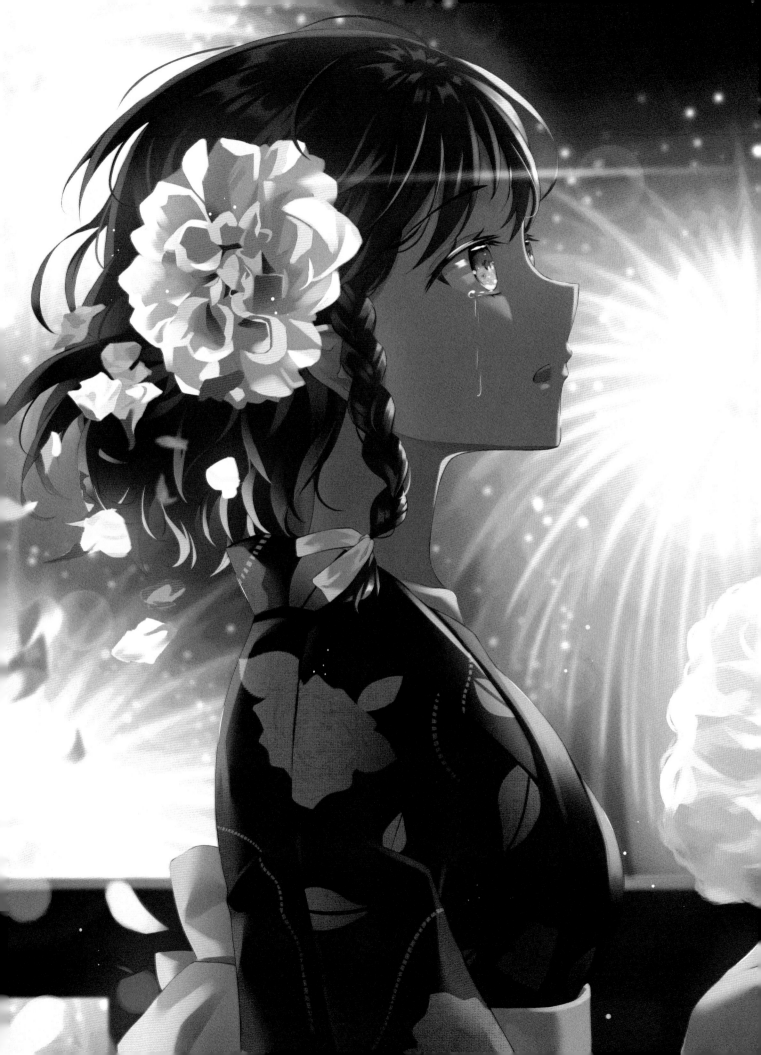

Iren

Language: Korean, English, Japanese

E-mail: ssyboa@naver.com

twitter.com/iren_lovel

pixiv ID : 34209175

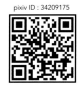

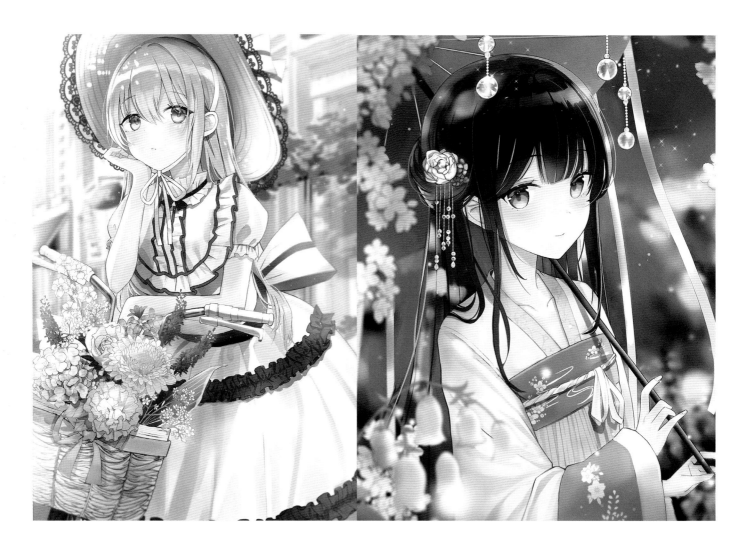

PROFILE

I often draw women in everyday life, using the flowers of the four seasons as a backdrop. It brings me joy to convey their natural beauty through my art to my readers.

		3	4
1	2		
		5	6

1. Flower /2021
2. Vilolet /2020
3. Maid /2021
4. Meeting for the First Time/2020
5.The End/2020
6.Last Day /2021

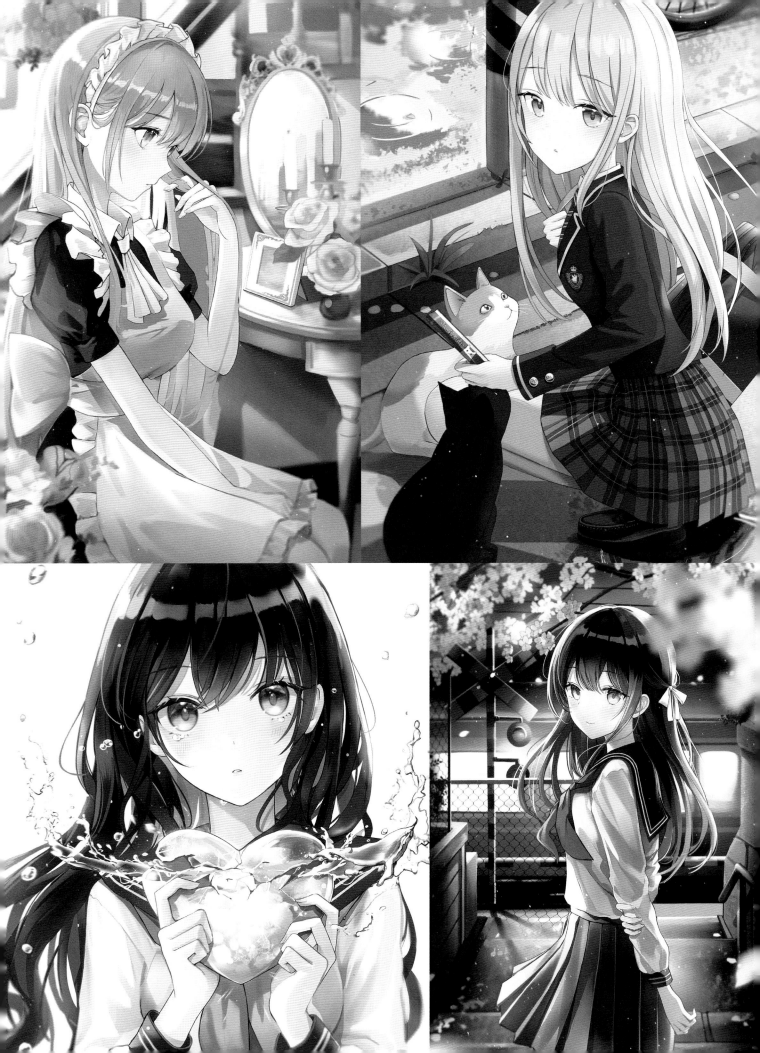

Kim il kwang

Language: Korean, English
E-mail: javu0126@naver.com
instagram.com/ilkwangkim

pixiv ID : 61916686

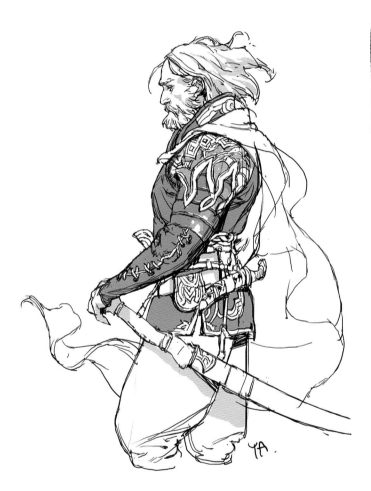

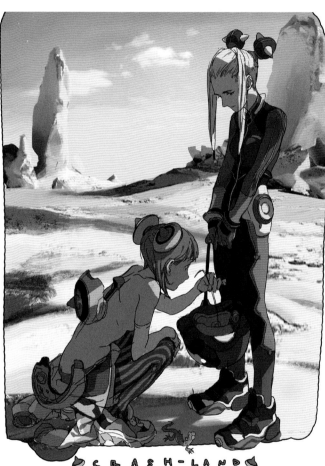

PROFILE

Kim il kwang is an art director and character designer. Credits include *DOTA: Dragon's Blood*, *Voltron: Legendary Defender*, *The Legendof Korra*, *The Boondocks - Season Four*, and *Lego Elves: The Secret of Elvendale*.

1 2 3

1. Crash-Land/2019
2. Summer of Kamakura/2020
3. Old Knight/2014

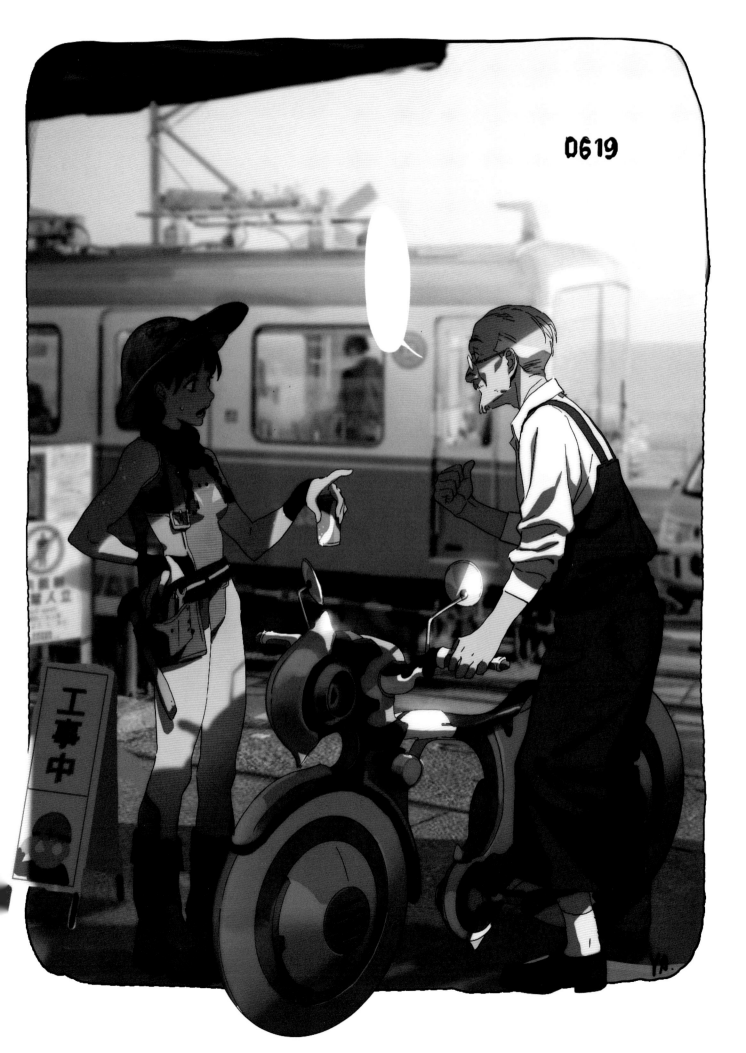

Kim Sung Hwan

Language: Korean, English

E-mail: azossy@naver.com

instagram.com/sung_hwan_kim_80

pixiv ID : 71094894

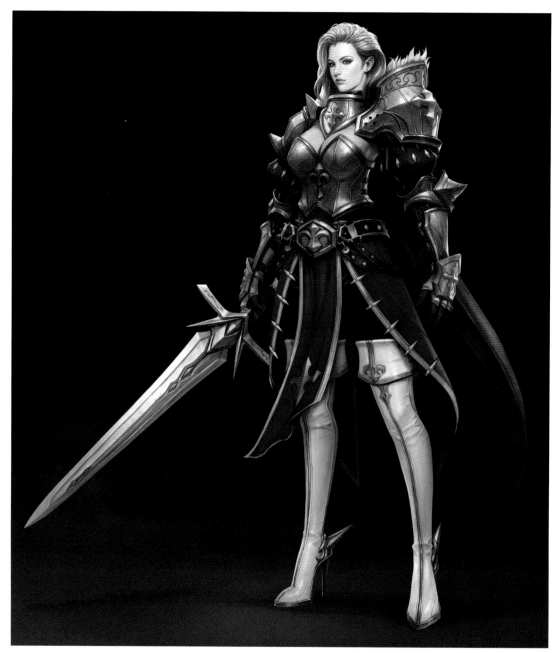

PROFILE

I am a concept artist and illustrator for video games. I was on the development teams for such games as *Lineage M* and *Lineage Remastered* for NCSoft, and *Prius Online* for CJIG.

	2	
1		
	3	4

1. Knight Female/2021
2. Battlefield/2021
3. Woman Face/2019
4. ELF/2017

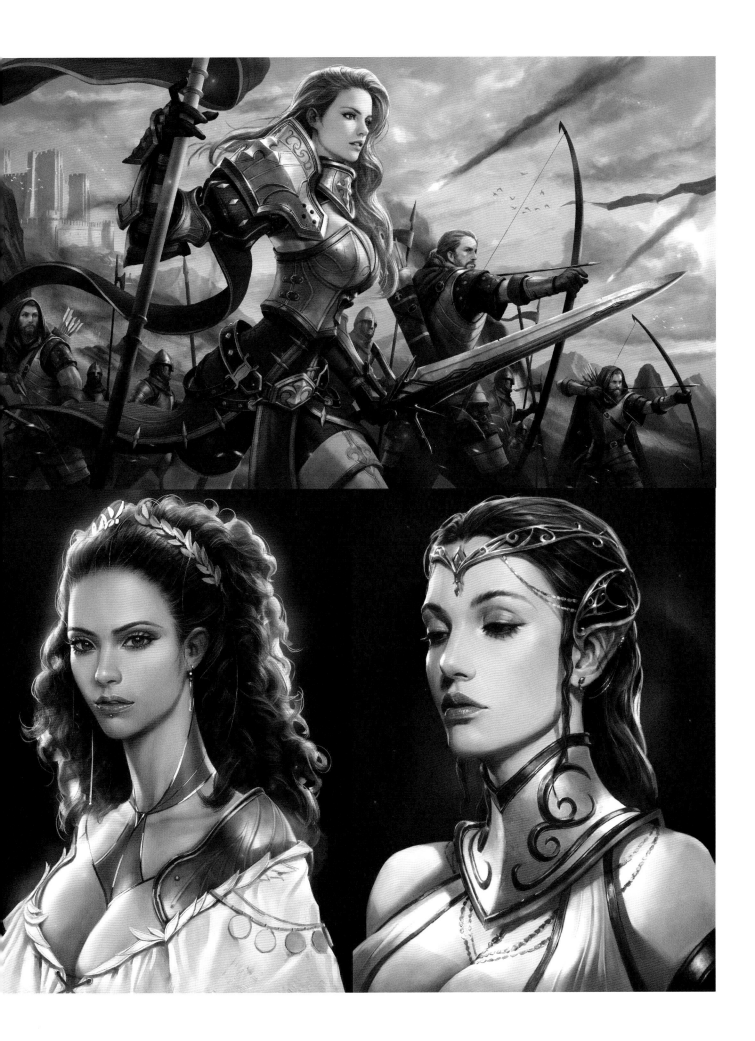

LUNYA

Language: Korean, English, Japanese

E-mail: art_yeunjae@naver.com

twitter.com/luna_nyann

pixiv ID : 38377136

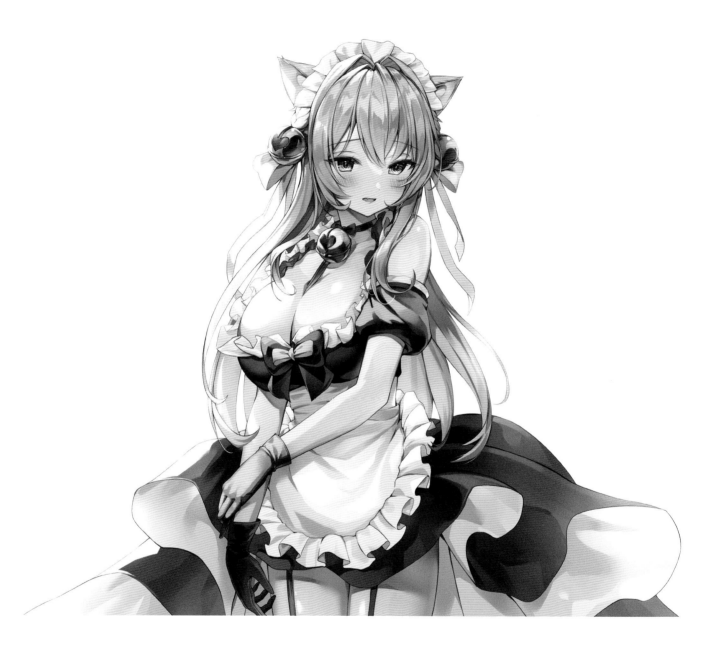

PROFILE

I have been a freelance illustrator since 2020 after working in the video game industry as a character designer and concept artist. Now I mainly create beautiful women, unique creatures and character designs for VTubers. My work includes the character design of VTuber Tsukiyomi Yomi, and Halloween illustrations for VTubers Hikuki Miu, Hana Tsukito and Lia Mitsurugi.

1 2

1. Cat Maid-san/2020
2. Azur Lane Maid Daiho/2021

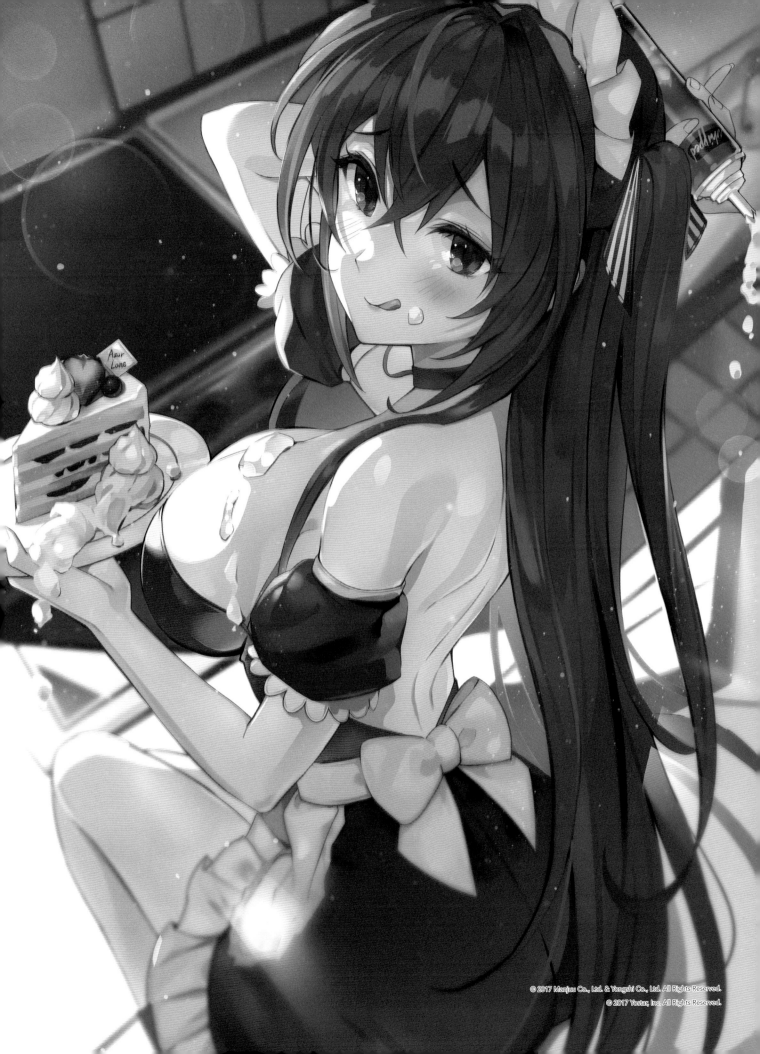

milky

Language: Korean, English, Japanese

E-mail: gsounjennie@gmail.com

twitter.com/icebox46

pixiv ID : 17013116

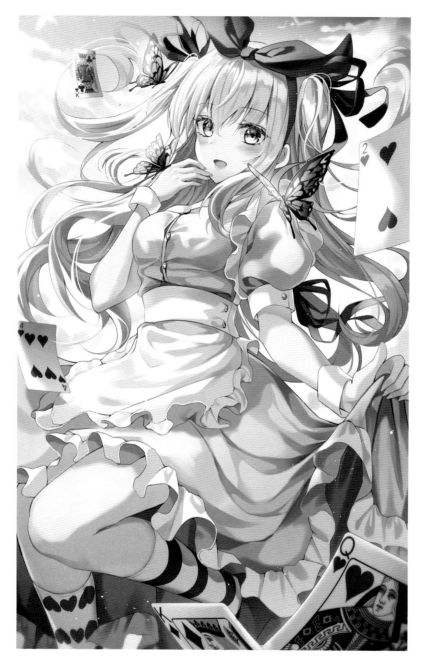

PROFILE
An illustrator who began the creative journey with the motivation to express the refreshing youth of women.

	2	
1		
	3	4

1. Alice/2020
2. Lycoris/2021
3. India/2021
4. Manjuu/2021

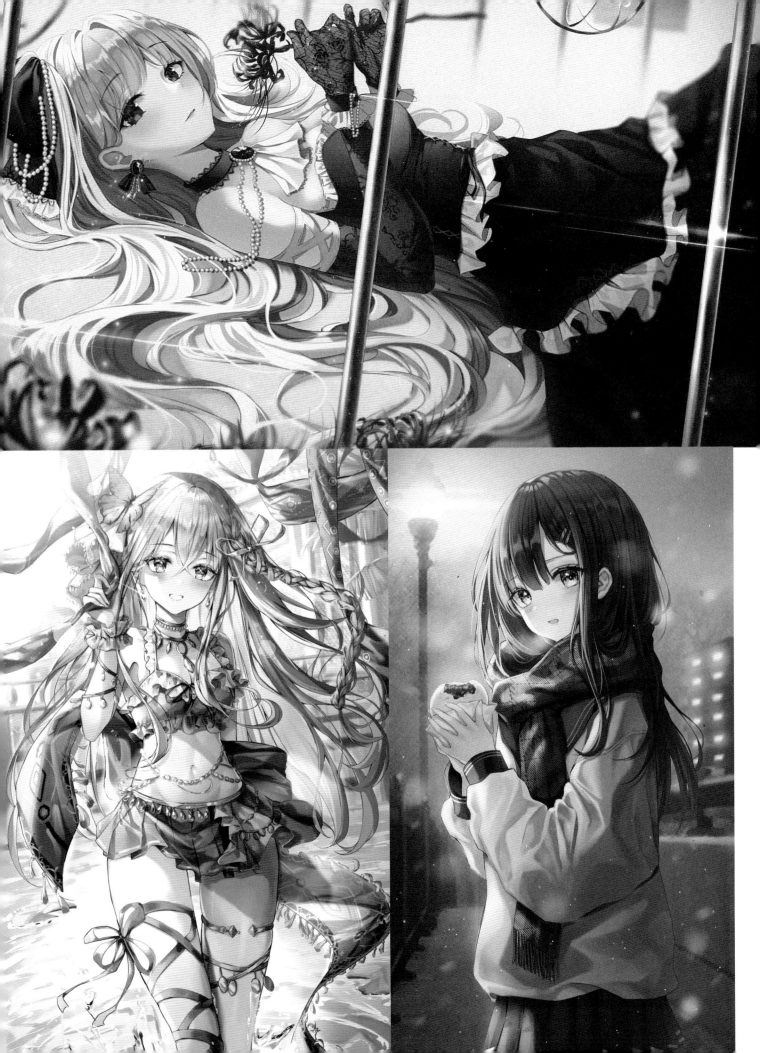

Mintchoco

Language: Korean, English, Japanese

E-mail: minttonim@gmail.com

twitter.com/minttomintto

pixiv ID : 1124380

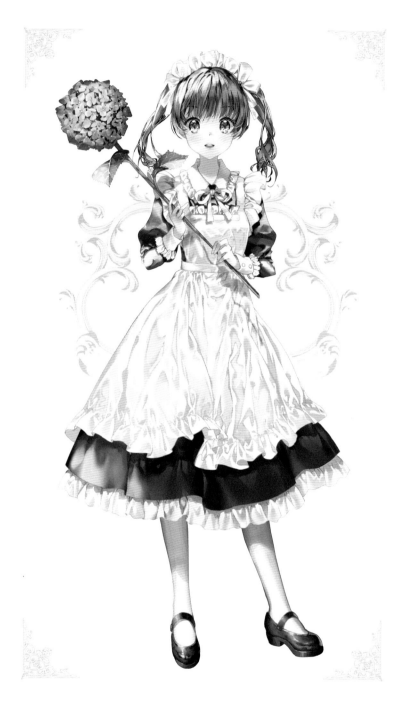

PROFILE
Illustrator in video game. Likes to draw cute women.

1. Maid/2020
2. Aqua Bee/2019
3. Lemon/2019
4. Jungle/2020

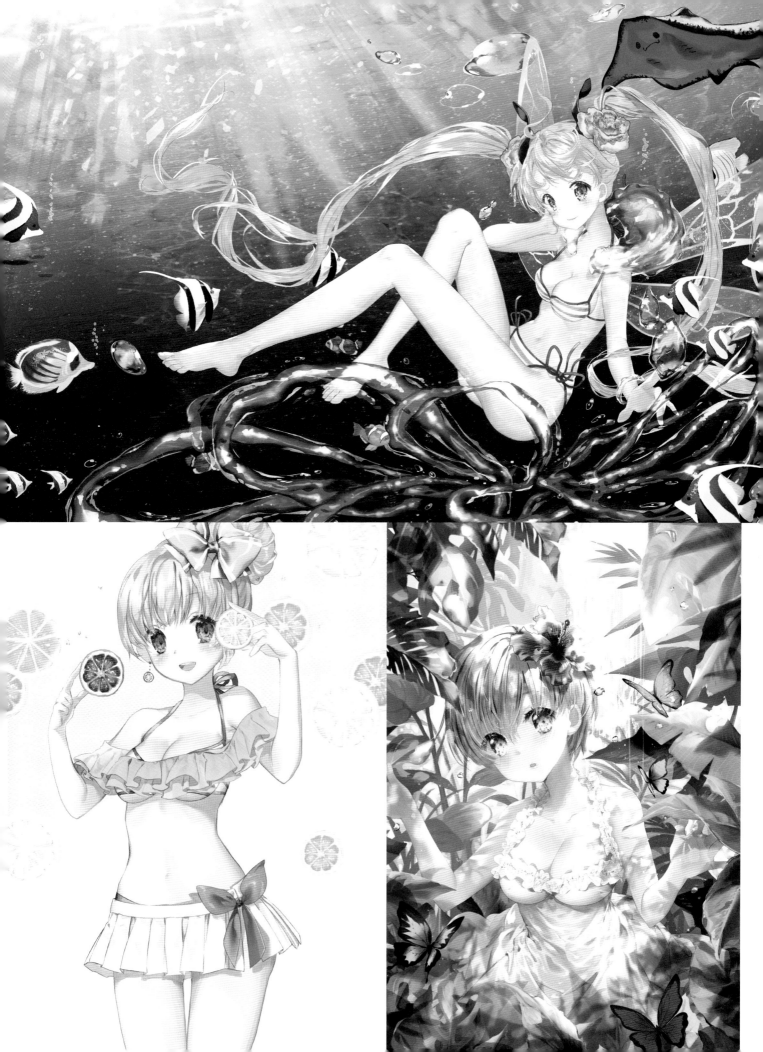

monjja

Language: Korean, English, Japanese

E-mail: monjja312@naver.com

twitter.com/monjja_12

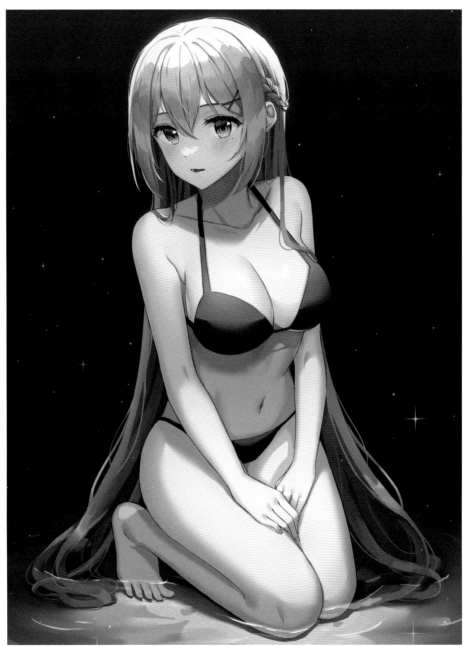

PROFILE

I was born in 2006 and live in Yongin, Gyeonggi-do, South Korea. I mainly work in digital illustration, with a focus on women characters. I like to experiment with different concepts and moods.

1. Swimsuit/2021
2. Flower/2021
3. Hatsune Miku/2021
4. Halloween/2020

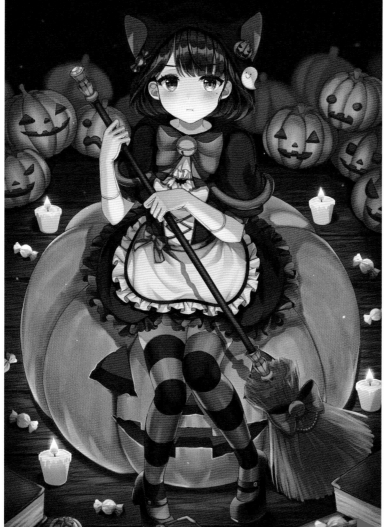

PP

Language: Korean, English, Japanese
E-mail: hyeonari@naver.com

twitter.com/hyeonari_

pixiv ID : 15177311

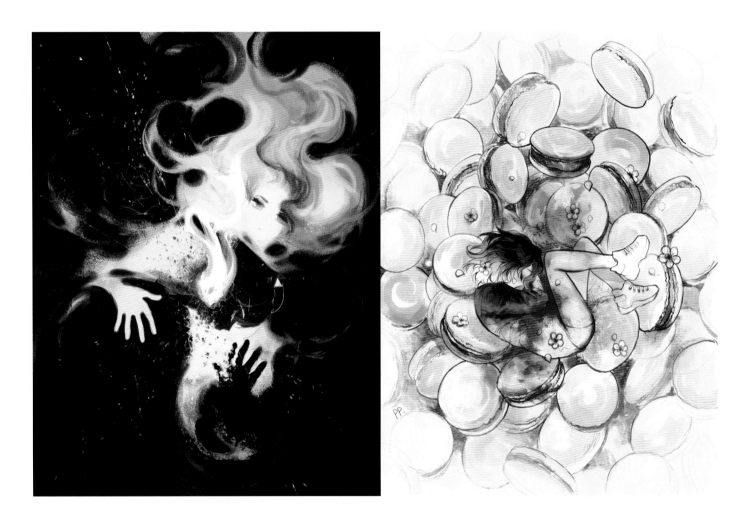

PROFILE
I create art that feels like something out of a dream. I like to use vivid and intense colors to portray emotions that everyone can relate to, such as love and sadness.

1 2 3

1. Setting Fires/2021
2. Sweet/2021
3. Ever After/2020

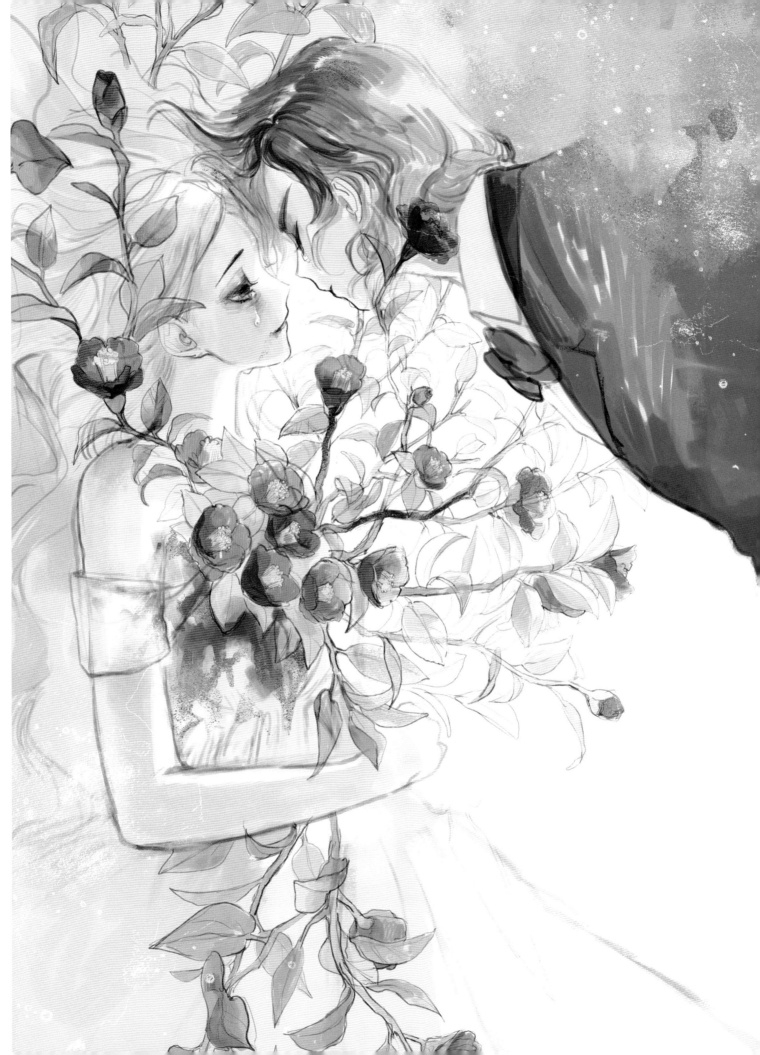

Roha

Language: Korean, English, Japanese

E-mail: slwjd08@naver.com

twitter.com/r_o_ha

pixiv ID : 14561023

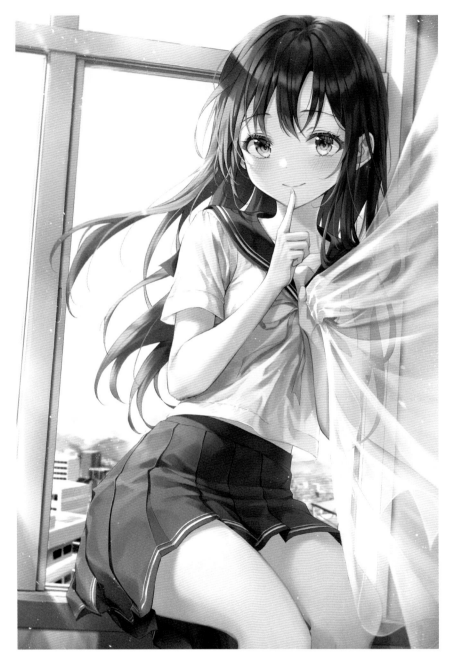

PROFILE

I am from Busan, South Korea. I love drawing cute women in their daily lives. I use a lot of painting photo references for a vivid sense of presence.

	2	3
1		
	4	5

1. School Window/2020
2. Maid 1/2020
3. Maid 2/2020
4. The Chair/2021
5. That Summer/2021

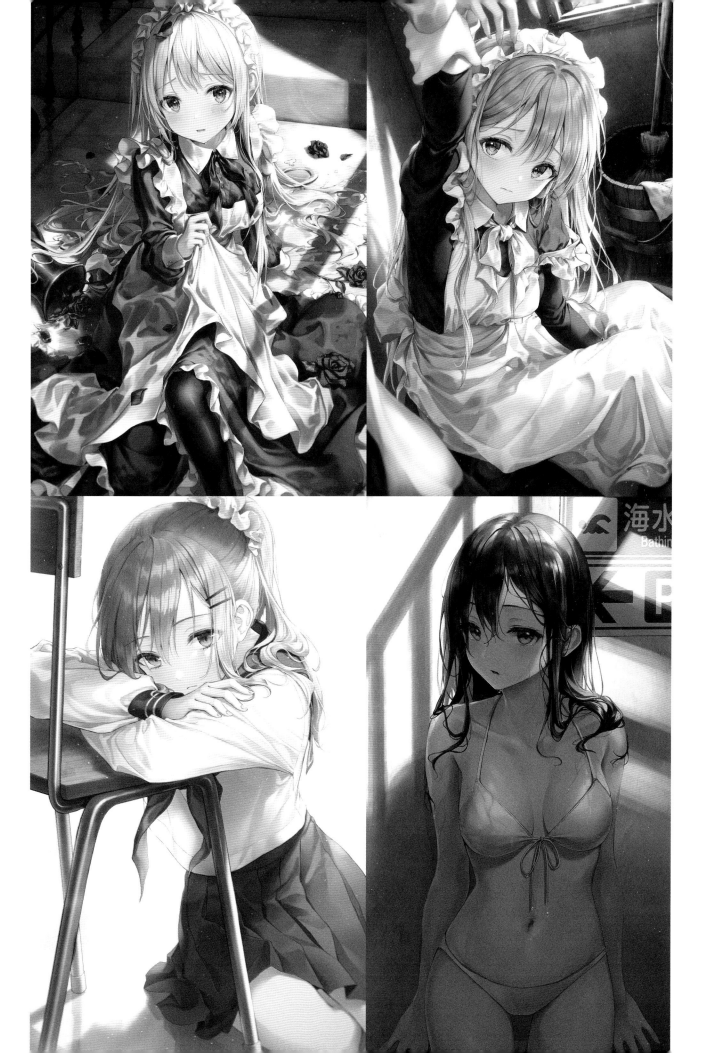

SJ

Language: Korean, English, Japanese
E-mail: rf_seoji@naver.com
twitter.com/RF_SSJ

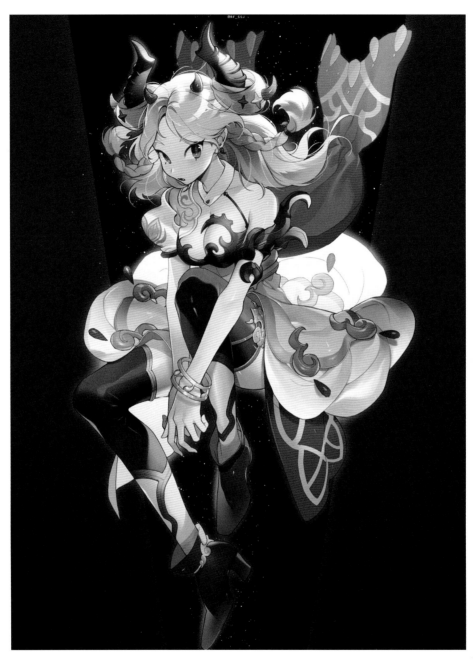

PROFILE
Video game illustrator for Netmarble's *Touch Monster*, and concept artist and illustrator for
Knights Chronicle.

1 2

1. Devil/2019
2. Miku/2020

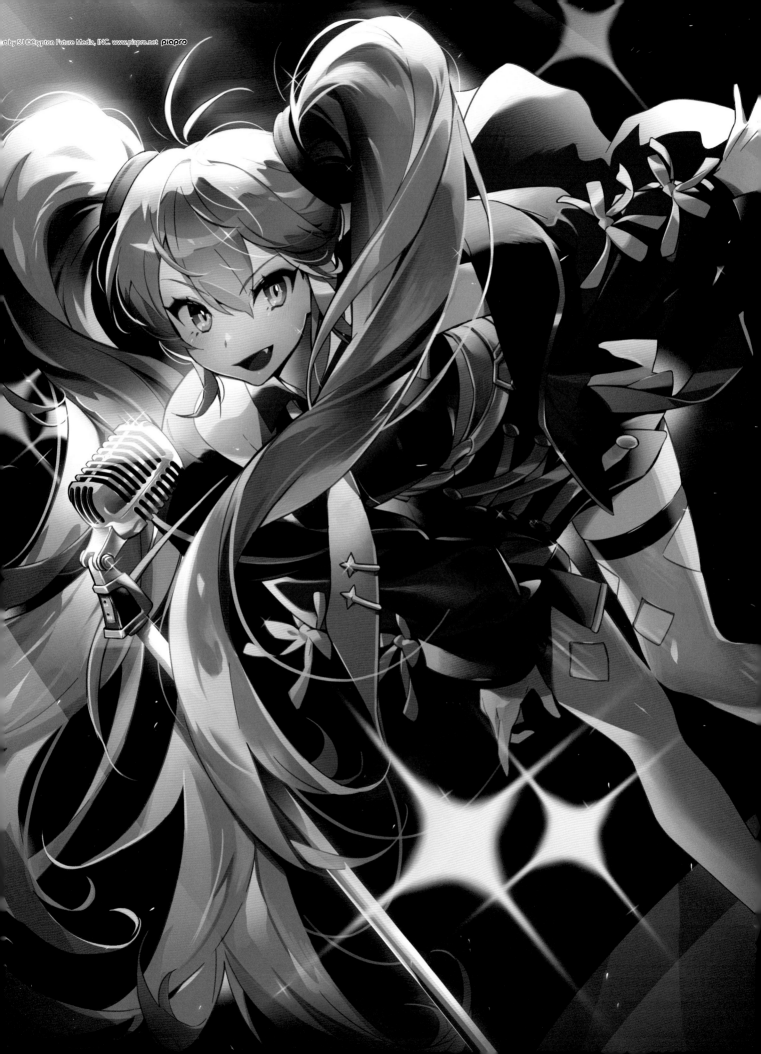

Sora Kim

Language: Korean, English, Japanese
E-mail: soraso0324@gmail.com
www.artstation.com/soraso0324

pixiv ID : 70309306

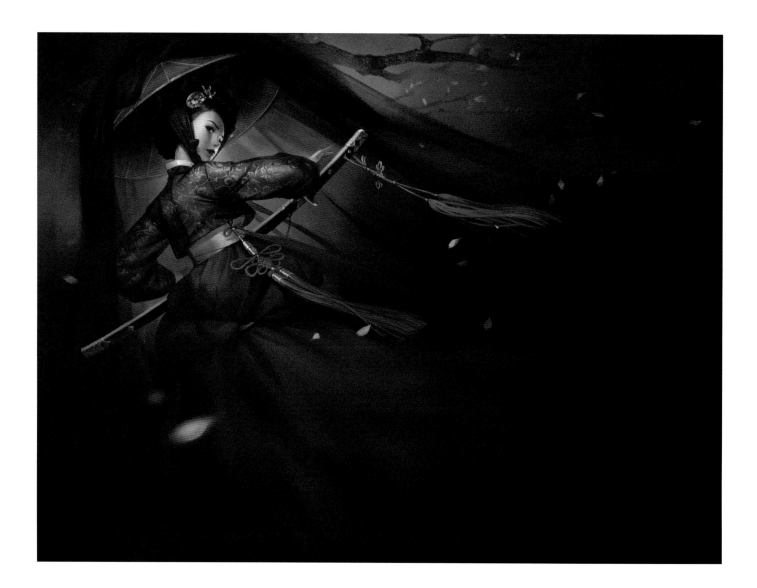

PROFILE
I am a concept artist and illustrator working in the gaming industry since 2014, and as a freelancer since 2021. I work with various studios in the US, China and South Korea.

1. Kisaeng/2018
2. Mudang/2020
3. Octopus/2021
4. Two swords/2021

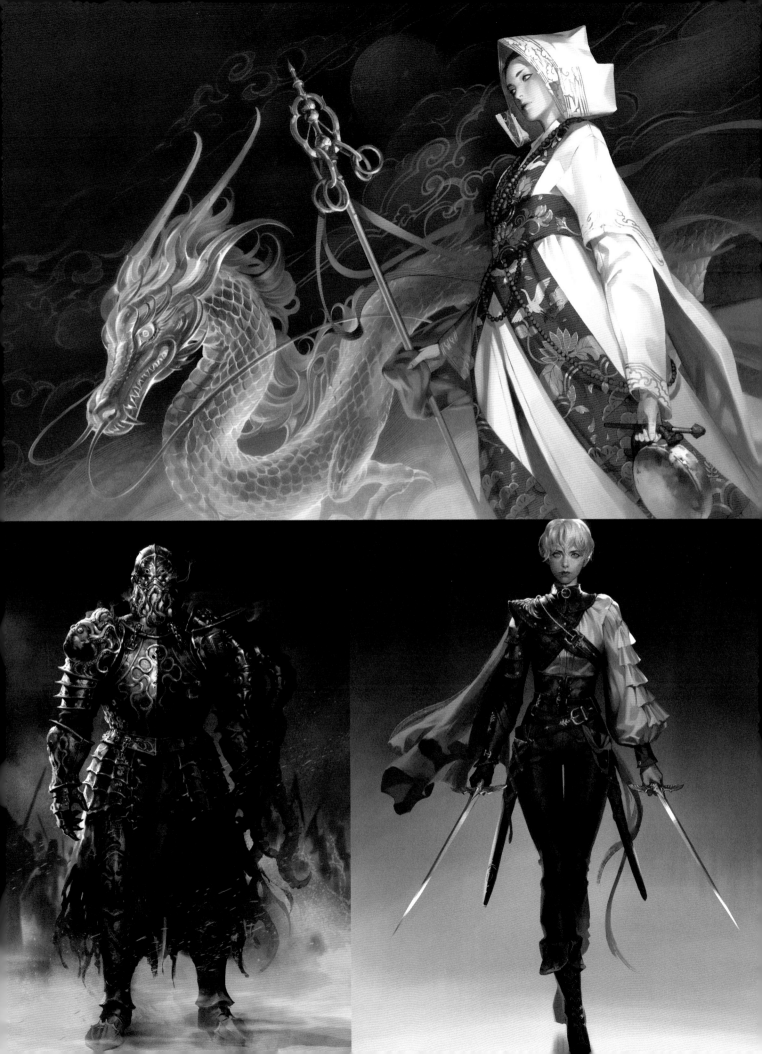

TAYA

Language: Korean, English, Japanese

E-mail: taya_oco@naver.com

twitter.com/taya_oco

pixiv ID : 5323203

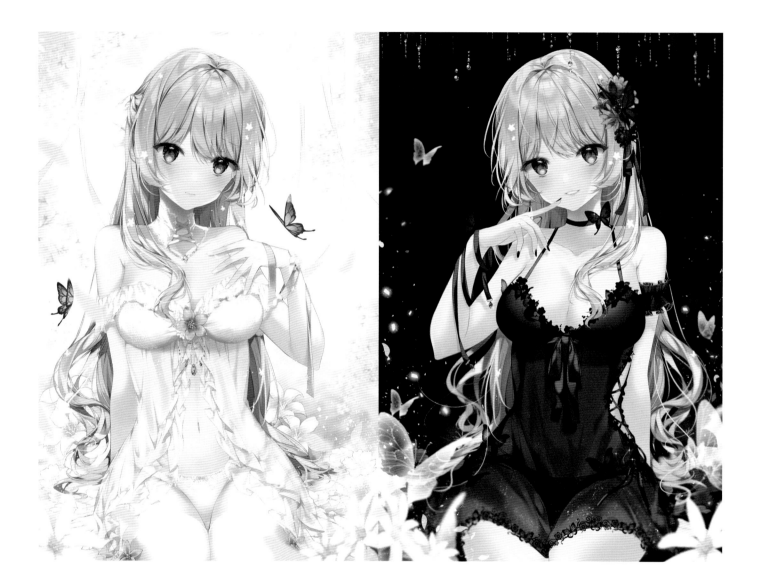

PROFILE
In my current work, I try to use techniques to create a soft and shiny atmosphere. My goal is to make my characters stand out through my concepts, colors and motifs.

1 2 3

1. Flower/2020
2. Butterfly/2020
3. Blue/2020

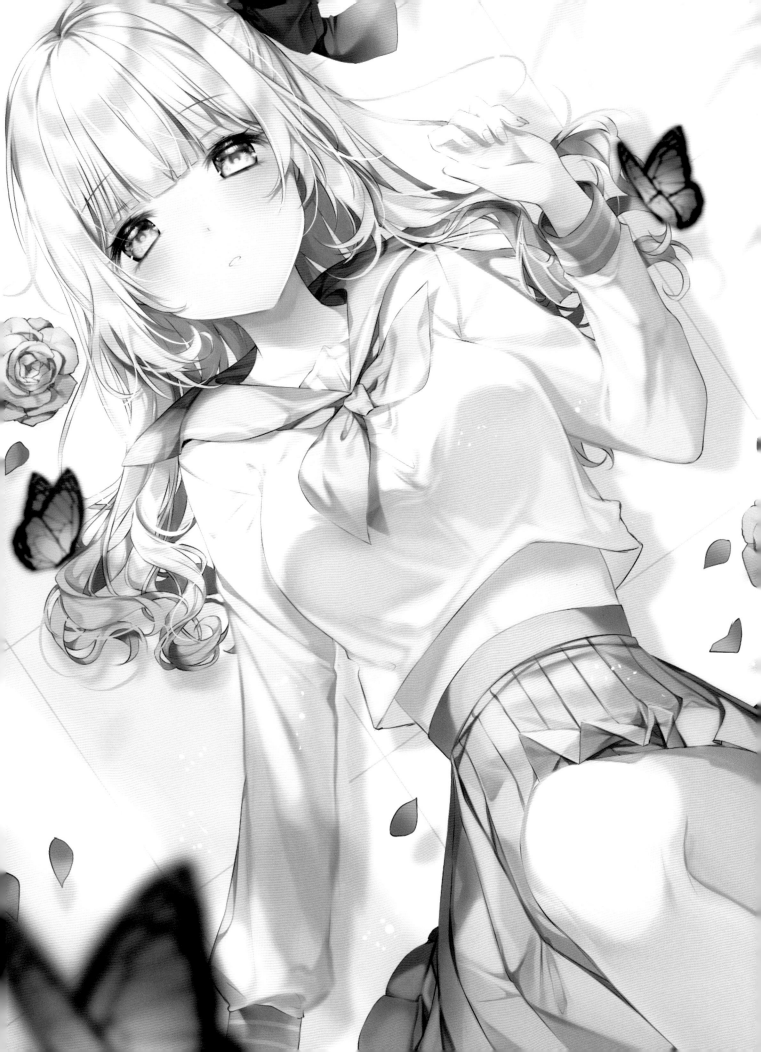

Tiv

Language: Korean, English, Japanese

E-mail: atelier.tiv@gmail.com

twitter.com/tiv_

pixiv ID : 35081

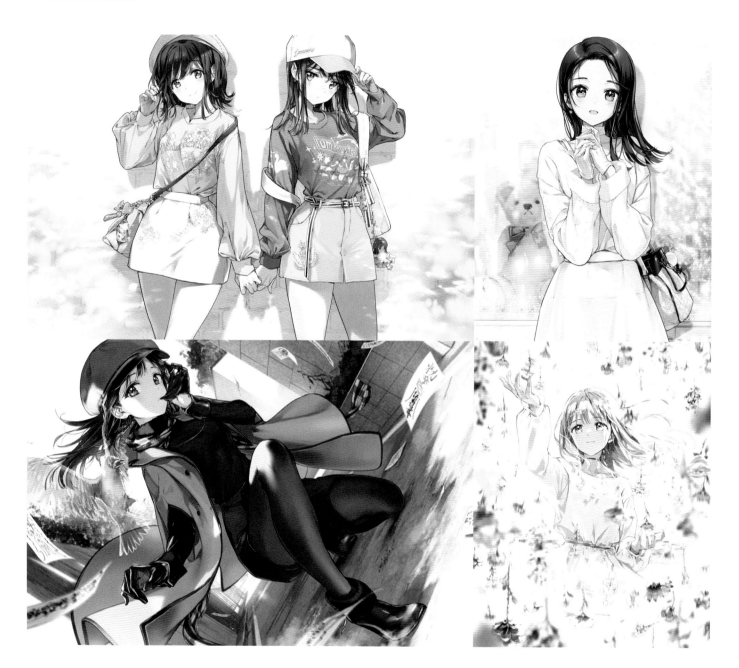

PROFILE

A manga artist and illustrator whose work emphasizes emotional expression. Credits include illustrator for Ichijinsha's manga series, *Masamune-kun's Revenge*, and the *Girls Symphony* and *Plantonica/Luminoustar* art books.

1	2	5
3	4	6

1. Platonica/Luminousstar/2019
2. Winter Holiday/2020
3. Ward Off/2021
4. Blossom Seasonable Rain/2021
5. Connect our Hearts, Chasing the Stars/2019
6. Clear After Rain/2019

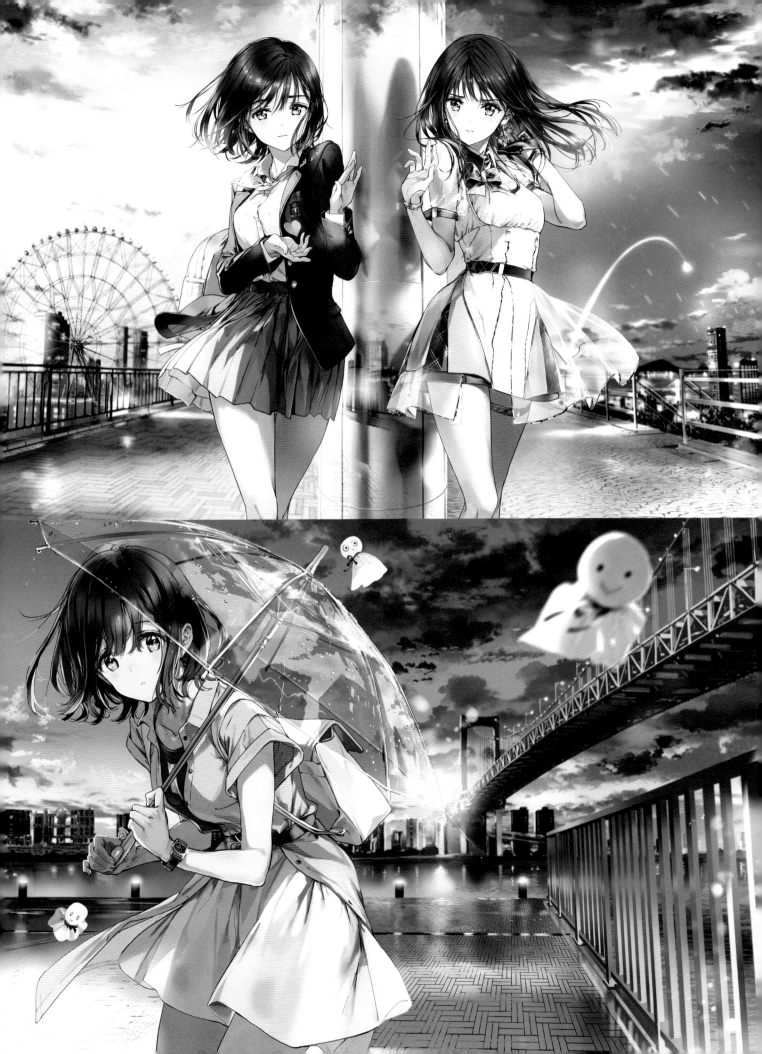

YOHAKU

Language: Korean, English, Japanese

E-mail: hyuns0206@gmail.com

twitter.com/yohaku_0w0

pixiv ID : 16331597

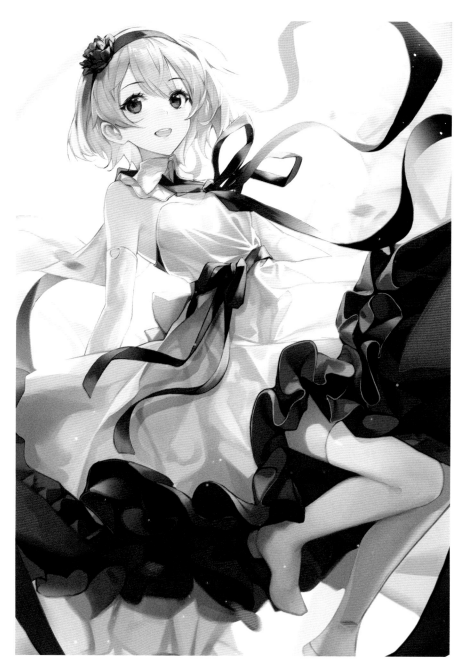

PROFILE

YOHAKU was born in 2002 in Seoul. A freelance illustrator, YOHAKU works in a variety of fields such as video games and web novels, specializing in a fantasy world view.

1. untitled 2/2020
2. untitled 3/2020
3. untitled 4/2020
4. untitled 1/2020

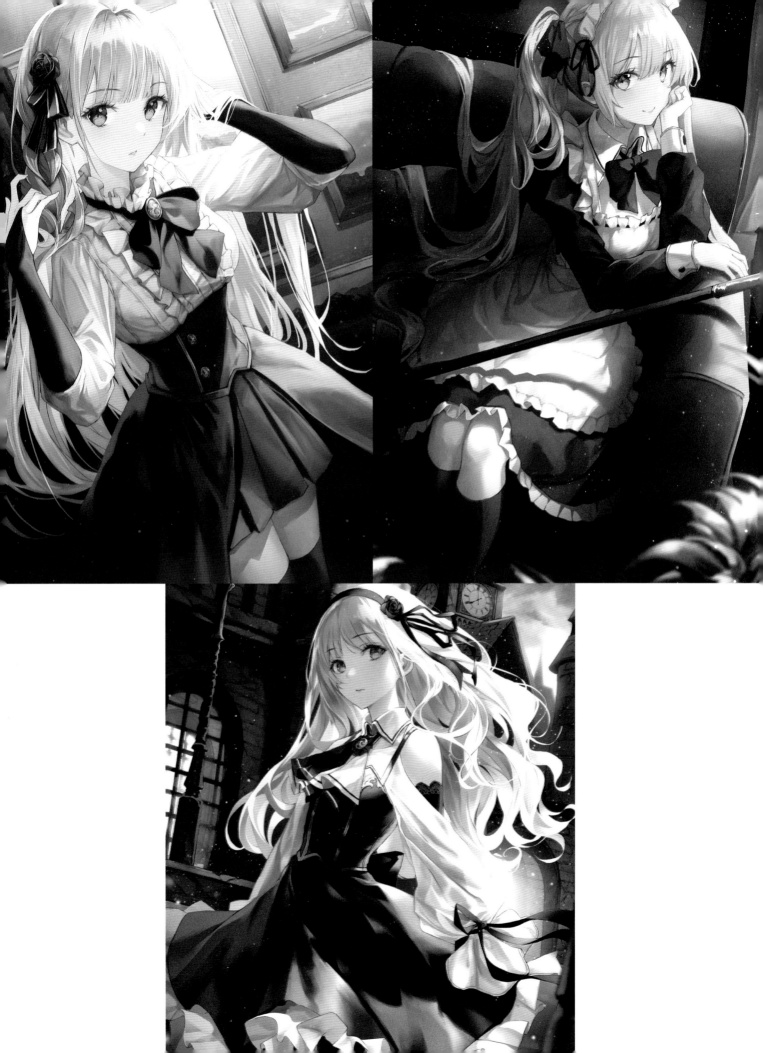

YUHO

Language: Korean, English, Japanese

E-mail: kayuikalin@naver.com

twitter.com/kayuikalin

pixiv ID : 1213646

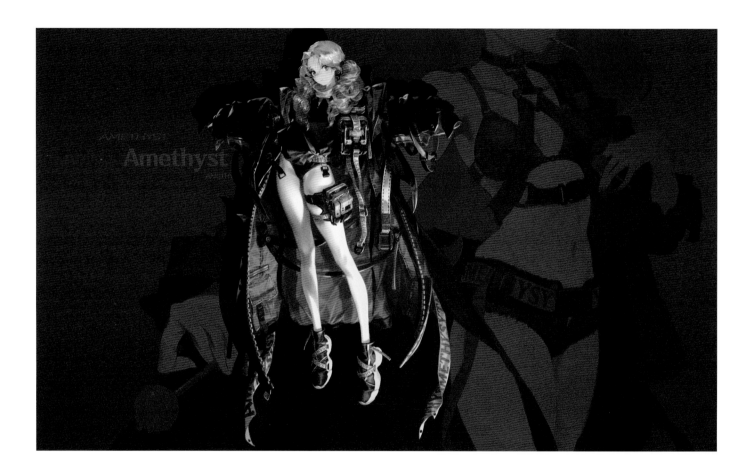

PROFILE
YUHO is a Korean's ma'am, a concept artist who focuses on color and design.

1. Amethyst/2020
2. Pink/2020
3. Orange/2020

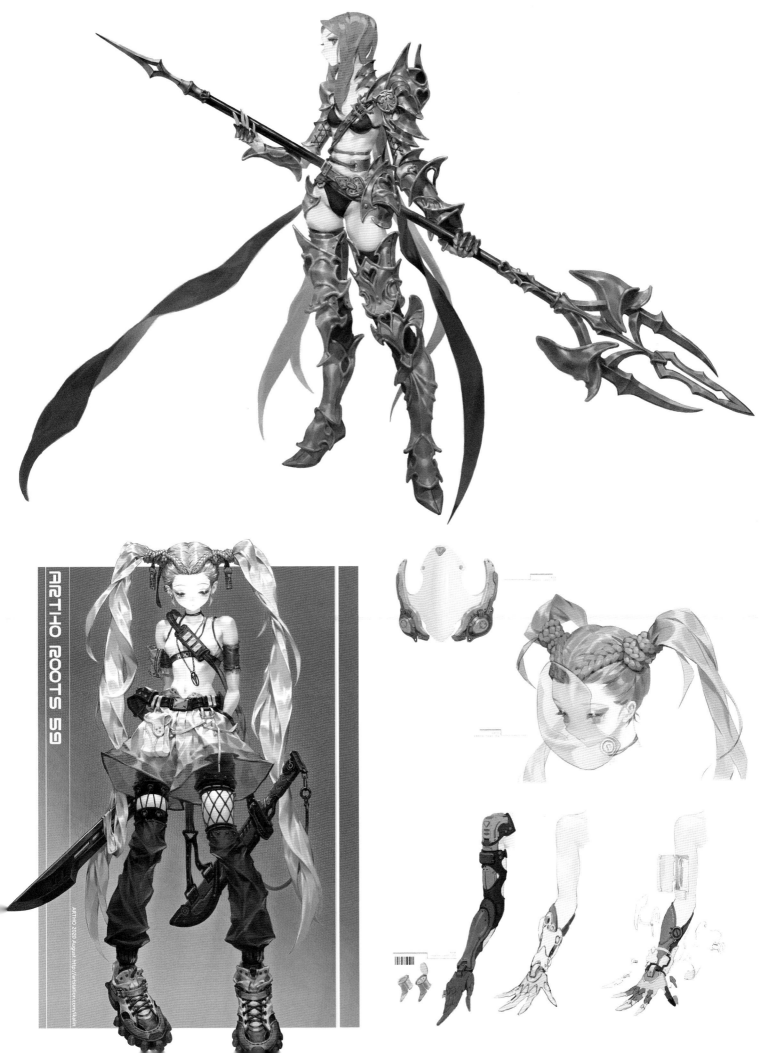

ETAMA

Language: Korean, English, Japanese

E-mail: etamaxwall@gmail.com

twitter.com/etamaquomo

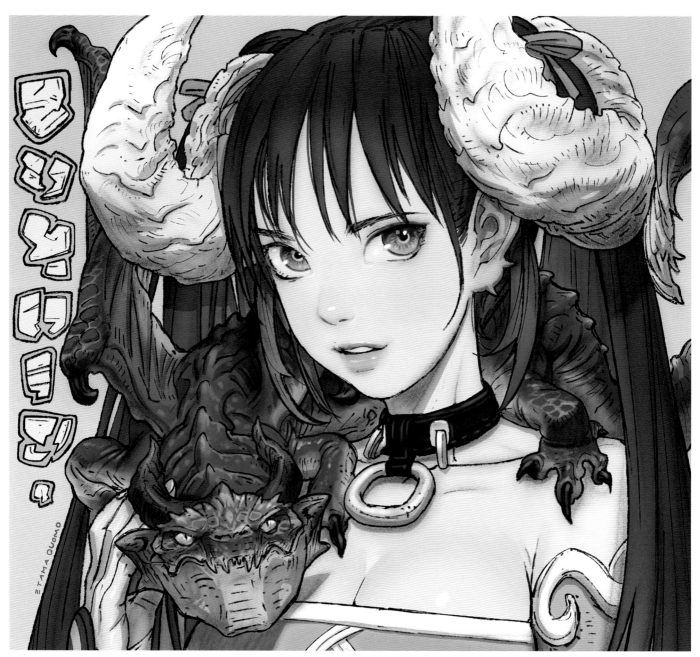

PROFILE

Since 2006, ETAMA has worked as a concept artist for video games, such as *Magyechon Online* from CAPCOM/Seed9 Ent, and *Dragon Nest* from Eyedentity Games. As of 2021, he works as a freelance illustrator and character concept artist.

		2	
1			
		3	4

1. Unknown Dragon Girl/2019
2. Commander/2019
3. Empress/2014
4. Discussion/2014

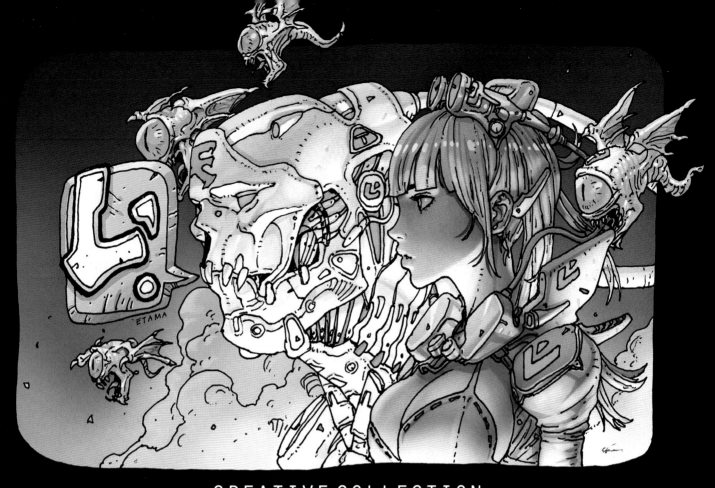

CREATIVE COLLECTION
ETAMA ARTWORKS

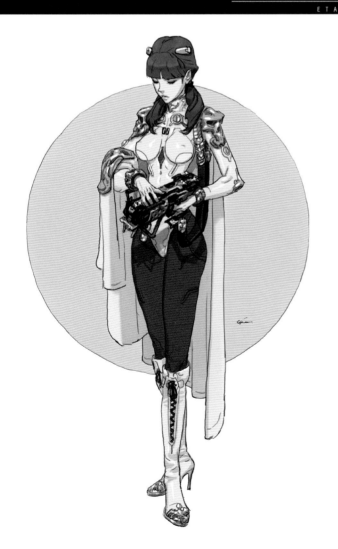

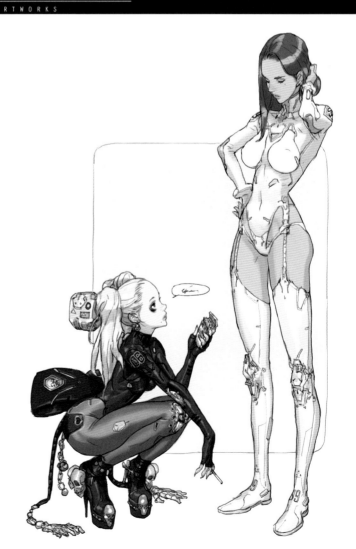

gomzi

Language: Korean, Japanese

E-mail: gcmzi@naver.com

twitter.com/gcmzi

pixiv ID : 1023317

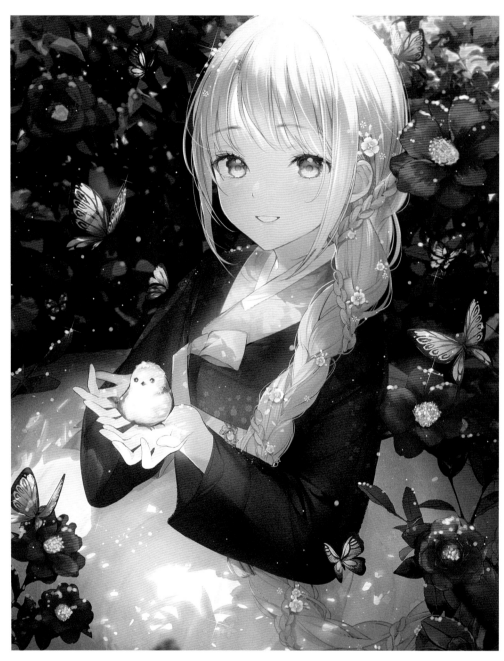

PROFILE
Love drawing women with flowers, butterflies and animals. My main focus is character illustration.

1	2	3
	4	5

1. Happy New Year/2021
2. Rabbit Room/2020
3. Starry Tale/2019
4. Wedding/2021
5. She in the Back Seat/2020

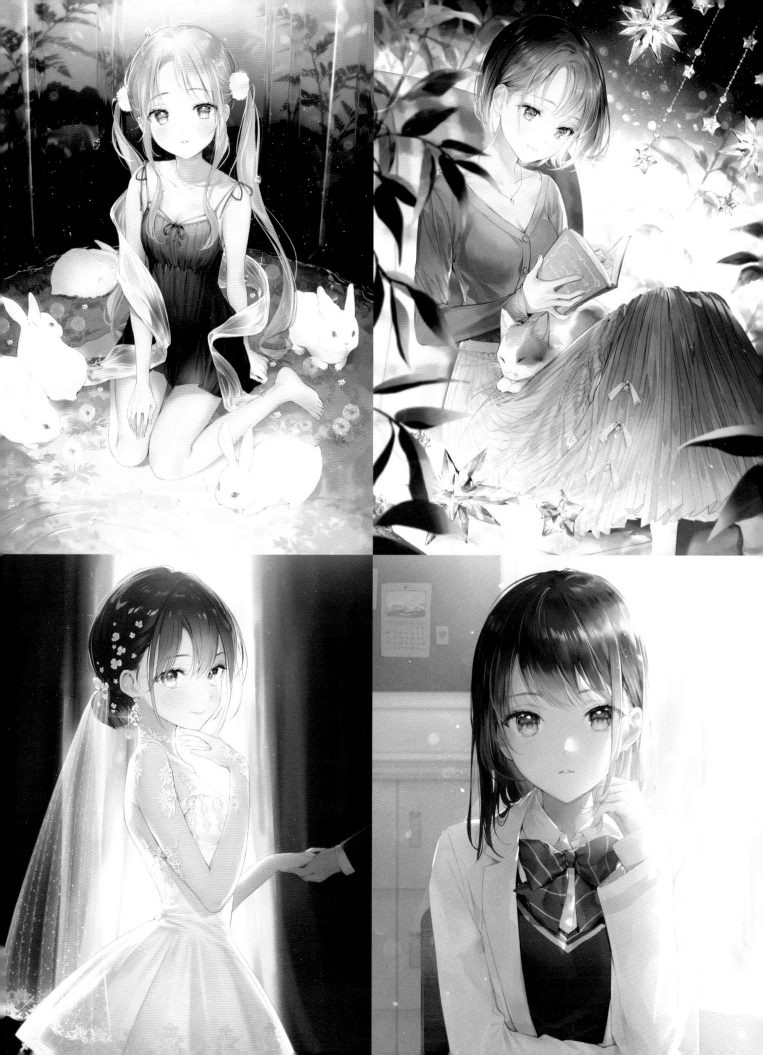

QMENG

Language: Korean, English, Japanese

E-mail: q_meng@naver.com

www.qmengcom.work

pixiv ID : 7421885

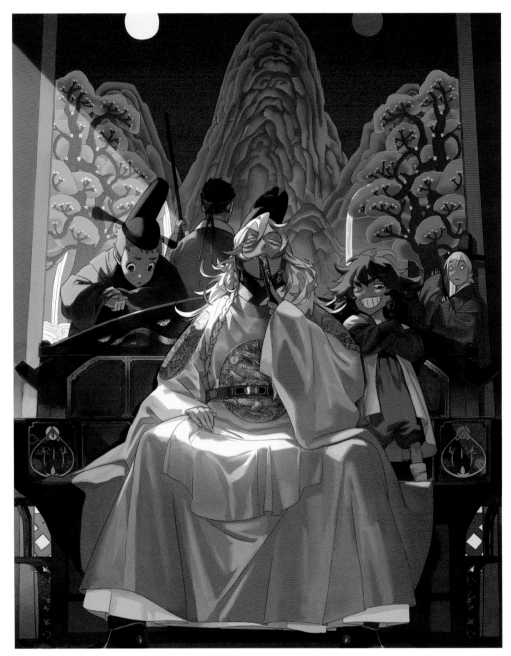

PROFILE
I work in the animation industry as a freelance production staff and director for shows like *Chase the Shadow*. I like to create concept art and character designs.

1. Chase the Shadow/2020
2. Young Agents/2021
3. Veteran Agents/2021
4. Meeting/2020
5. Children of Star/2021

Kim Jungsung

Language: Korean, English

E-mail: kronaya@naver.com

www.linktr.ee/JS_Art

pixiv ID : 1861547

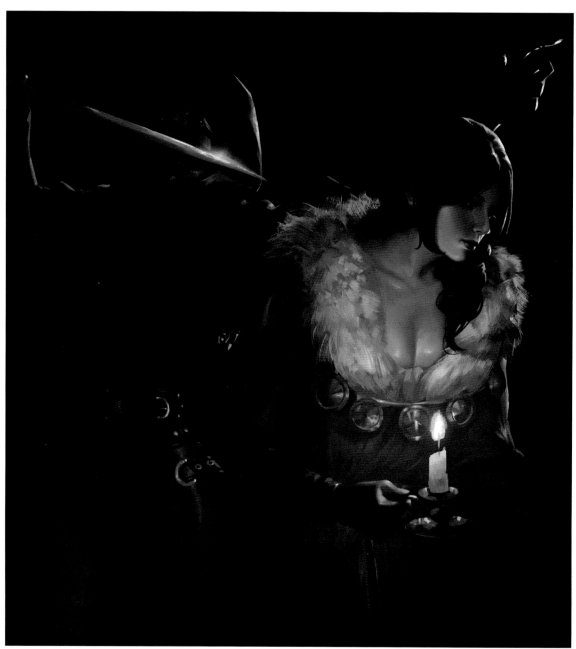

	2	3
1		
	4	

PROFILE

An original artist based in Seoul, Kim Jungsung created fantasy illustrations with elements of modern war. His work can be found on social media.

1. In the Dark/2020
2. Sorrow/2020
3. Witch/2021
4. Trio Mafioso/2021

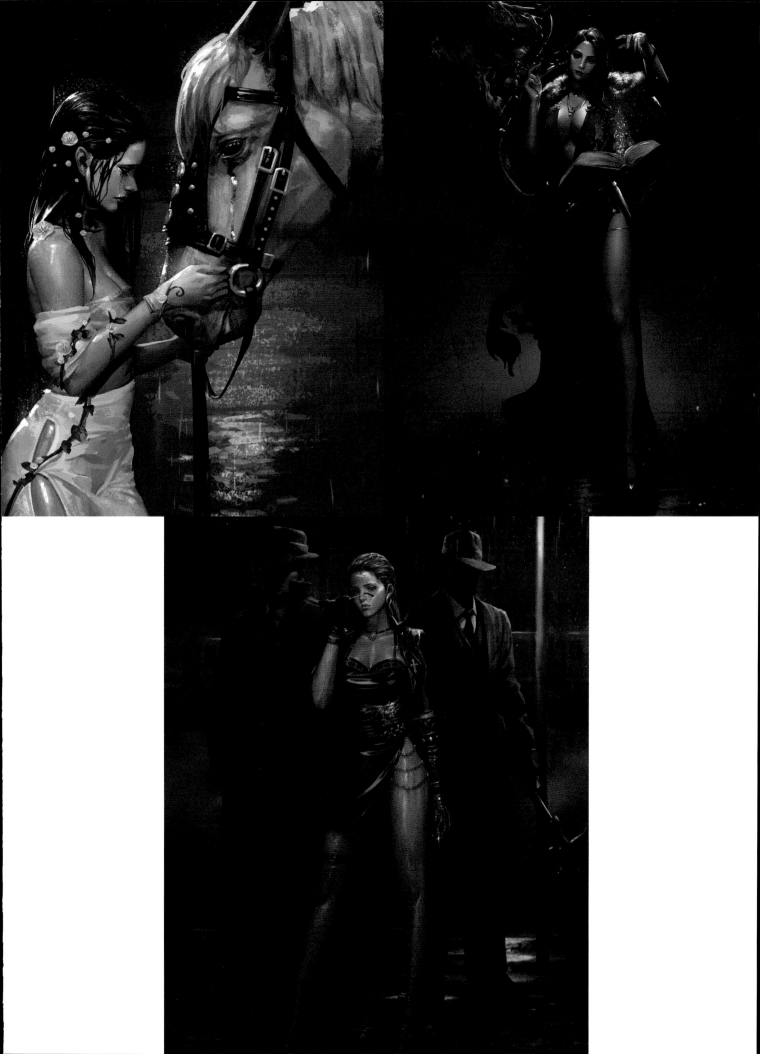

KKUEM

Language: Korean, English, Japanese

E-mail: kkuem@naver.com

twitter.com/kkuem

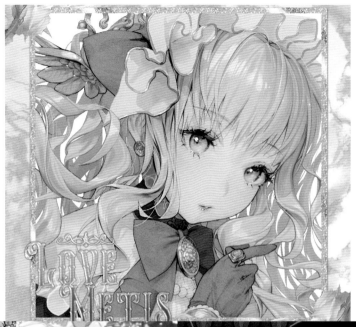

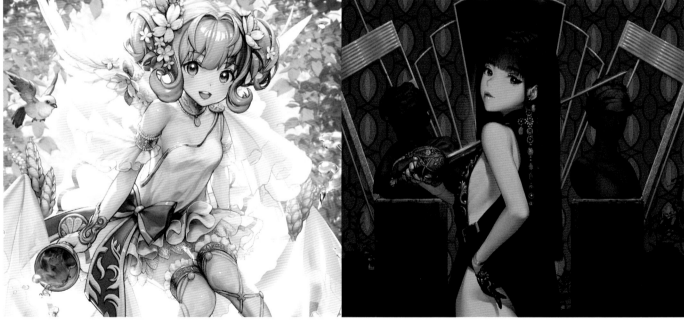

PROFILE
Video game credits include *Destiny Child, Million Arthur, Lord of Vermillion, Overwatch, Rage of Bahamut*, and much more.

1. Metis/2020
2. Syrinx/2019
3. Love Cacao/2020
4. Tiwaz /2020

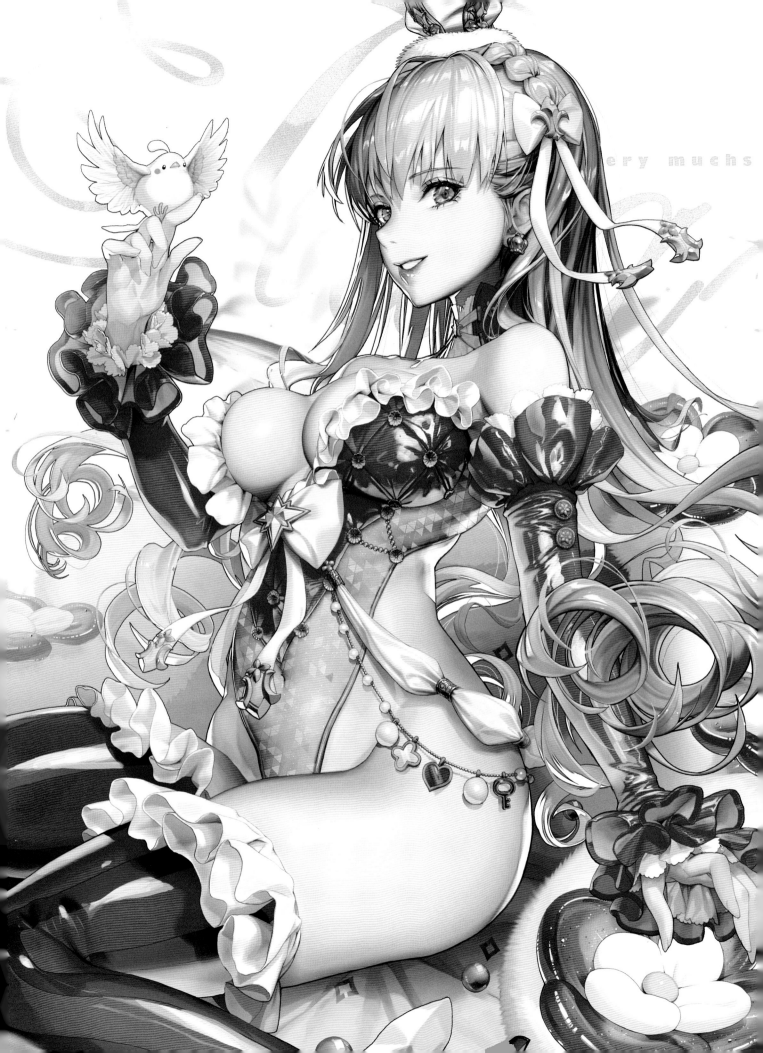

Naru

Language: Korean, English, Japanese

E-mail: ksa828235@naver.com

twitter.com/Naru_0__

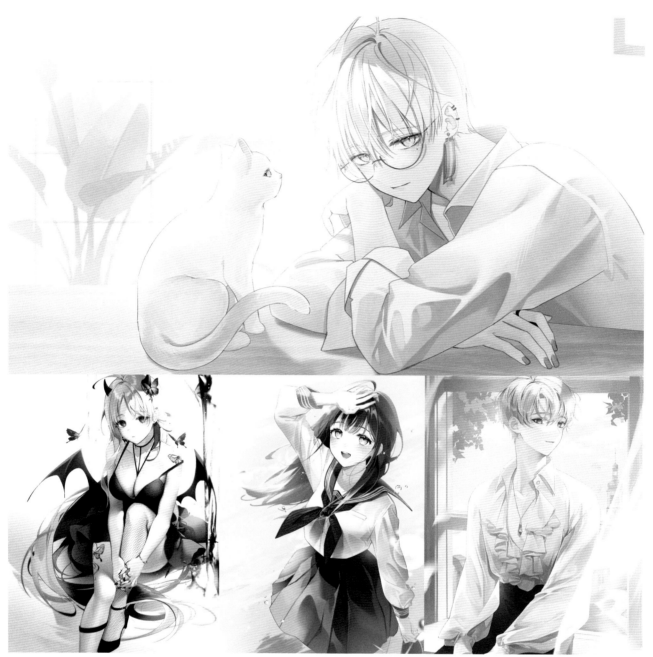

PROFILE

Naru is an emotional illustrator capable of a wide variety of modern styles. Regularly streams on Twitch.

1. Mellifluous/2021
2. Ice Color/2021
3. Foot of Summer/2021
4. Einz the Magician/2021
5. Charlotte/2021

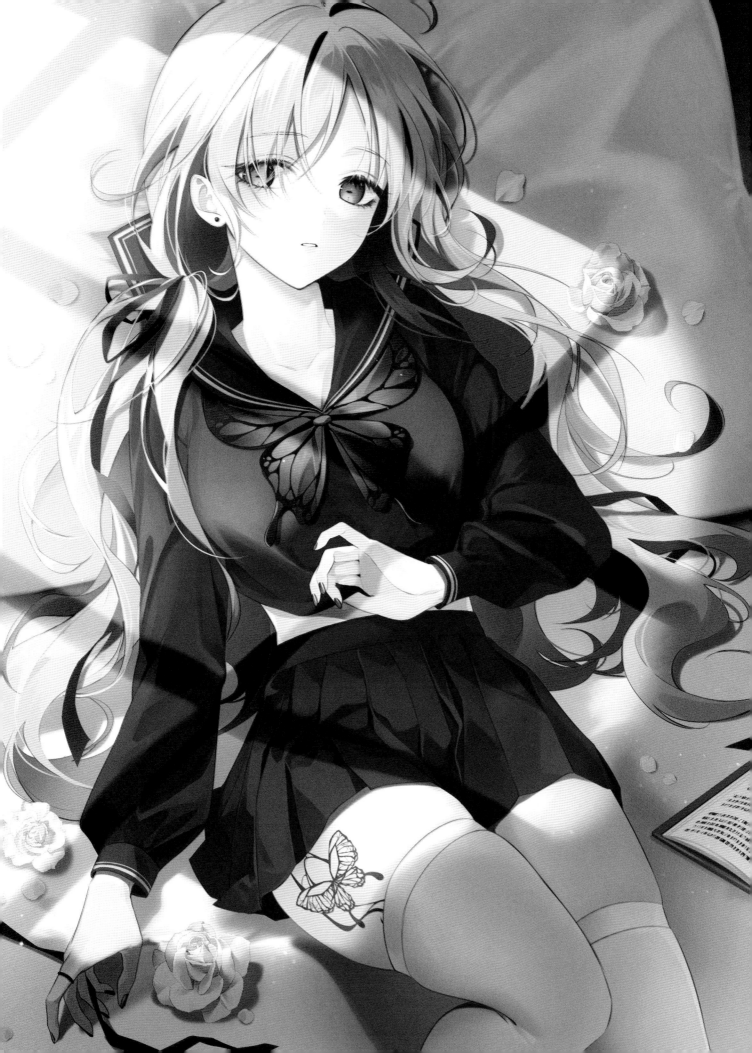

Nardack

Language: Korean, English, Japanese

E-mail: nardack43@gmail.com

twitter.com/nardack

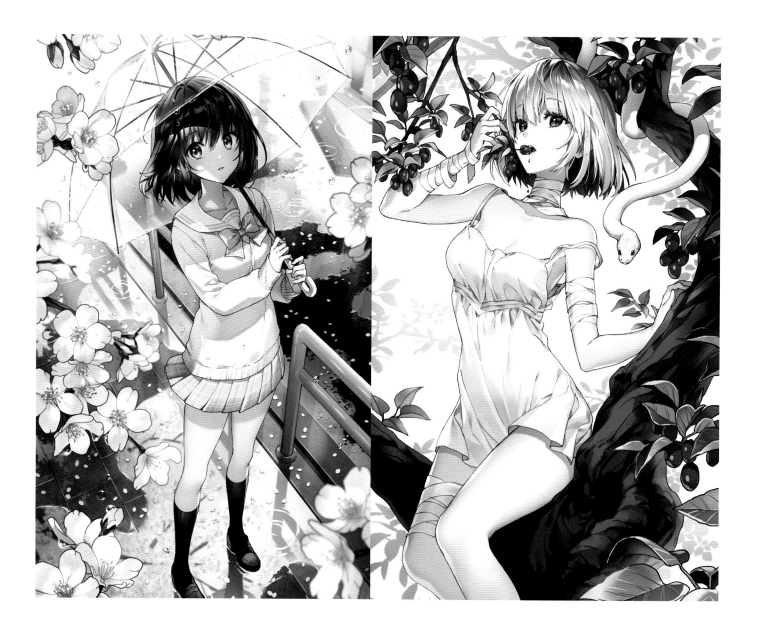

PROFILE
Active in various fields such as novel covers and game illustrations.

| 1 | 2 | 3 |

1. Rain/2021
2. White Snake/2021
3. Goldfish2021/2021

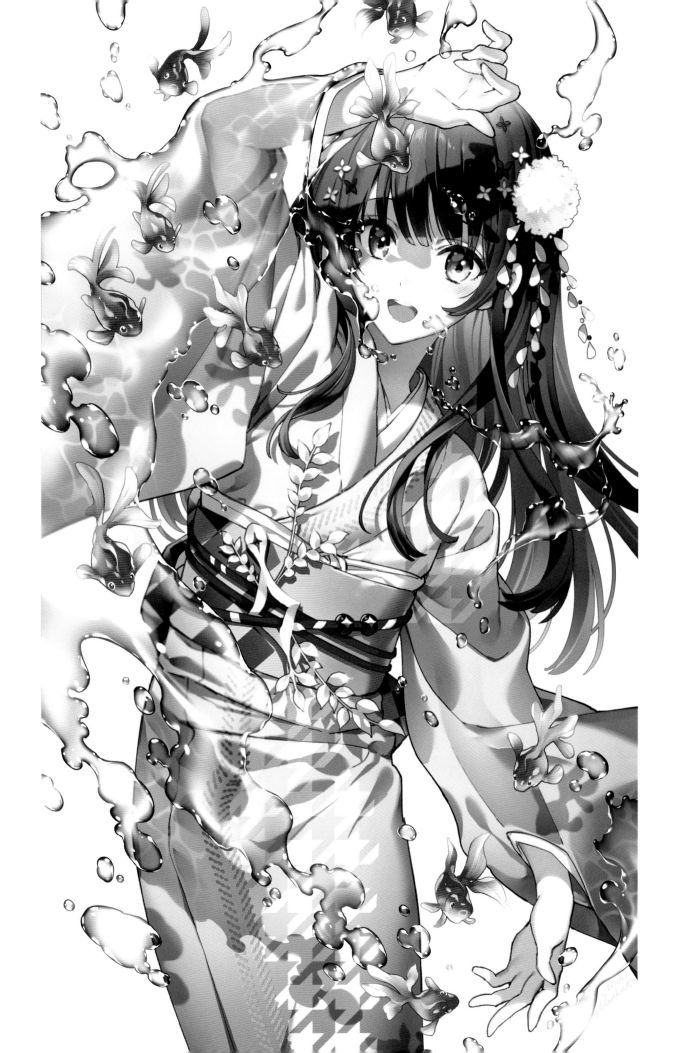

DADACHYO

Language: Korean, English, Japanese
E-mail: ddchyo@gmail.com
instagram.com/dadachyo

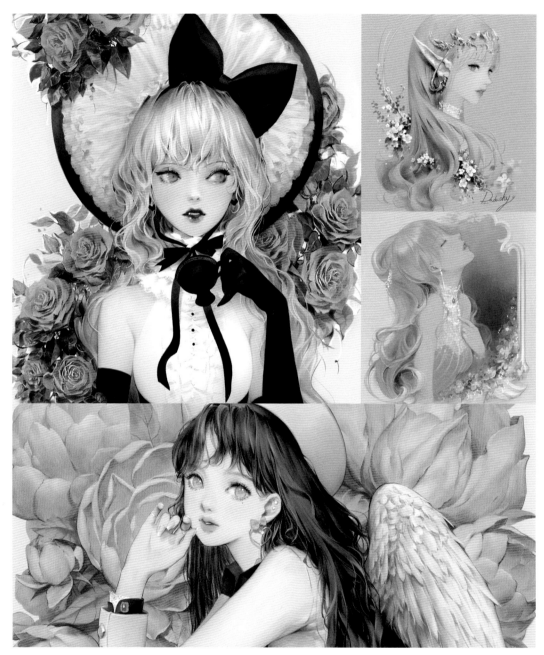

PROFILE
People think that "I draw the face that I want to be" but this just isn't true. I just draw the beautiful ladies I want to worship and the cute women I'd love to wine and dine.

1	2		5
	3		
4		6	7

1. Rose Tea/2018
2. Elf/2018
3. Dear Mom/2017
4. Peony/2019
5. You Said You Loved Me/2017
6. Chu/2018
7. Flower Giraffe/2019

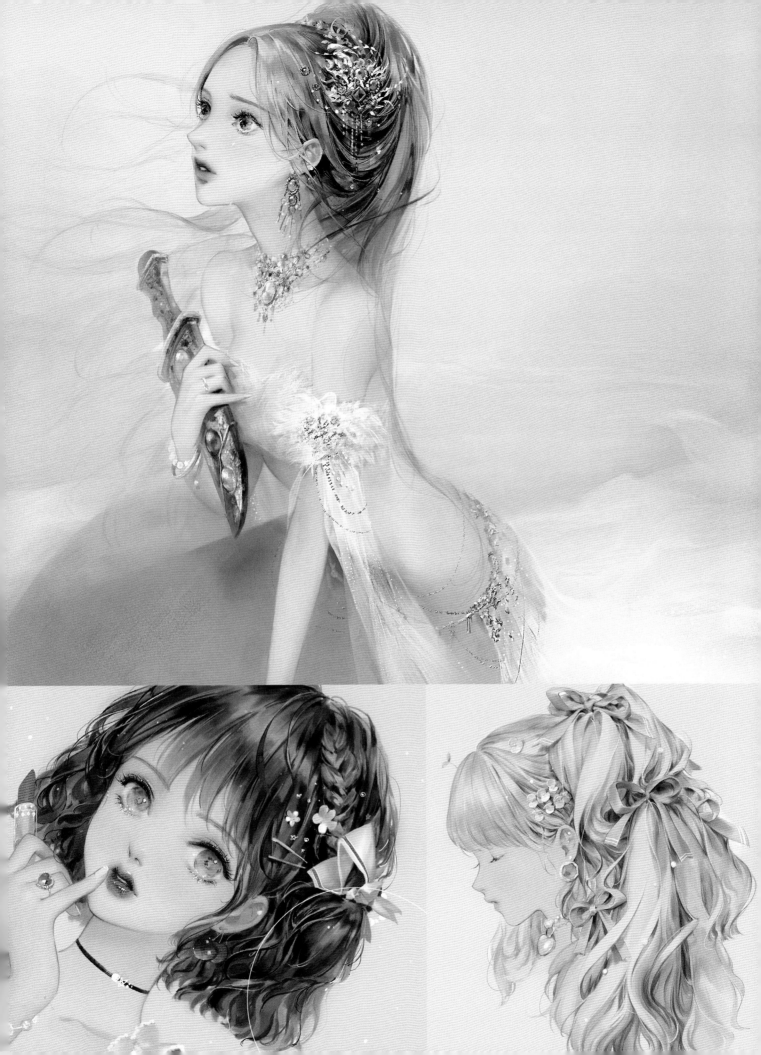

DABAEK

Language: Korean, English, Japanese

E-mail: lldamiill@naver.com

twitter.com/iiDA100ii

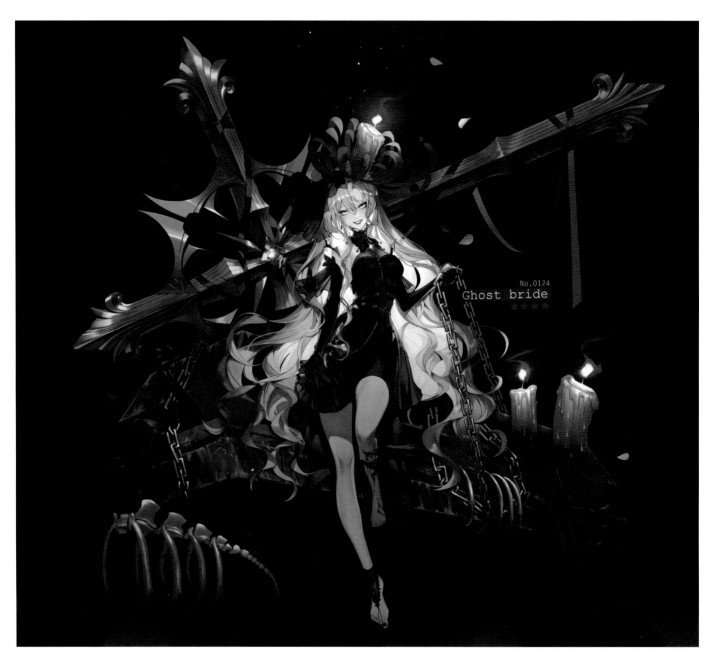

No.0124
Ghost bride
★★★★

PROFILE

Concept artist and illustrator in the gaming industry. Dabaek employs a semi-realistic modern style, accented by bold colors.

1. Ghost Bride/2020
2. Mermaid/2020
3. Sporty/2020
4. Spring/2020

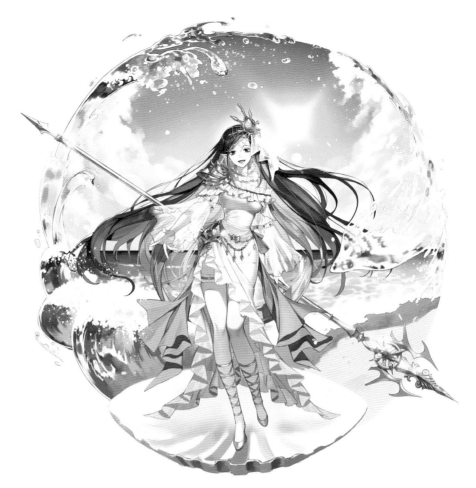
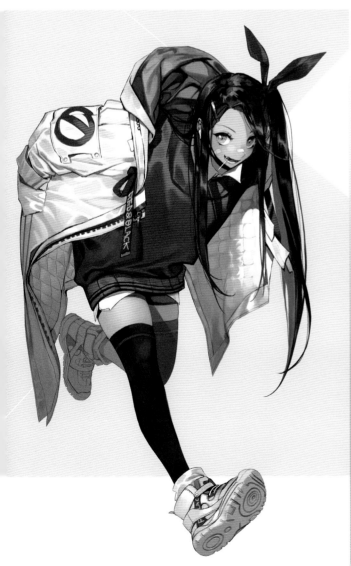
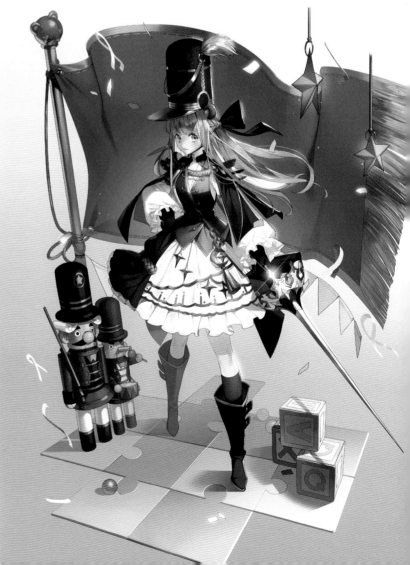

Momoka

Language: Korean, English, Japanese

E-mail: aengdohwa@gmail.com

twitter.com/aengdohwa

pixiv ID : 4959310

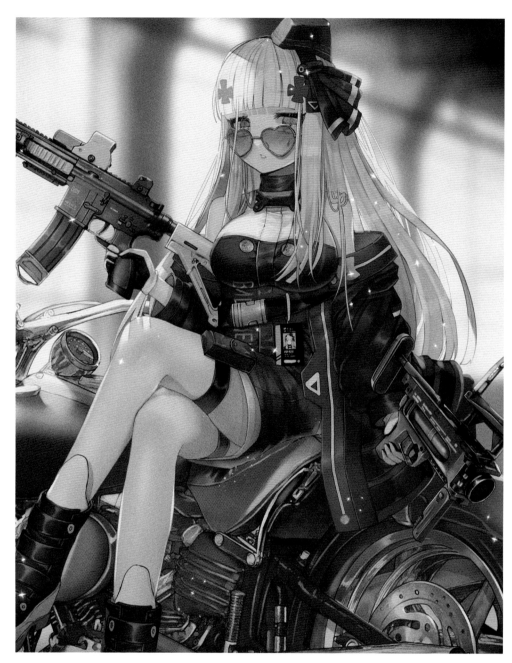

PROFILE
I am an illustrator who draws beautiful women in a variety of genres.

1. Girls' Frontline 416/2019
2. Code: Dragon Blood
 1st Anniversary Illustration/2021
3. Maid/2021
4. Sunflower/2021

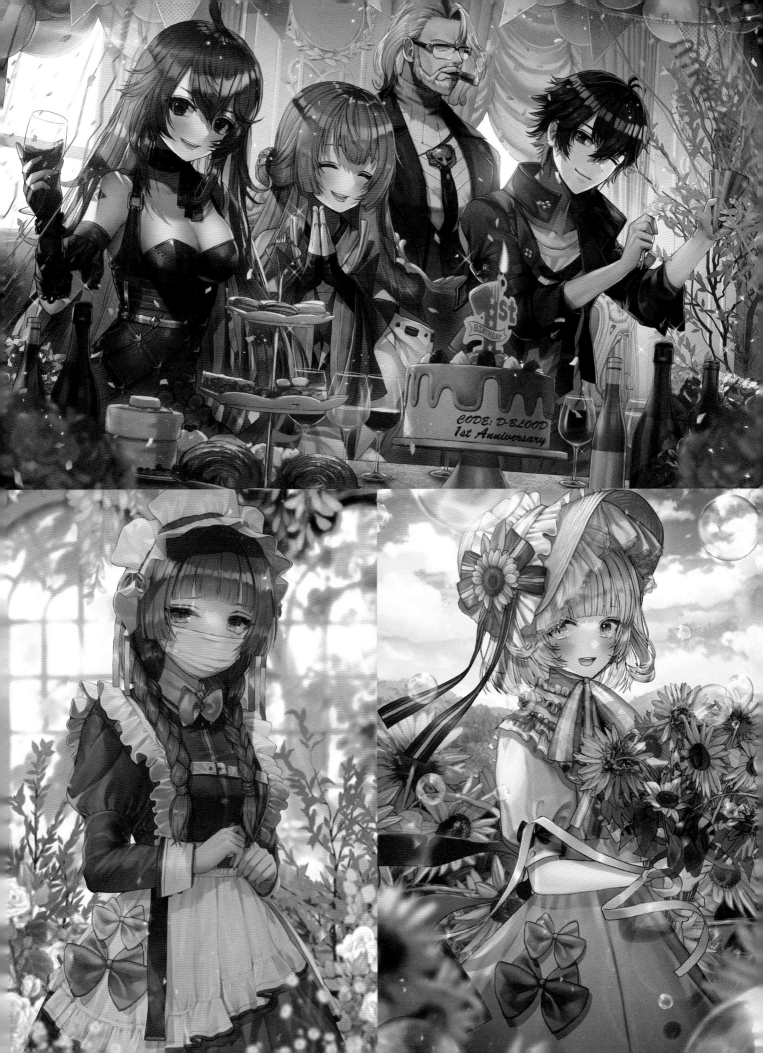

CODE: D-BLOOD
1st Anniversary

ttosom

Language: Korean, English, Japanese

E-mail: ponsberry@gmail.com

twitter.com/ttosom58

pixiv ID : 6203904

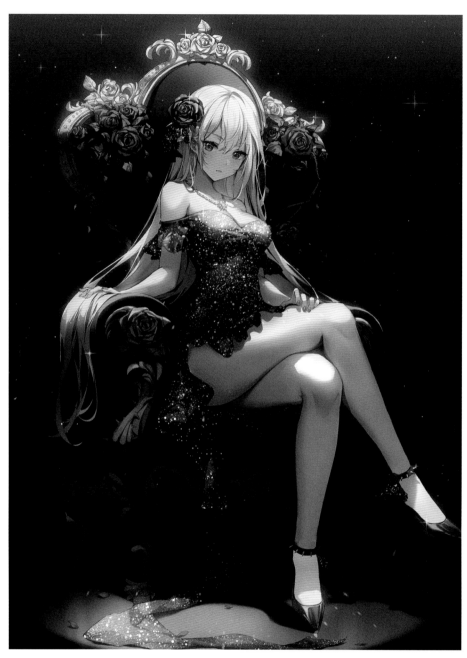

PROFILE

Ttosom is an illustrator who mainly paints with the expression of glittering light and transparency.

	2	3
1		
	4	5

1. Queen/2021
2. Red Cheongsam/2020
3. Soda Girl/2021
4. Black 'n Red/2021
5. Maldive/2021

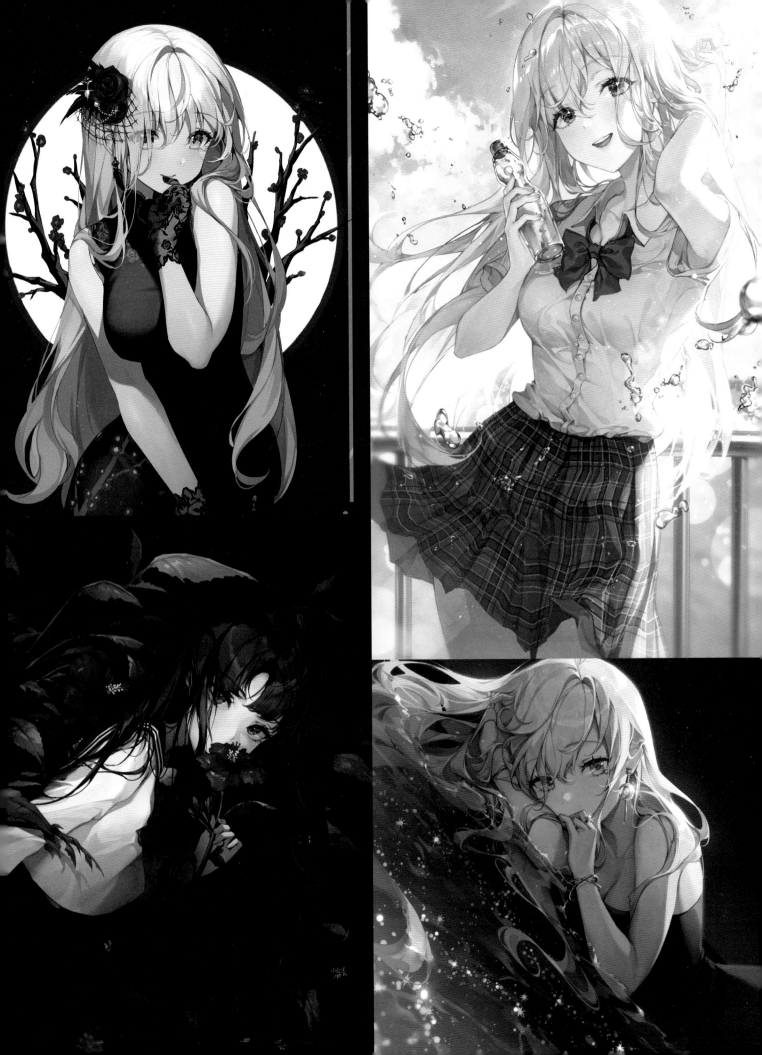

Ryat

Language: Korean, English, Japanese
E-mail: o3o000103@gmail.com
twitter.com/112423a

pixiv ID : 67671264

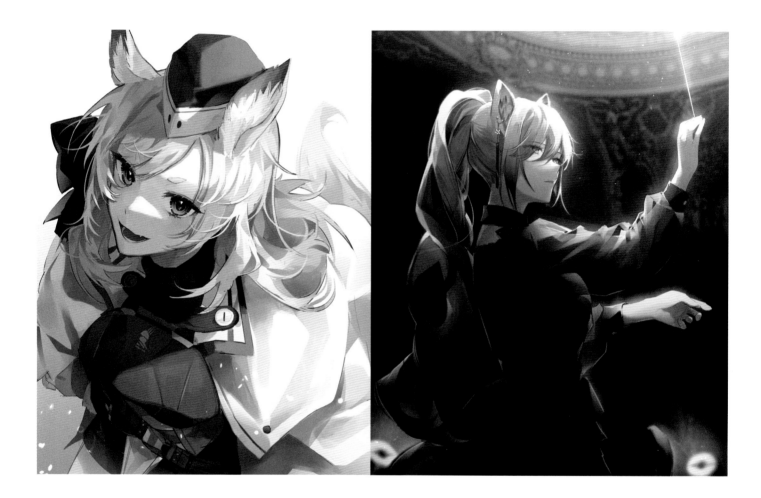

PROFILE
Ryat creates digital fan art, primarily based on the Chinese mobile game, *Arknights*.

1 2 3

1. Whislash from Arknights/2020
2. Schwarz from Arknights/2021
3. OC/2021

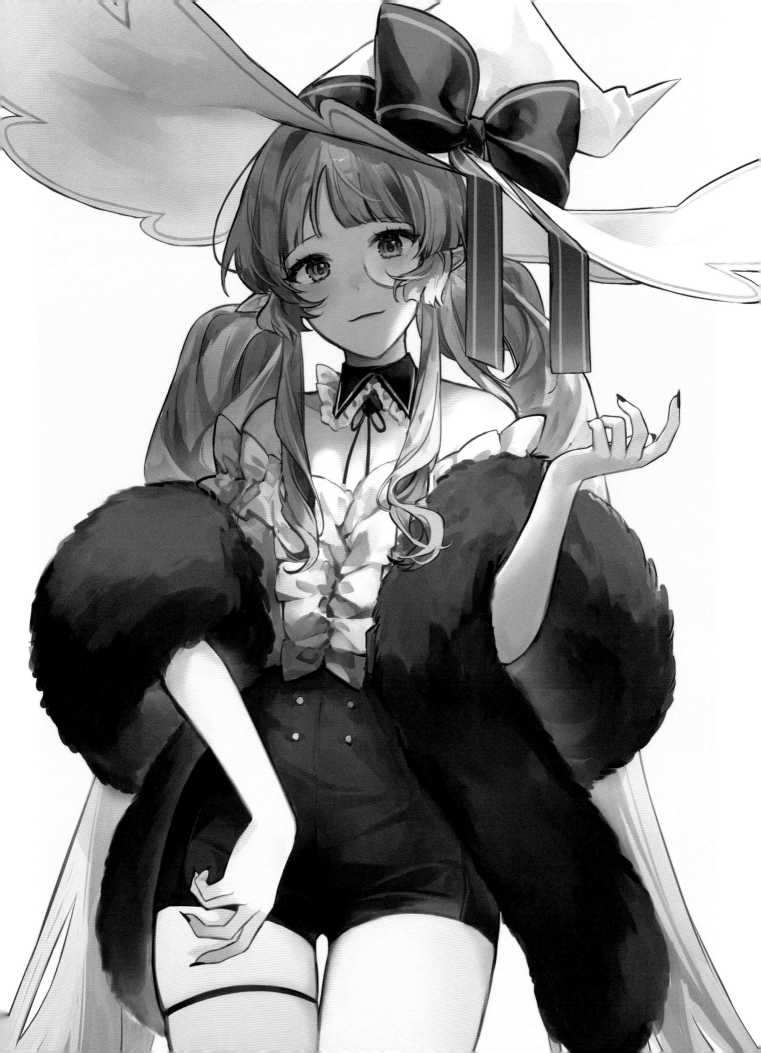

Renian

Language: Korean, English, Japanese

E-mail: rednian@naver.com

twitter.com/Renian_

pixiv ID : 760140

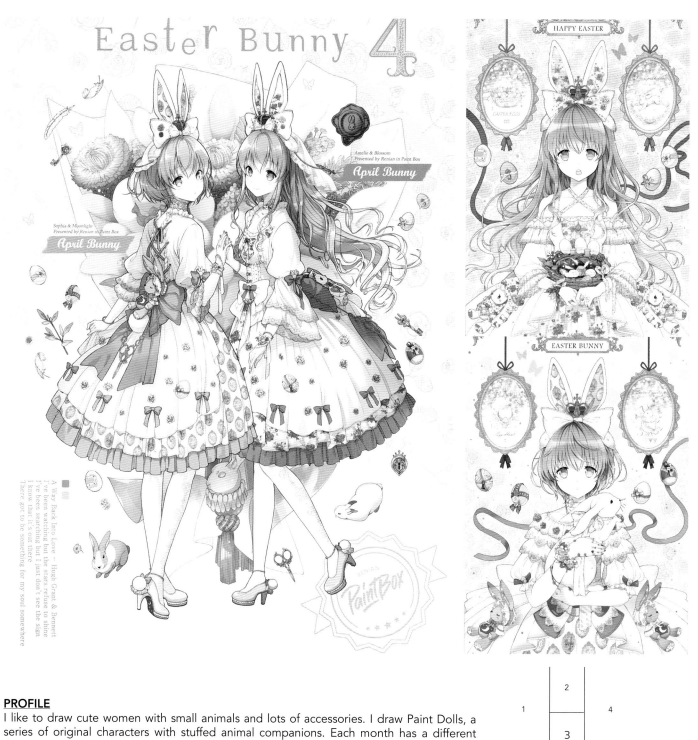

PROFILE

I like to draw cute women with small animals and lots of accessories. I draw Paint Dolls, a series of original characters with stuffed animal companions. Each month has a different theme.

1. April Bunny/2019
2. Amelie & Blossom/2019
3. Sophia & Moonlight/2019
4. March Mouse/2019

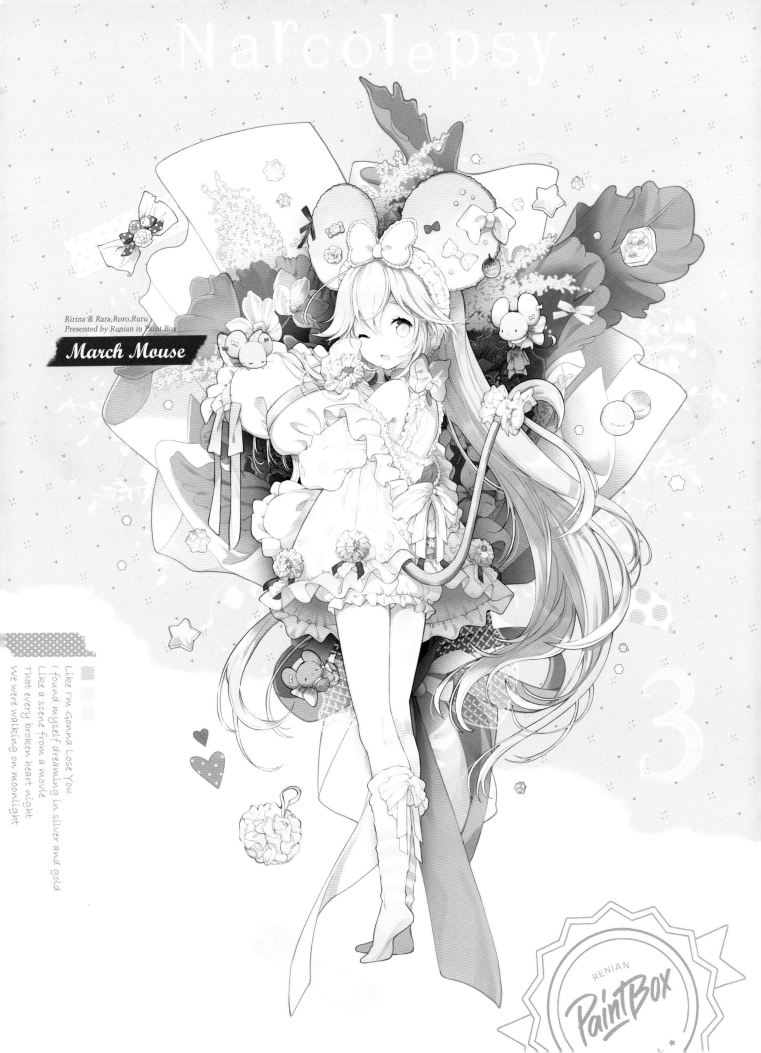

Ring

Language: Korean, English, Japanese

E-mail: ju411@me.com

twitter.com/ring_411

pixiv ID : 62019411

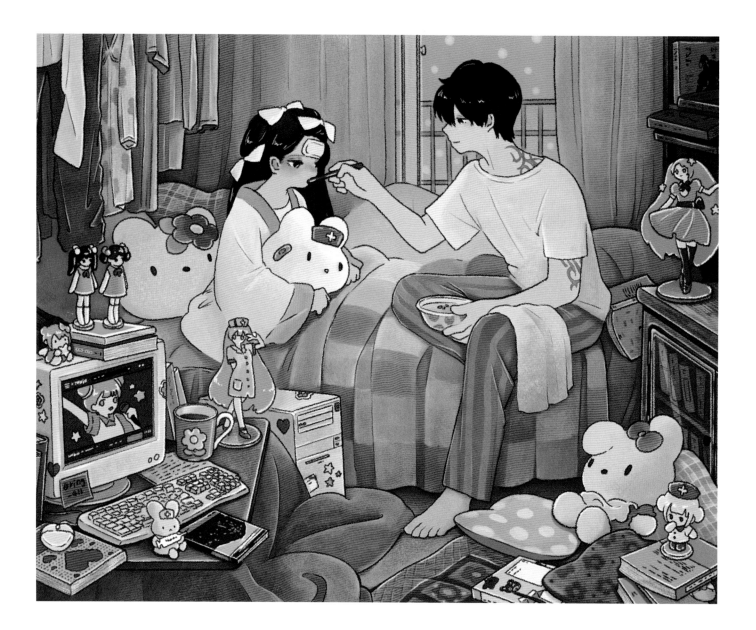

PROFILE

Ring works in a stylized otaku world of retro kitsch. This style is on full display in Kayoko Yoshizawa's *Oni* music video.

	2	3
1	4	5

1. Taking Care/2021
2. The Perfect Dinner/2020
3. Cherry Blossom Rain/2021
4. Days/2021
5. 2021/2021

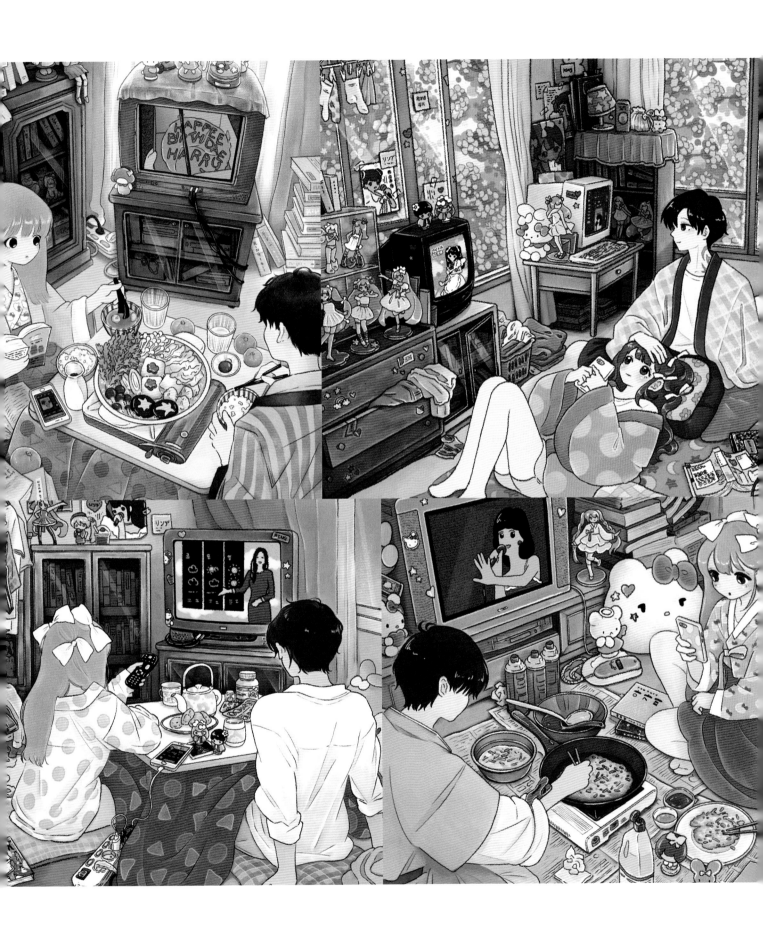

Bakery00

Language: Korean, English, Japanese
E-mail: zzinp70@naver.com

pixiv ID : 638895

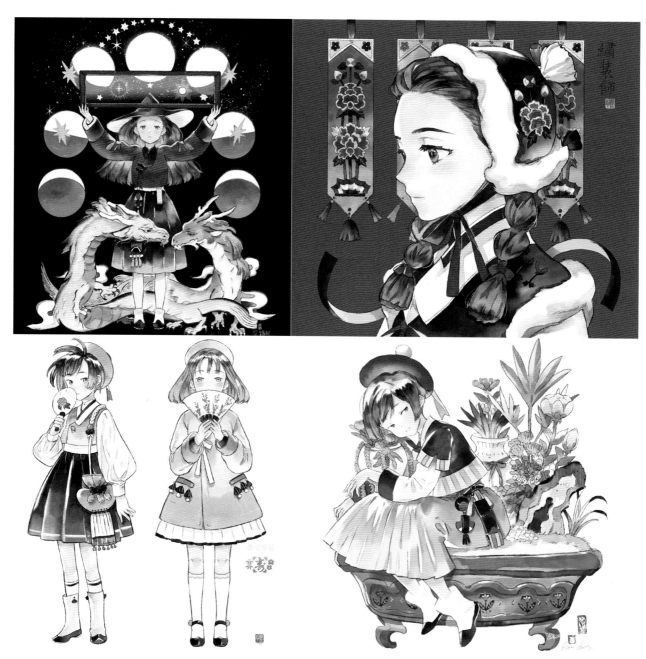

1	2	
3	4	5

1. Red Window/2020
2. Red Girl/2019
3. The Girls/2021
4. The Flowrpot and Girl/2019
5. Light Snow/2020

PROFILE
I draw from various aspects of a unique and familiar Asian worldview. I enjoy creating stories and situations for fantasy characters, based on traditional Korean paintings and hanbok.

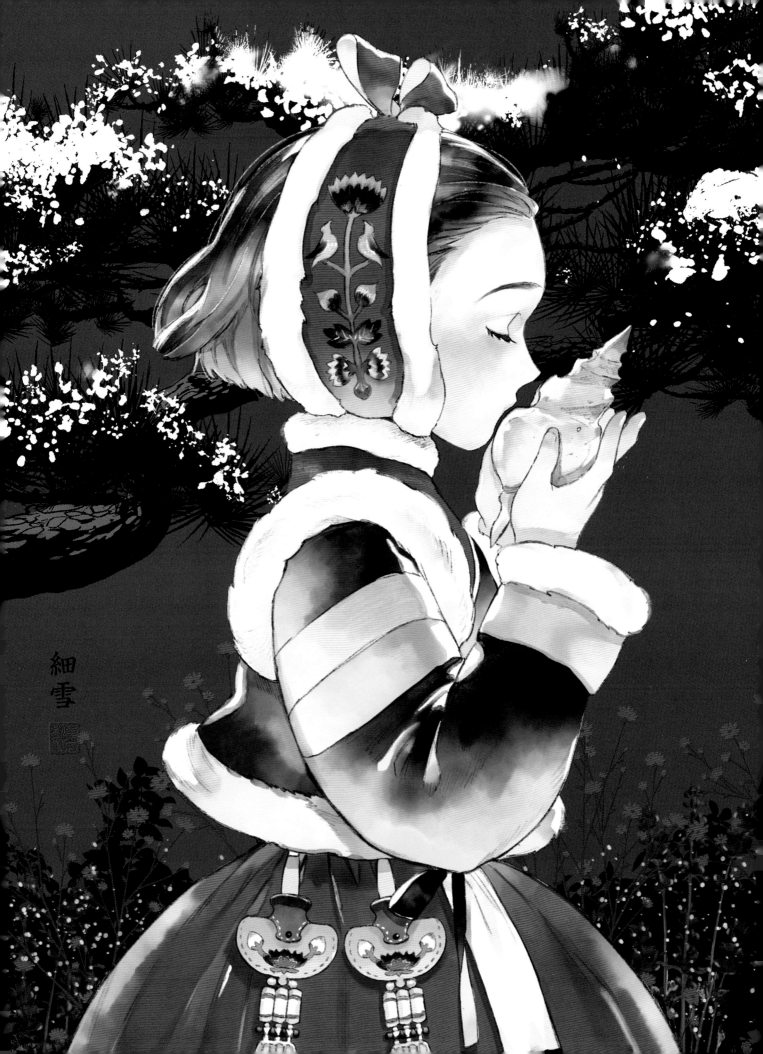

Mogo

Language: Korean, English, Japanese

E-mail: aurorao9@naver.com

instagram.com/mogoshin

pixiv ID : 142494

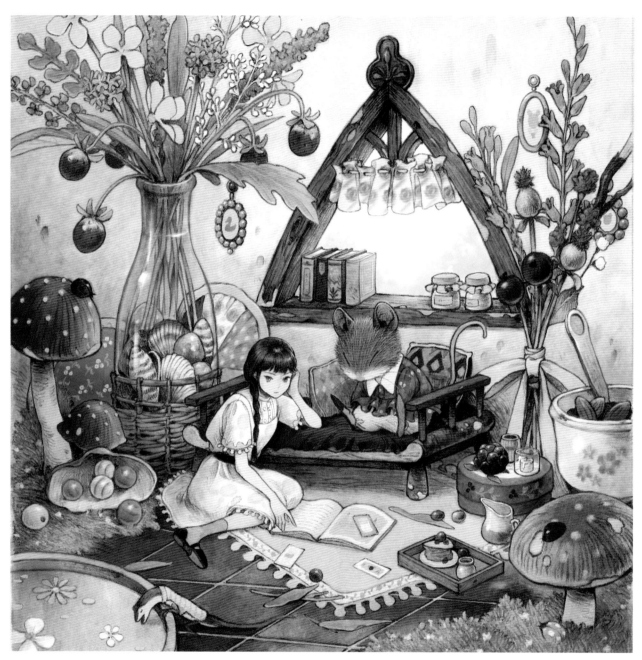

PROFILE
My art is all based in an original, Provencal fairytale world. My work blends both analog and digital mediums.

1. Friend's Room/2021
2. Marmalade/2020
3. Summer Adventure/2020

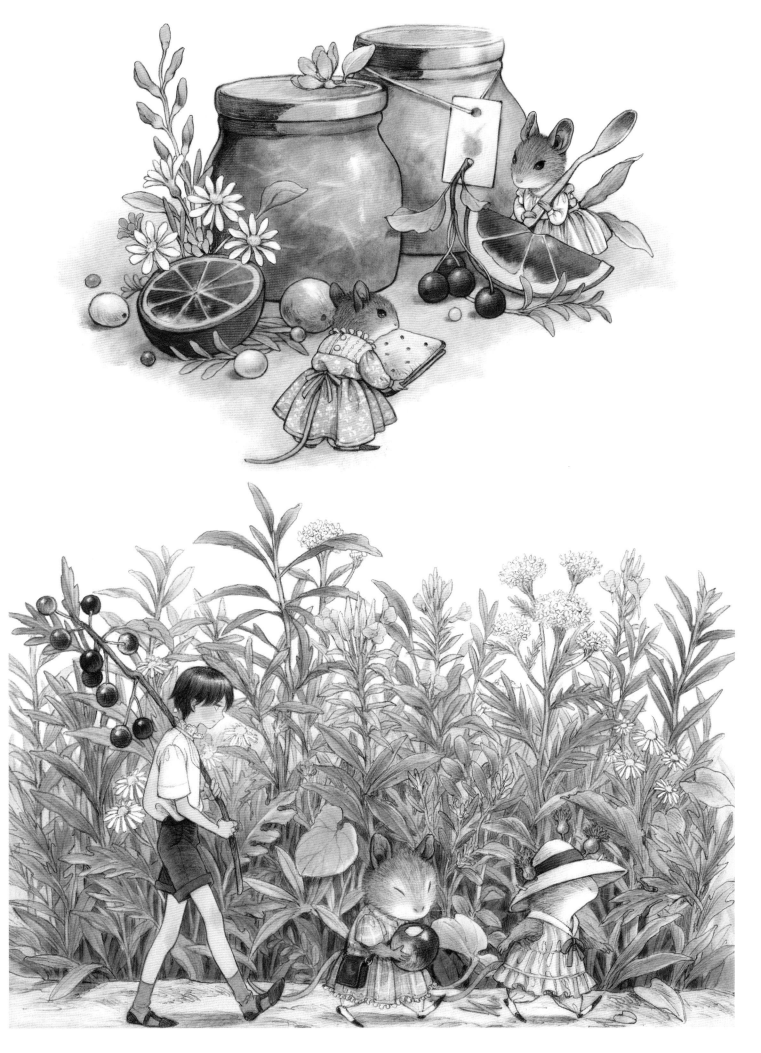

modare

Language: Korean, English, Japanese
E-mail: jeonghee1414@naver.com
twitter.com/jeonghee1414

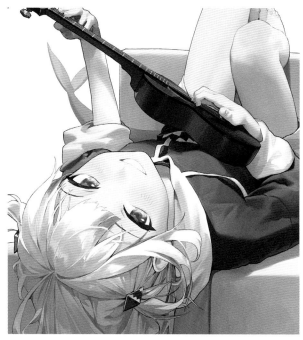

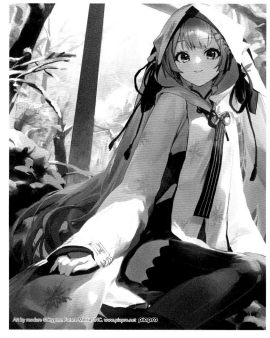

PROFILE
I am an artist who is always drawing.

	1		4
	2	3	

1. Azur Lane 3rd Anniversary/2020
2. Gawr Gura (Holo Live English)
 fan art Gura/2021
3. Hatsune Miku Series/2020
4. Houshou Marine (Hololive)
 fan art The Captain and Treasure/2021

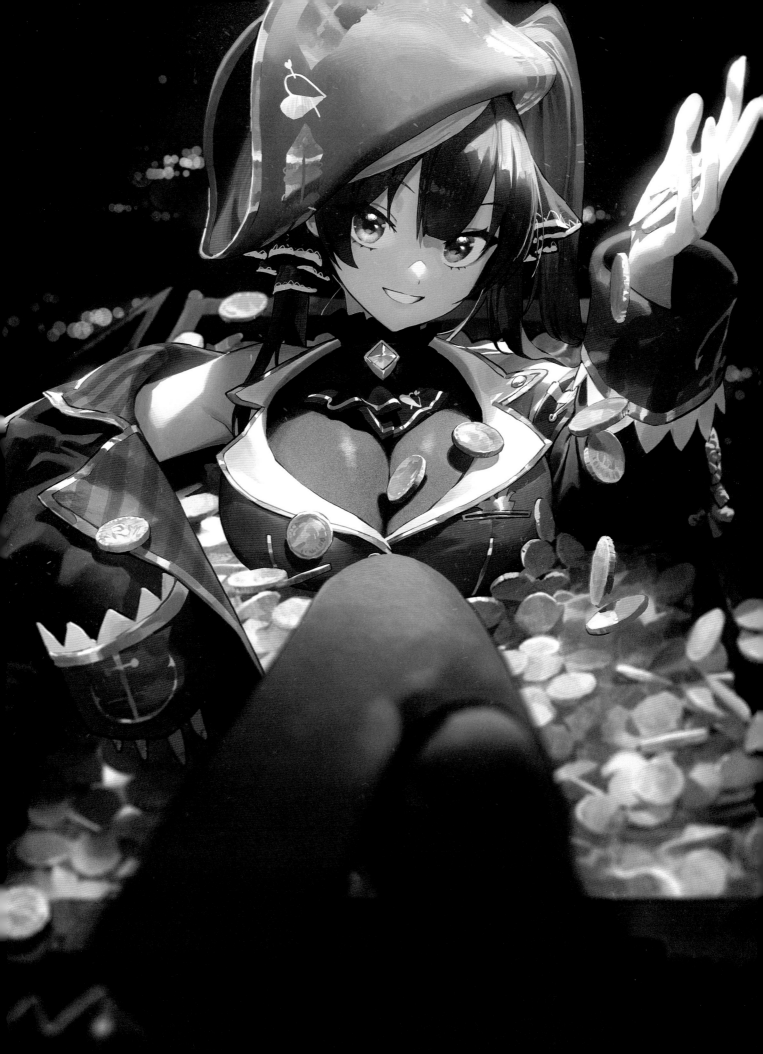

MYOWA

Language: Korean, English, Japanese

E-mail: myowa927@gmail.com

twitter.com/_MYOWA

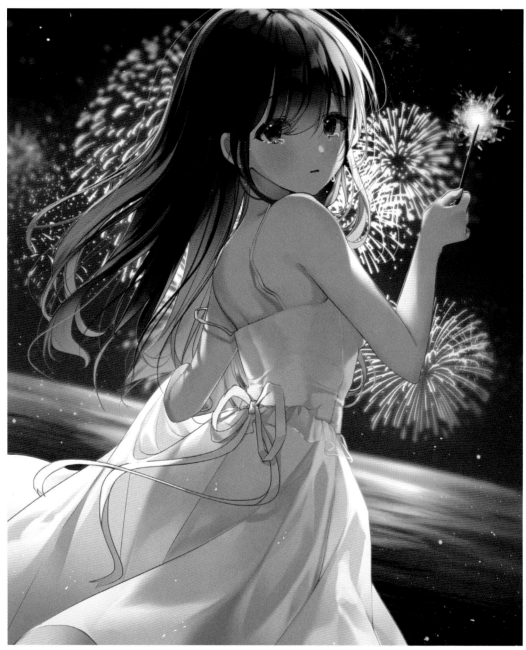

PROFILE

I was born in 2003. My illustrations are mainly of female characters in warm and inviting environments. I convey emotion through the characters and narrative scenes that I create.

	2	3
1		
	4	5

1. You and the End of Summer/2021
2. Summer/2021
3. untitled/2021
4. The Way Home from School/2021
5. untitled 2/2021

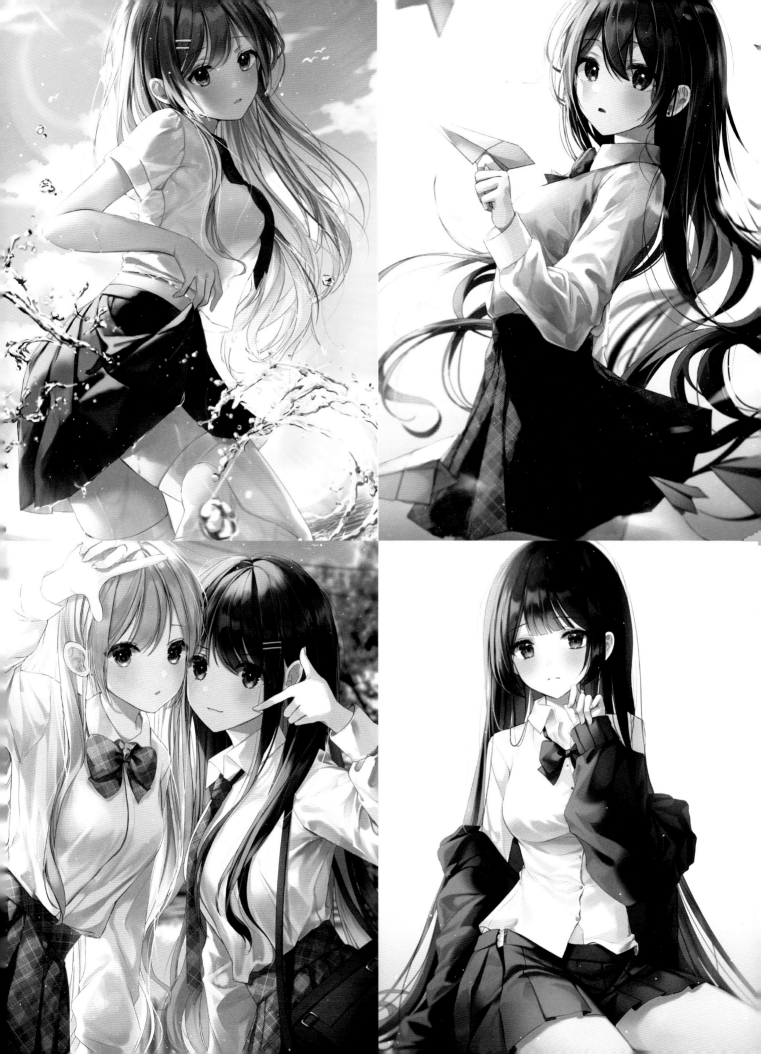

VIVINOS

Language: Korean, English, Japanese

E-mail: vivinos162@gmail.com

youtube.com/c/VIVINOS

pixiv ID : 13128008

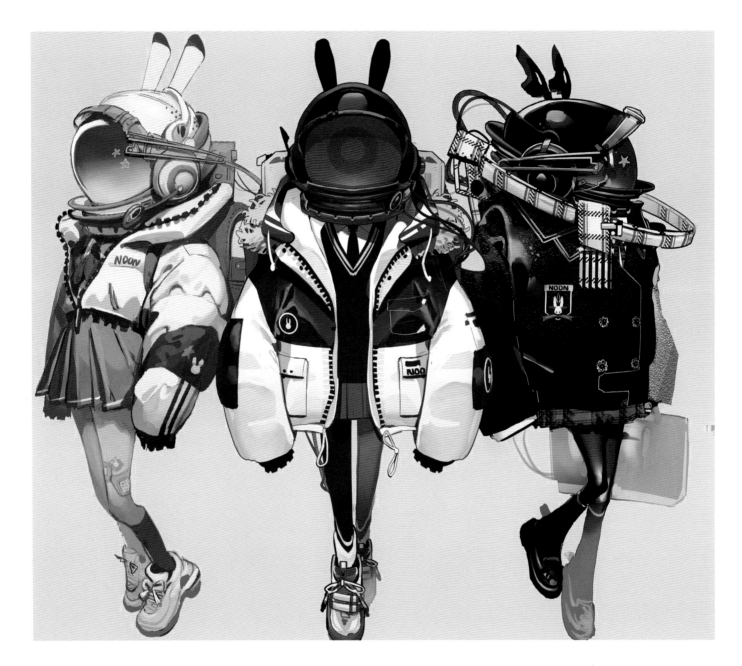

PROFILE
VIVINOS is an illustrator and animator who runs the VIVINOS YouTube channel.

1

2

3

1. VIVINOS/2019
2. VIVINOS2/2019
3. PLANET/2019

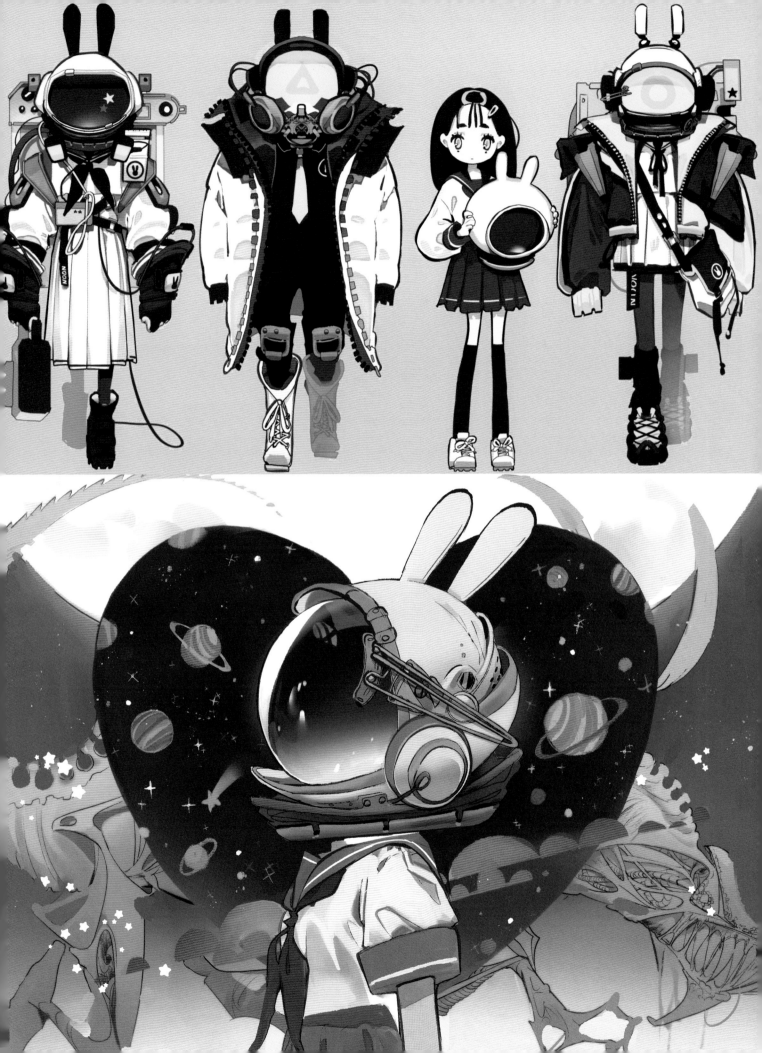

VIBIBO

Language: Korean, English, Japanese

E-mail: vibibo@naver.com

twitter.com/vibibo_

pixiv ID : 14622966

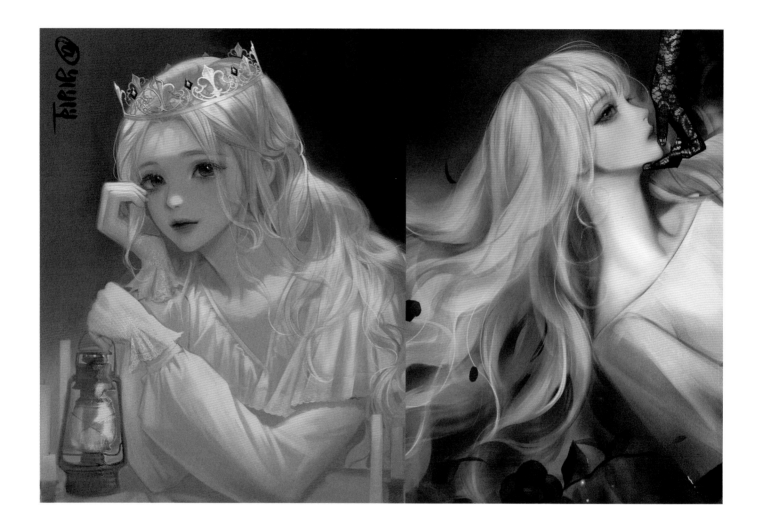

PROFILE
I love recreating the style of classic oil paintings using digital tools to create a style befitting modern eyes.

1. Portrait of the Youth/2020
2. People Who are Really Swamped/2021
3. Bird Can't Fly/2020

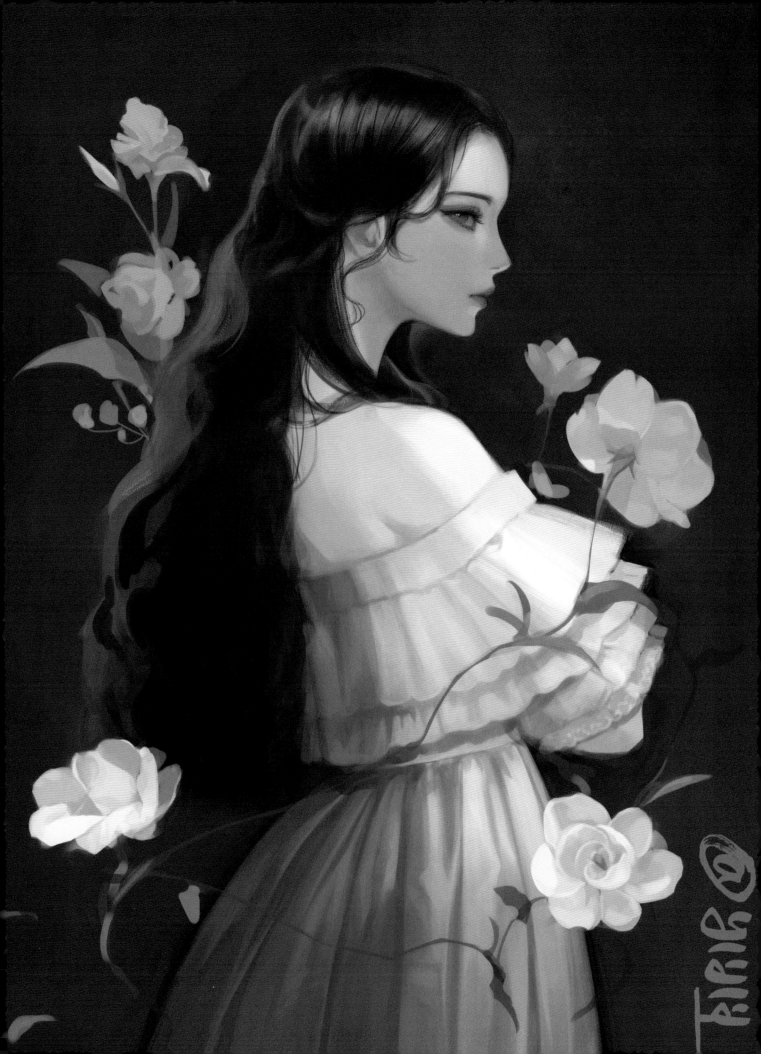

SoyooNG

Language: Korean, English, Japanese

E-mail: rr_ronron@naver.com

twitter.com/rr_ronron

pixiv ID : 10142455

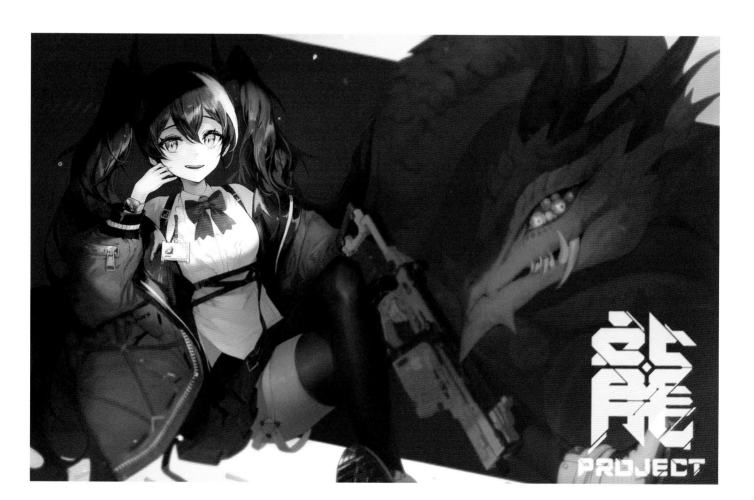

PROFILE

SoyooNG is an illustrator in the video game industry, as well as a lecturer and a freelance illustrator who loves character design.

	2	3
1	4	5

1. Athan/2020
2. Ares/2021
3. Muse/2021
4. Rondo/2020
5. Arck/2021

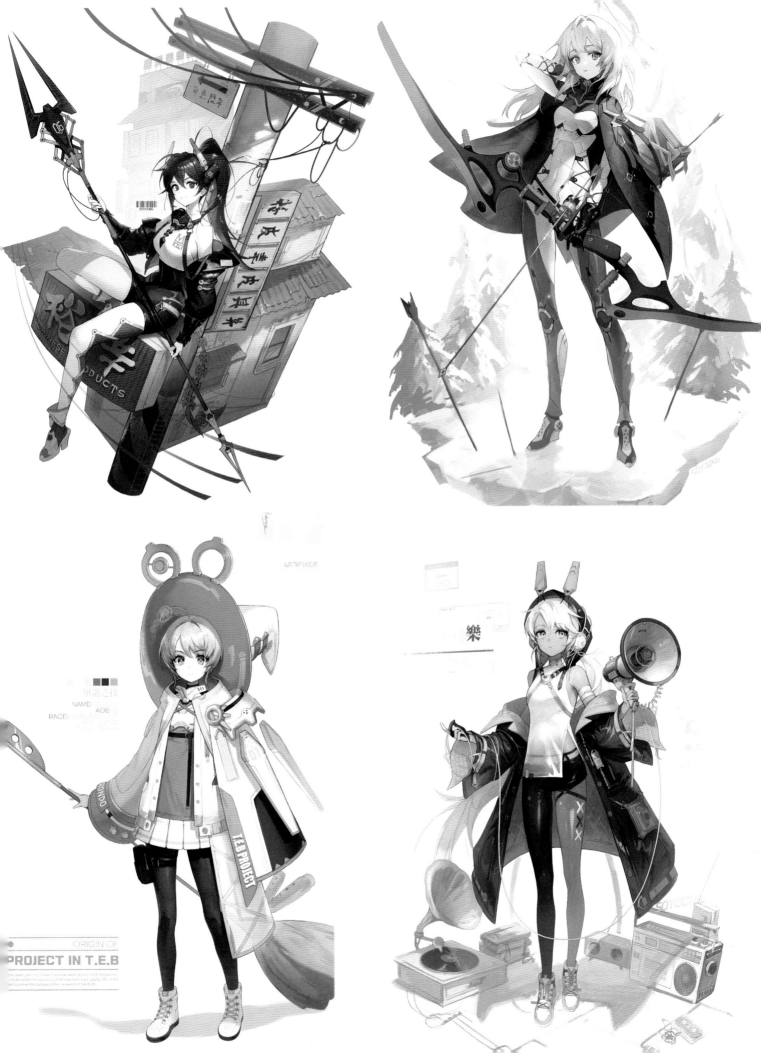

NAME:
RACE:

AGE:

ORIGIN OF
PROJECT IN T.E.B

shinkiru

Language: Korean, English, Japanese

E-mail: chosk1992@naver.com

instagram.com/kwon___a

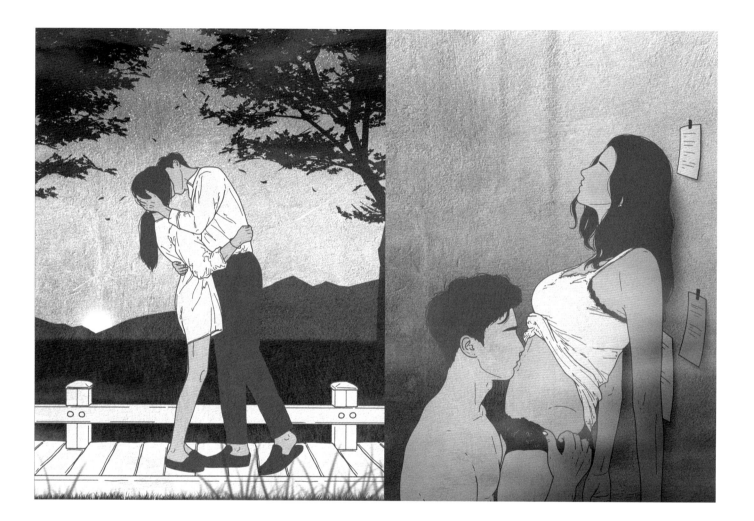

PROFILE

Each of my paintings are like diary entries that I jot down every night, alone in the cold or together, keeping each other warm. These are the moments I love.

1. Everyday in a Strange Place/2020
2. 7:20 Wanna Night Forever/2018
3. A Scent Like You/2020

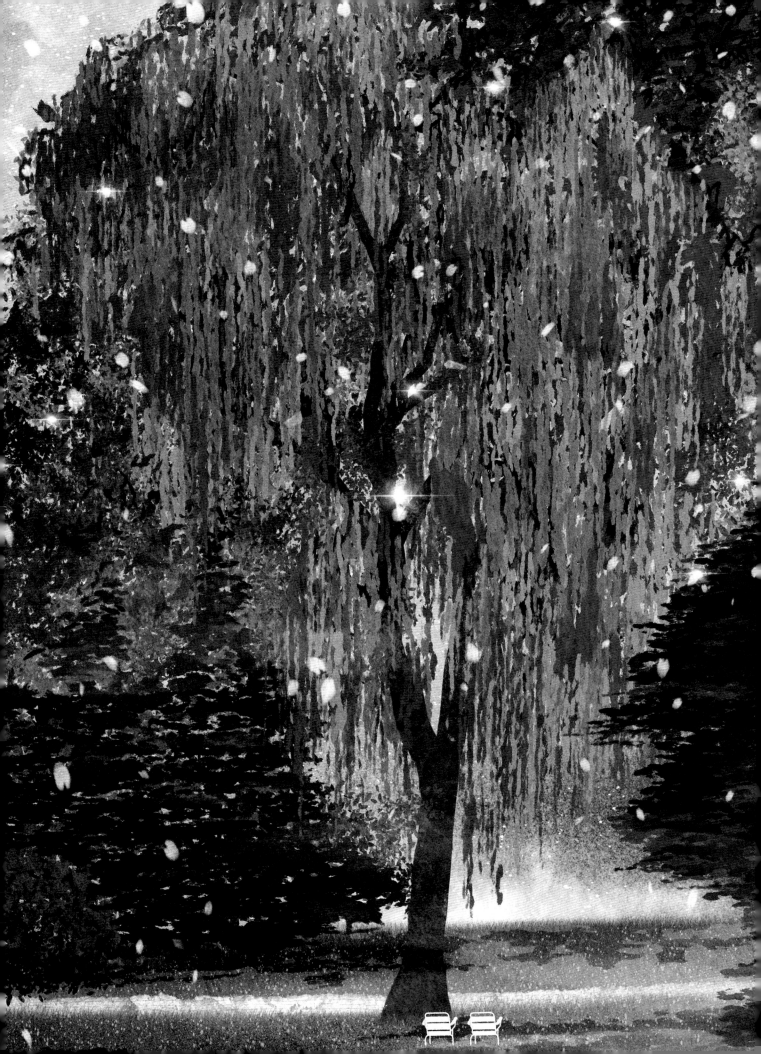

yaya

Language: Korean, English, Japanese

E-mail: inhoya2000@naver.com

twitter.com/yayaa_00

pixiv ID : 16507889

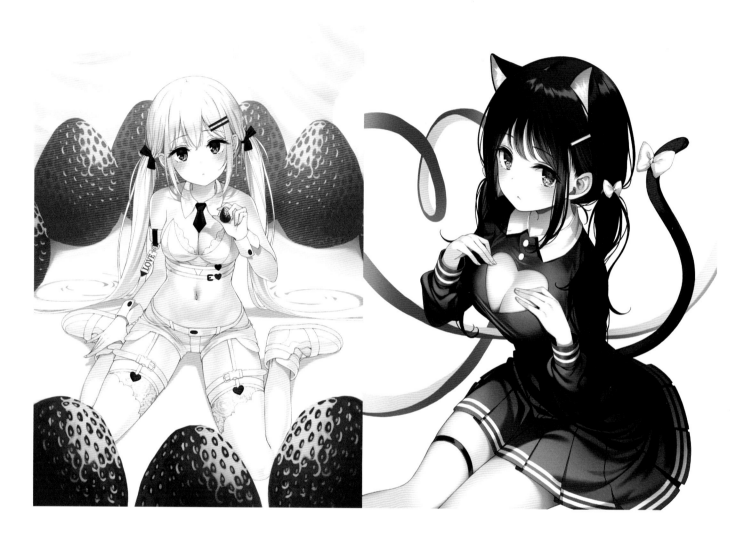

1 2 3

1. Strawberry Girl/2021
2. Cat Girl/2021
3. Flower Shop Girl/2021

PROFILE

Hello, I am illustrator Yaya. I love drawing women in cute and gentle atmosphere.

120

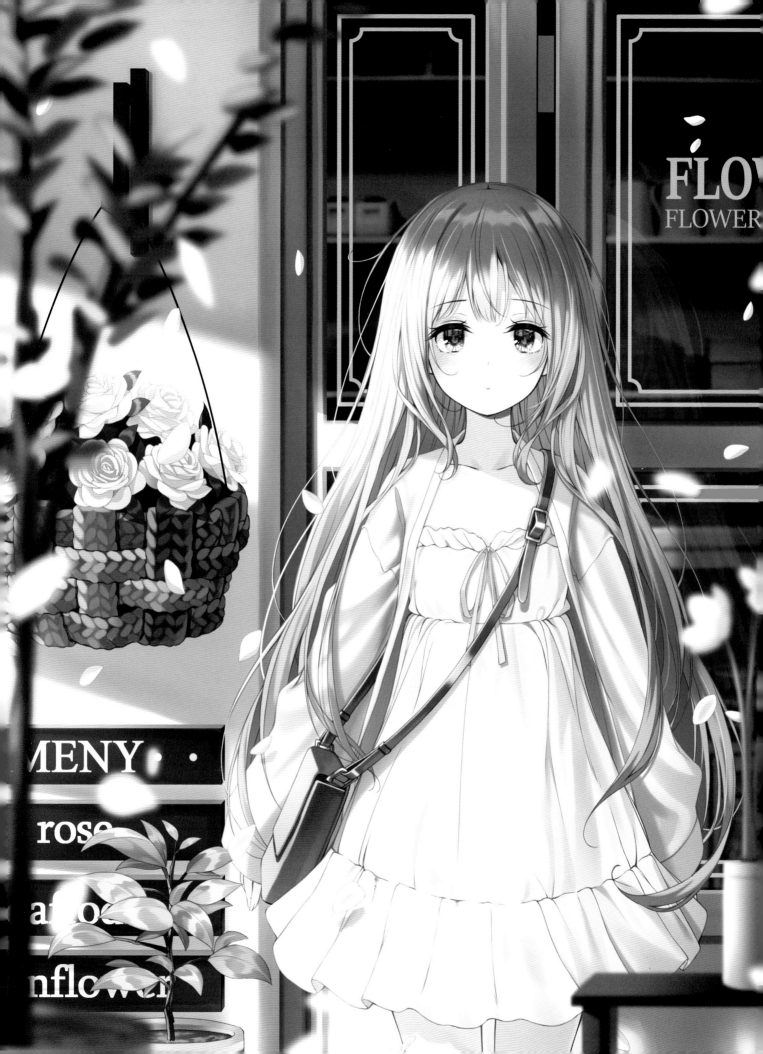

lee su yeon

Language: Korean, English, Japanese
E-mail: ggaburi73@naver.com
twitter.com/eeeeeeeeinsang

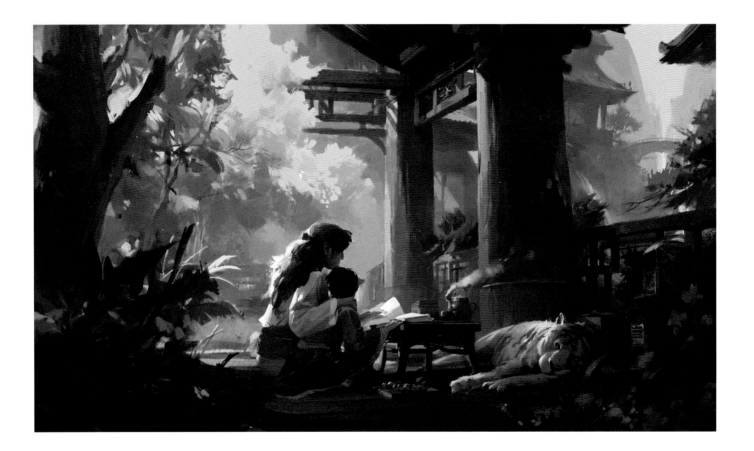

PROFILE
Born in 1999, living in South Korea. Lately, I've been into apocalypse-type worlds and I've been drawing them a lot. I've worked with Netflix, NCSOFT, Nexon, and NetEase.

```
          2
1
          3
```

1. In the Yellow/2021
2. On the Pond/2021
3. On the Wall/2021

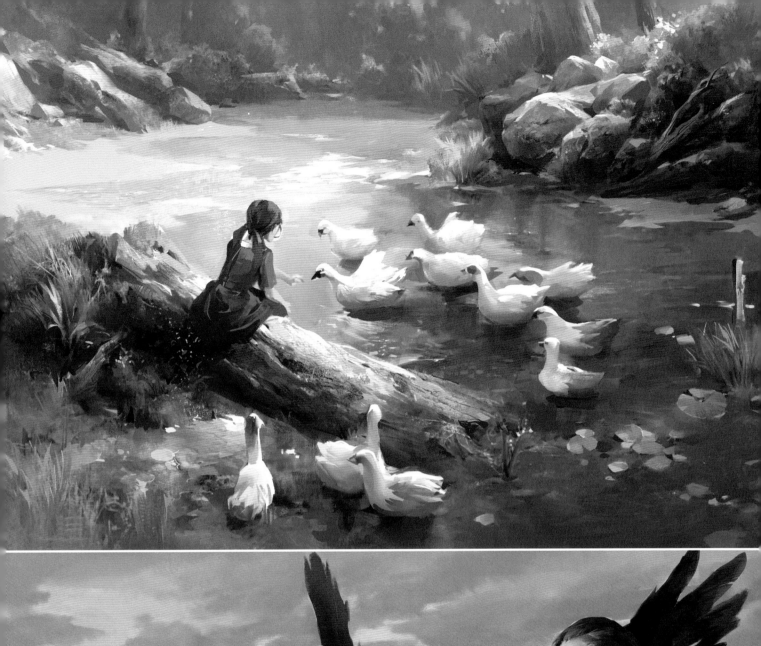
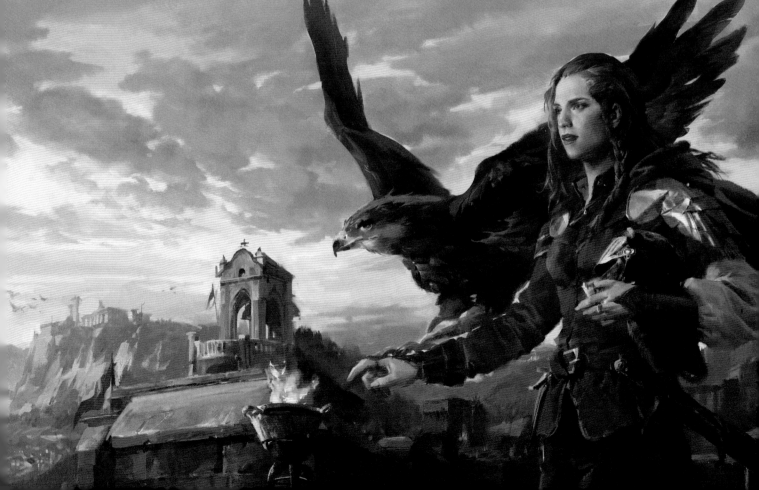

YOTTI

Language: Korean, English, Japanese

E-mail: y8tti@naver.com

twitter.com/Y8TT

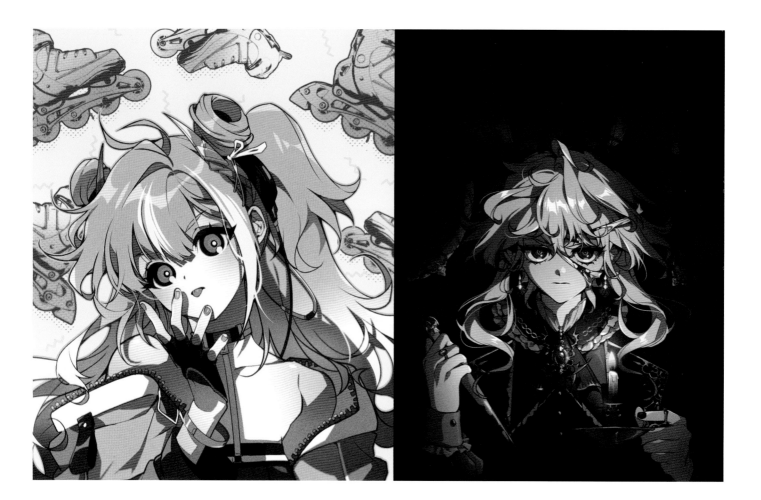

PROFILE

I am very interested in fashion that incorporates techwear. Each drawing I do has a new costume design that brings out the unique personalities of the characters that I create.

1	2		
		3	4
		5	6

1. Pink+Blue/2020
2. Unhappy Halloween/2019
3. Sight/2021
4. Look at You/2021
5. Pink/2019
6. Flower/2020

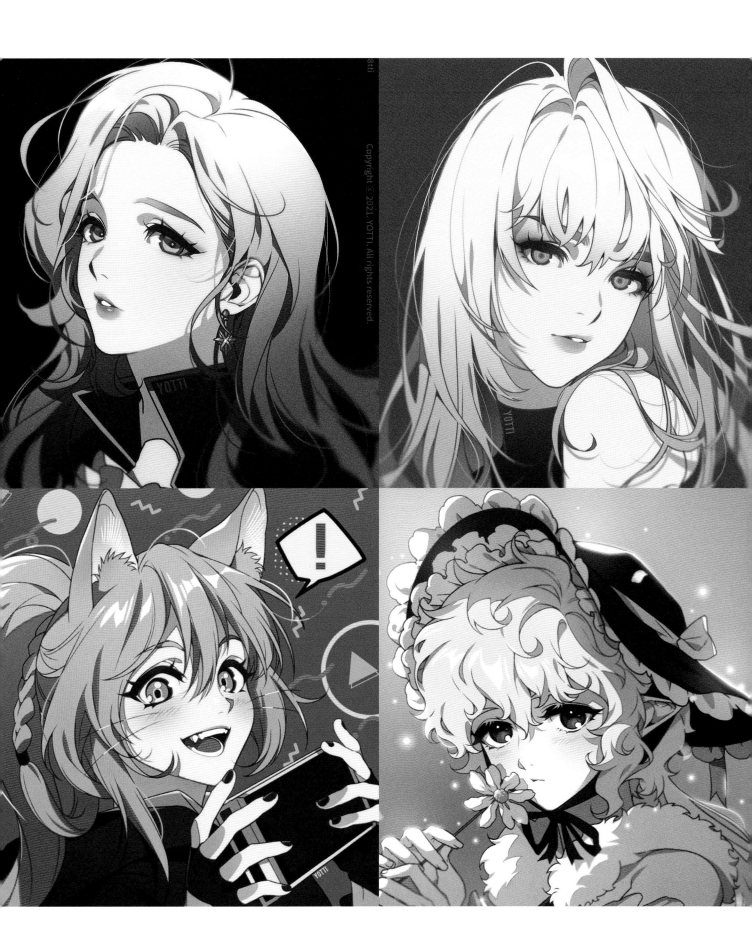

Yulri

Language: Korean, English, Japanese

E-mail: yul@yy-graphics.com

instagram.com/yulri.kr

pixiv ID : 18200099

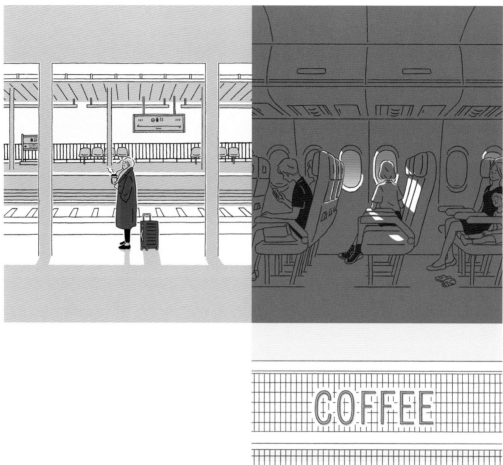

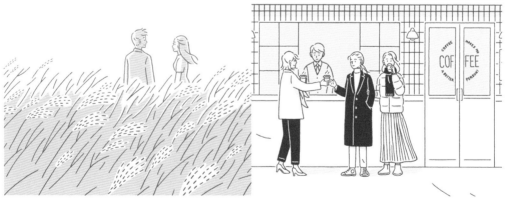

PROFILE

I am working on comics and illustrations that have themes of love and everyday life. My previous work includes the travel essay *Walk Slowly in Chiang Mai* (Gimm-Young Publishers, 2019), and the webtoon *Perhaps Love* (Tapas, 2019).

1	2	
		5
3	4	

1. January/2020
2. June/2020
3. October/2020
4. November/2020
5. March/2020

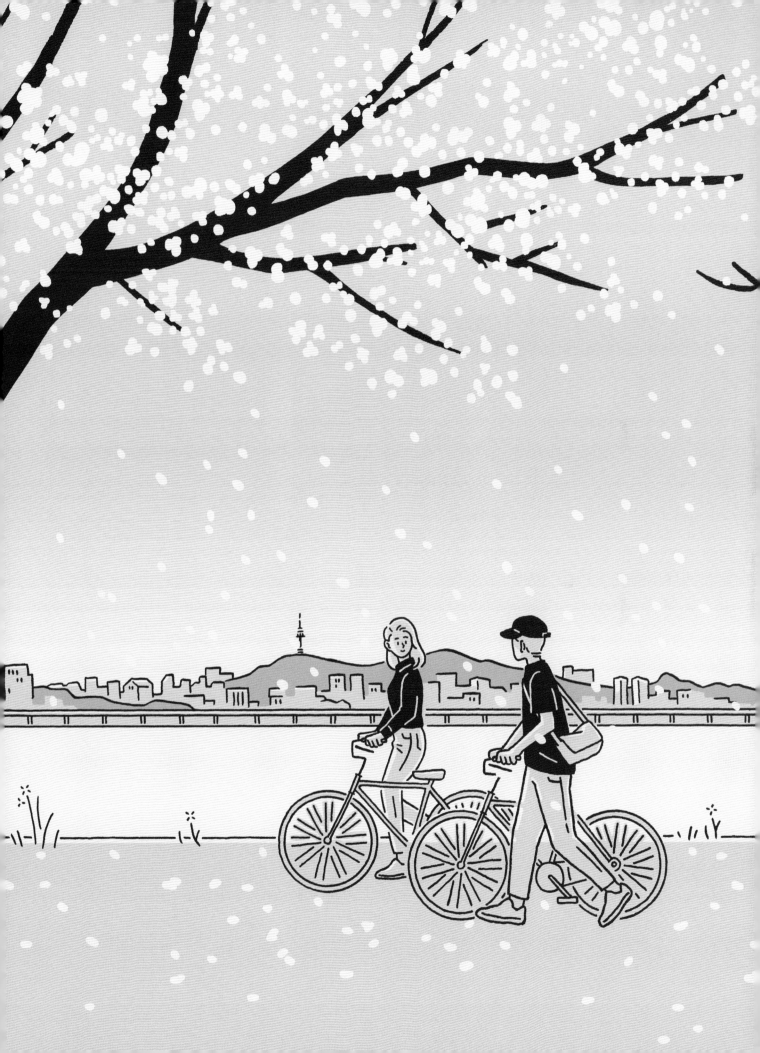

Umi

Language: Korean, English, Japanese

E-mail: chlwjddma114@naver.com

twitter.com/eumi_114

pixiv ID : 39258616

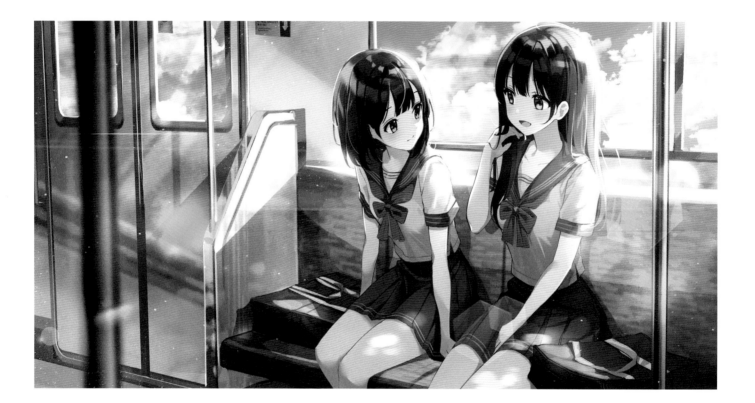

PROFILE

I currently work as a freelance illustrator. I like to make art that gives off a sense of youth and use a lot of blue tones to create clear and calm moods.

	2	3
1		
	4	5

1. One Summer Day/2021
2. Wedding/2021
3. Swimming pool/2021
4. A Green Apple/2021
5. Rooftop/2021

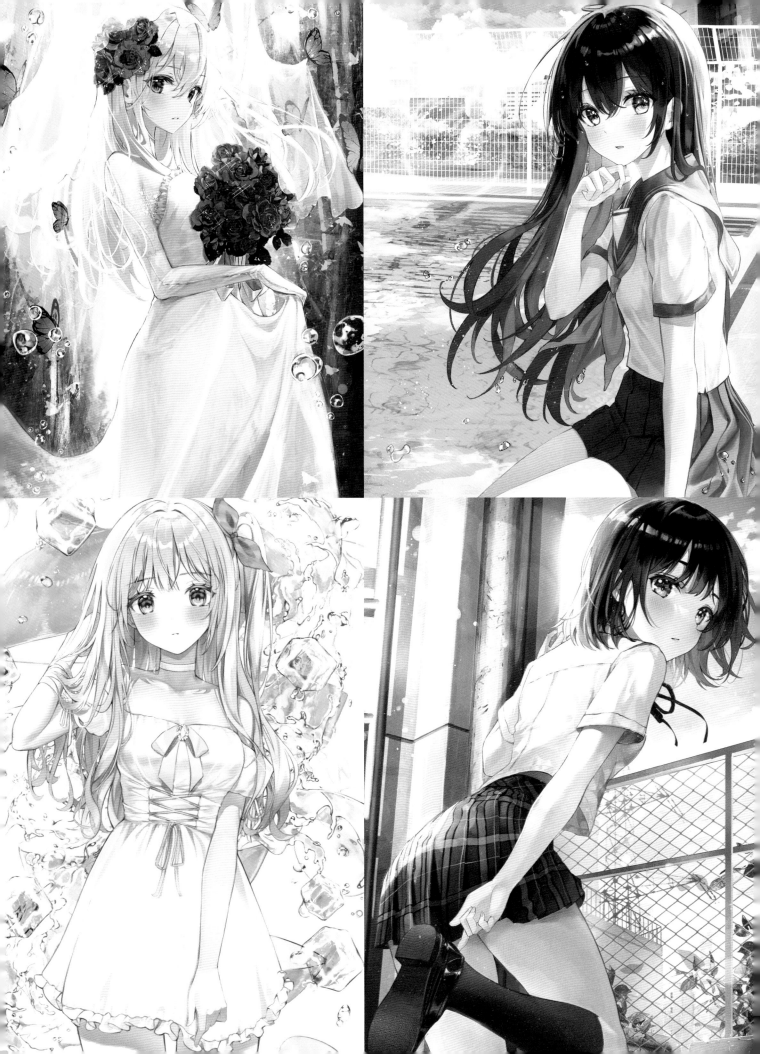

irure

Language: Korean, English, Japanese

E-mail: mingou91@naver.com

twitter.com/mingou91

pixiv ID : 1911006

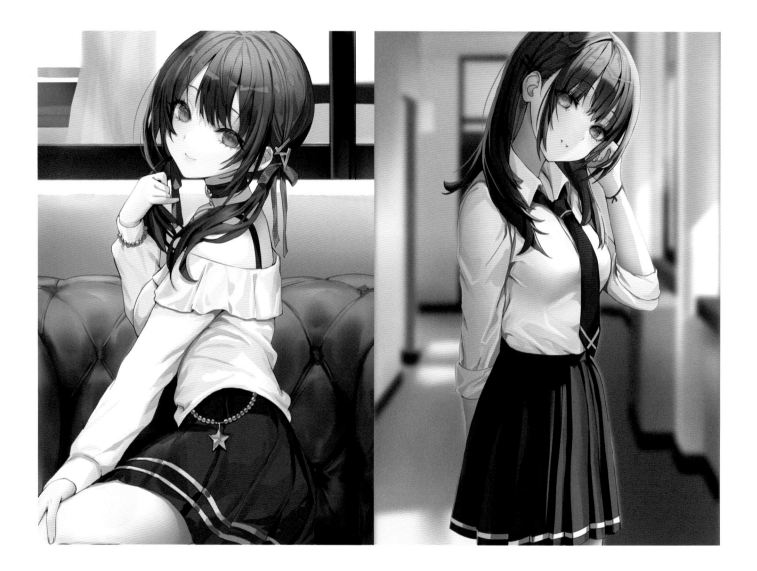

PROFILE

Irure is an illustrator whose main goal is to draw "women with atmosphere."

1 2 3

1. untitled 1/2021
2. untitled 2/2021
3. untitled 3/2021

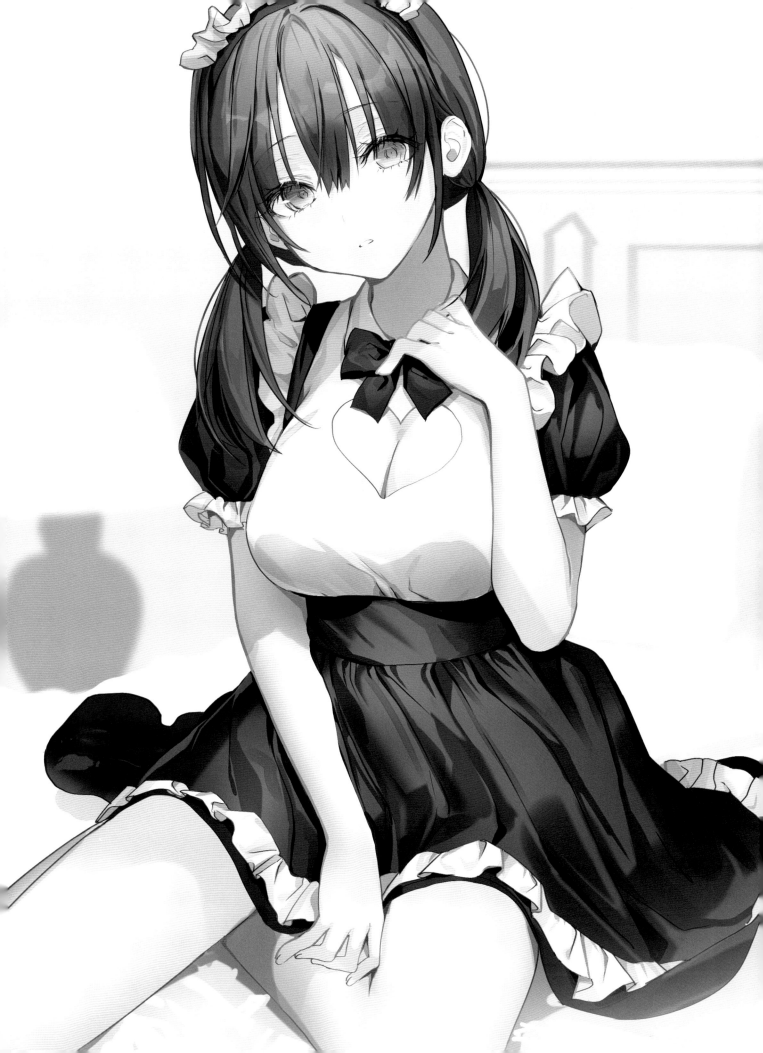

Sung Jae Lee

Language: Korean, English, Japanese

E-mail: kaisar0131@naver.com

artstation.com/kaisar0131

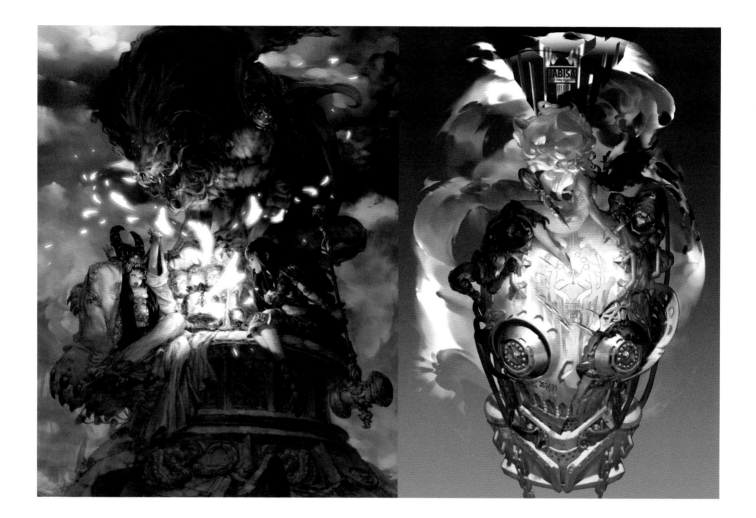

PROFILE

Sung Jae Lee is South Korean and runs the Kassam Art Game Concept Art Academy. He is an active instructor, freelance illustrator and creates his own original art.

1. East Vampir/2018
2. Deep Sea Skull/2021
3. Trinitas Vampir/2018
4. Siames, the Knight Commander of Perris/2018

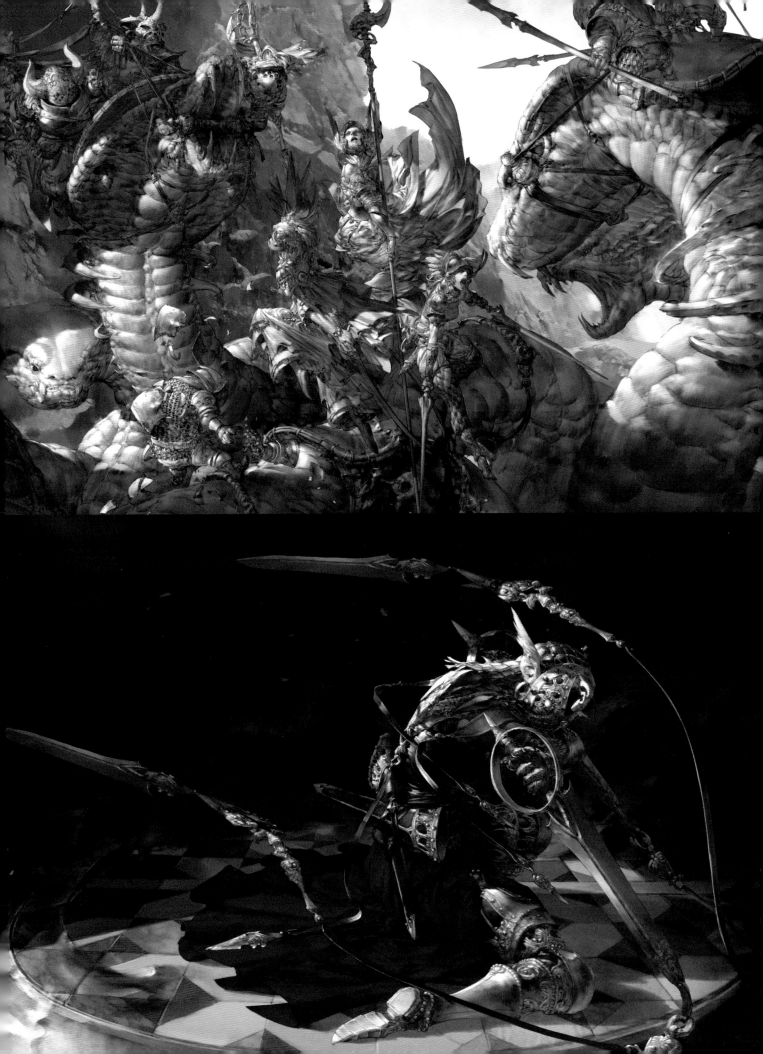

JUWON

Language: Korean, English, Japanese

E-mail: osungsigi@gmail.com

twiiter.com/Death_Mogi

pixiv ID : 67967044

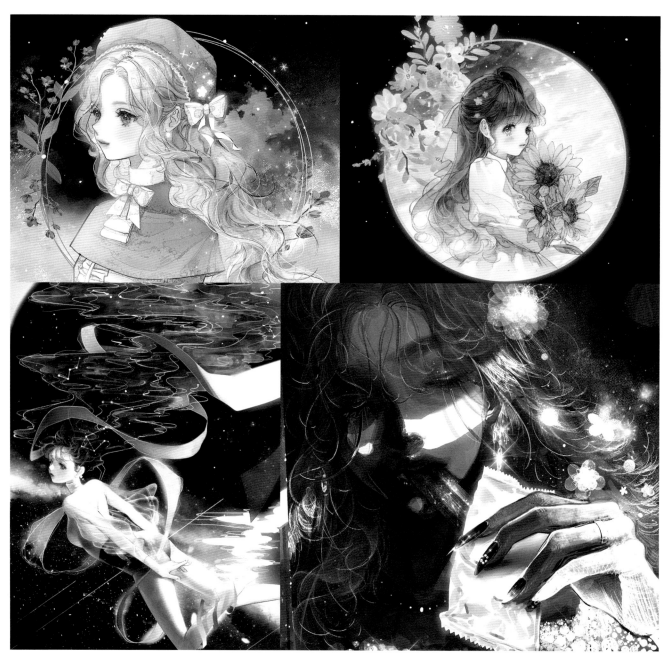

PROFILE

Illustrations follow the theme of women in dream-like scenes using many blue tones.

1. untitled 1/2020
2. untitled 2/2020
3. Diving/2020
4. Poisoned/2021
5. Affim/2020

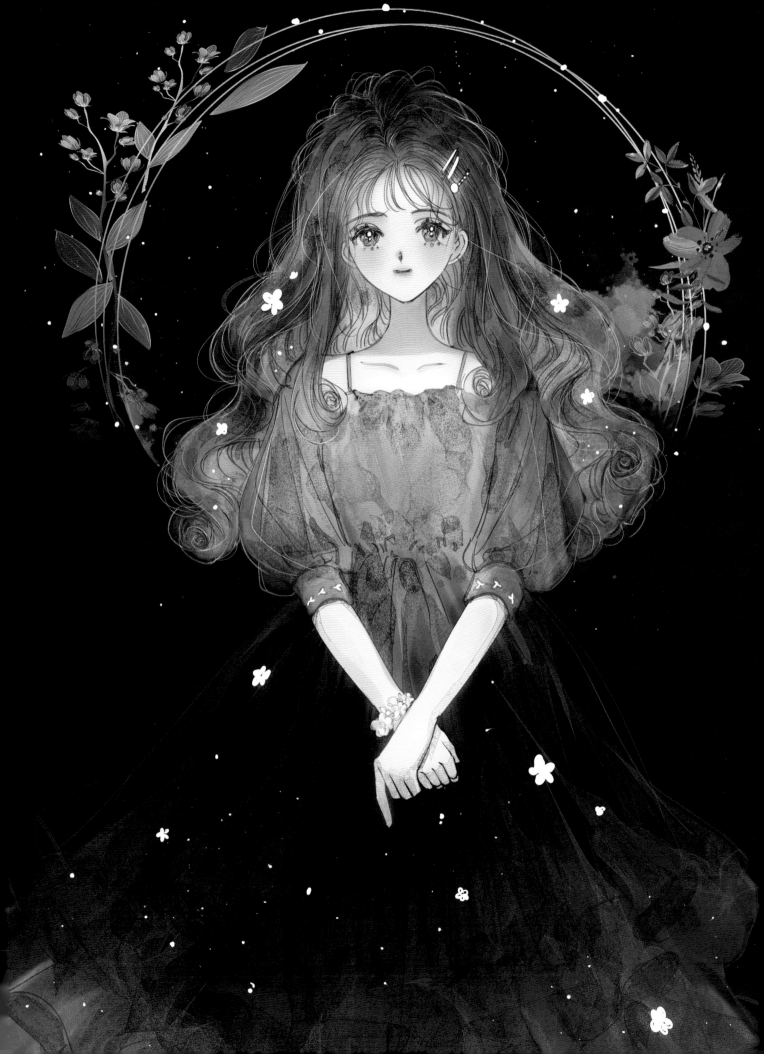

Jisu

Language: Korean, English
E-mail: jisu@jisu.art
https://twitter.com/JisuArtist

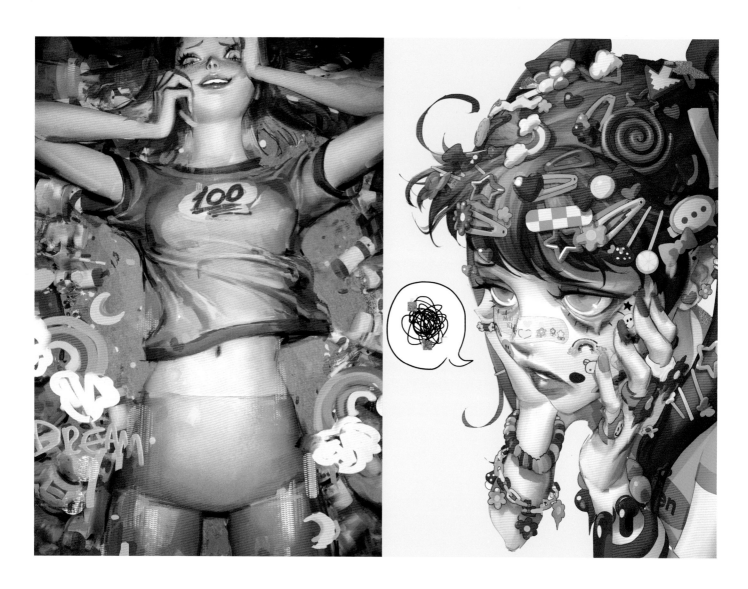

PROFILE
I am a self-taught illustrator. My goal is to evoke the emotions and experiences of everyday life. I love combining new and retro aesthetics. My hope is that my work will bring positive change to the world.

1. Drugz/2021
2. Pressure/2021
3. Anxiety/2021

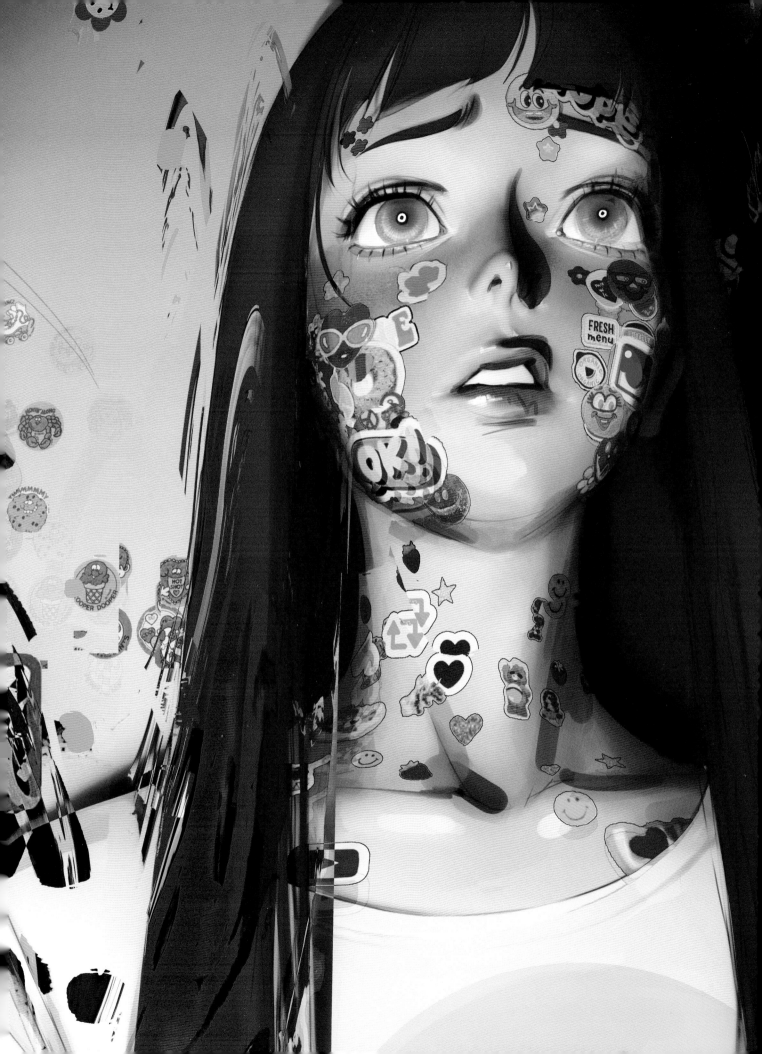

Jinhee

Language: Korean, English

E-mail: jinheek421@gmail.com

twitter.com/hiimjinjin

pixiv ID : 67660516

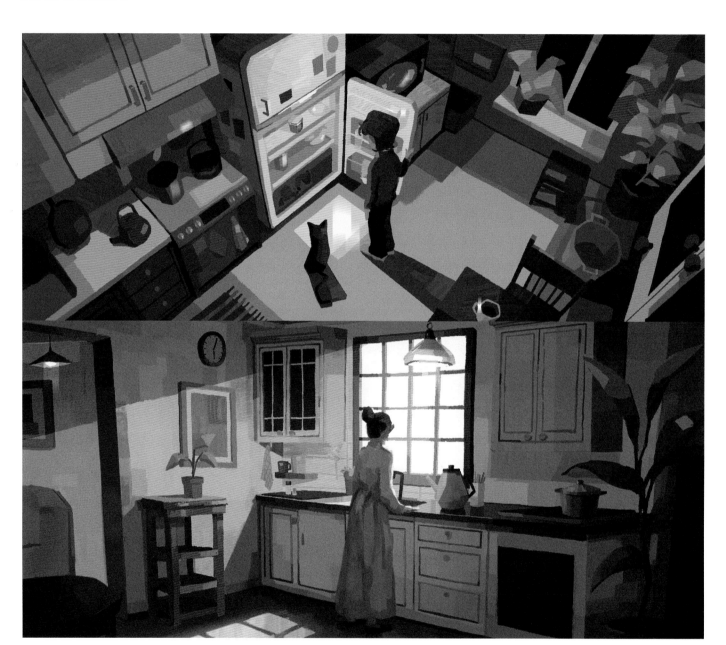

PROFILE

Born in 2000 in Seoul, Jinhee is mainly active in the fields of animation and illustration. He creates original digital art, making use of warm and vivid colors and shapes in scenes that look like they could be taken out of an anime.

```
        1
_____|_____
                |         3
        2
```

1. At Midnight/2019
2. Golden Hour/2019
3. Midnight Blues/2020

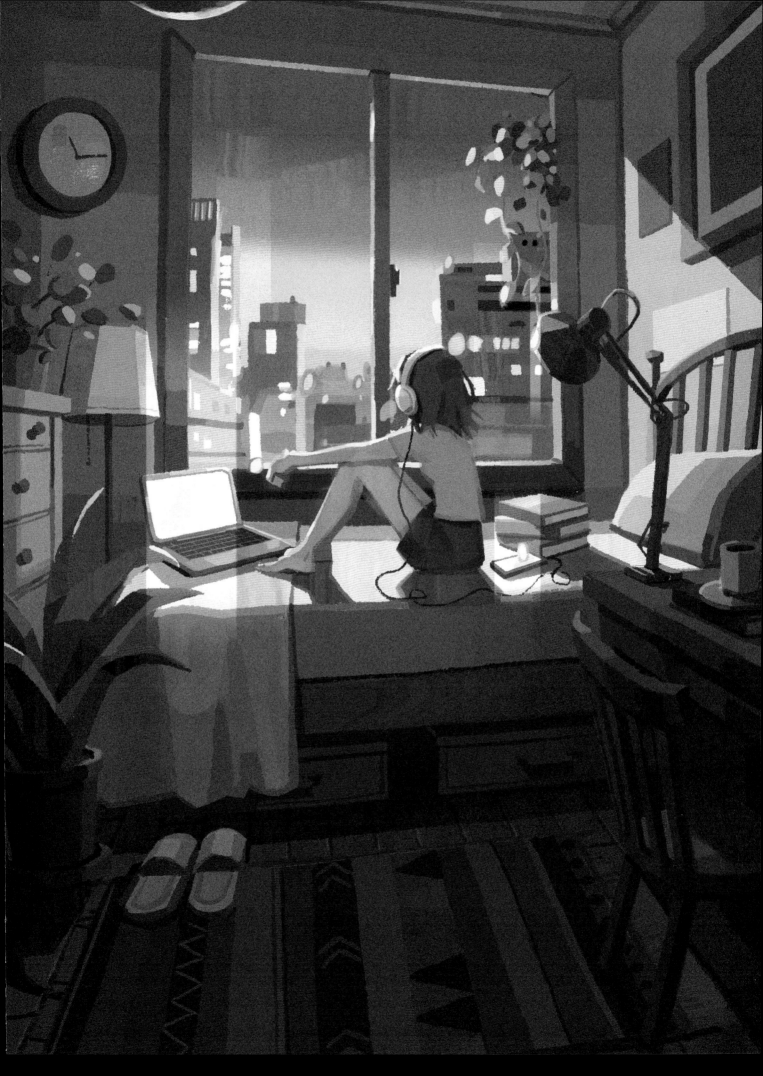

ZIPCY

Language: Korean, English

E-mail: zipcy88@gmail.com

instagram/com/zipcy

pixiv ID : 17093263

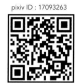

PROFILE

Author of *Touch*. I have worked with domestic and international companies such as Netflix (*The Witcher, The School Nurse Files*), Clip Studio, and Johnnie Walker. I have lectured at Class101+. As a clever hedonist and illustrator, I draw pictures rather than give into impulsive emotions.

1. Cigarette Duet/2019
2. Scent of Dawn/2018
3. You, Dyed by the Setting Sun/2018
4. Breezy/2020

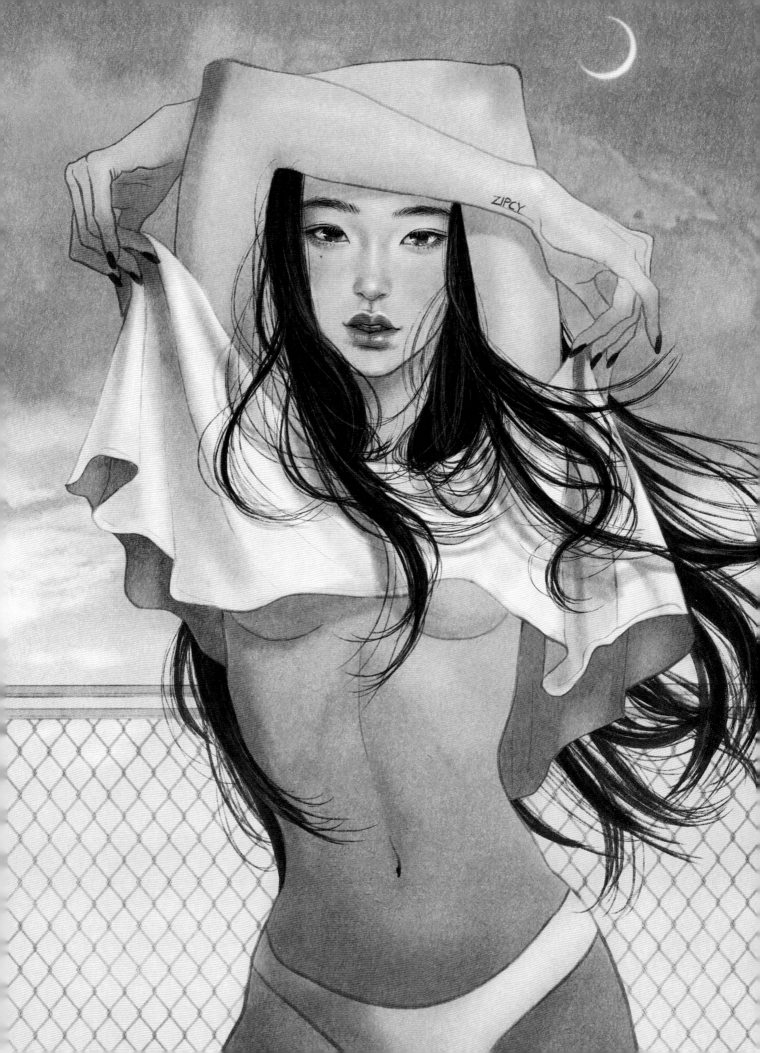

Choyeon

Language: Korean, English, Japanese

E-mail: kkid9624@naver.com

twitter.com/piche9468

pixiv ID : 15337031

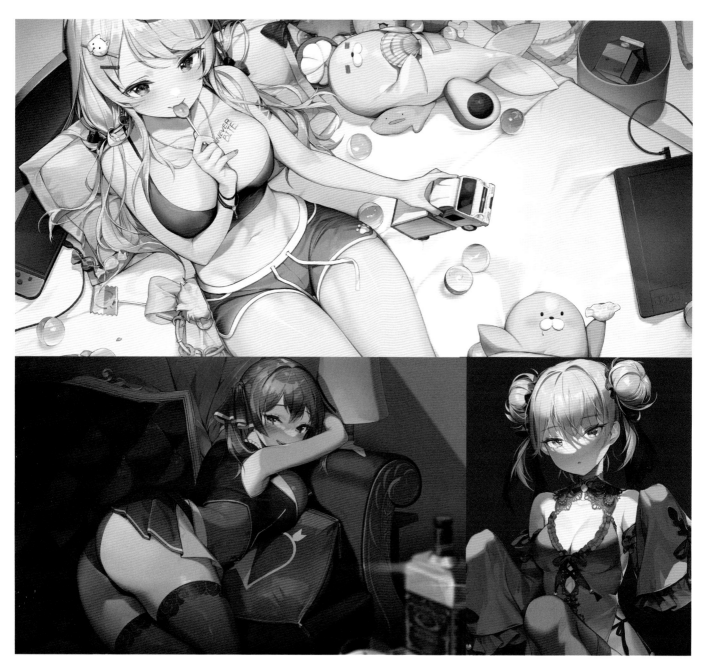

PROFILE

My main job is illustrating for a number of video games such as *Destiny Child* and *Goddess Kiss: OVE*. In my free time, I draw my own original creations as well as fan art of my favorite characters.

```
        | 1 |
        |---|---| 4
| 2 | 3 |
```

1. My Sweet Home/2020
2. Houshou Marine (Hololive)
 Fan Art Houshou Marine/2020
3. Cheongsam/2020
4. Bunny Girl Ammul/2021

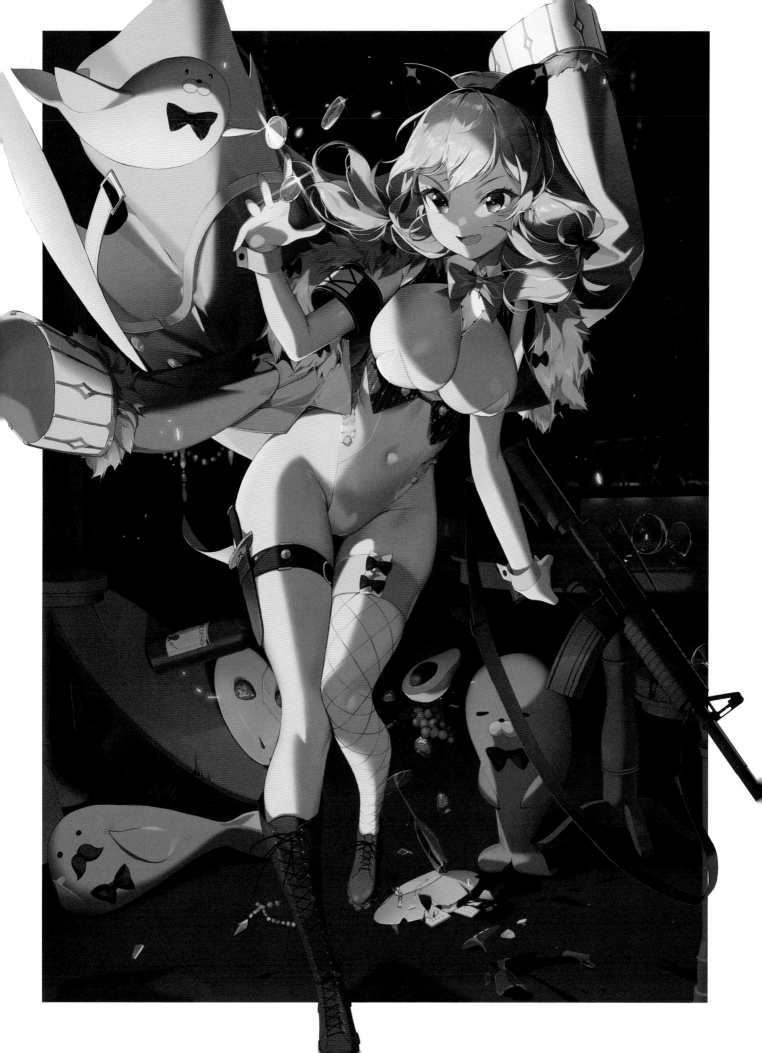

hyeonsick choi

Language: Korean, English, Japanese

E-mail: arowana211@naver.com

artstation.com/arowana

pixiv ID : 35999572

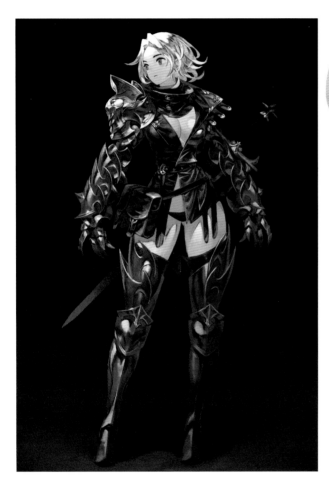

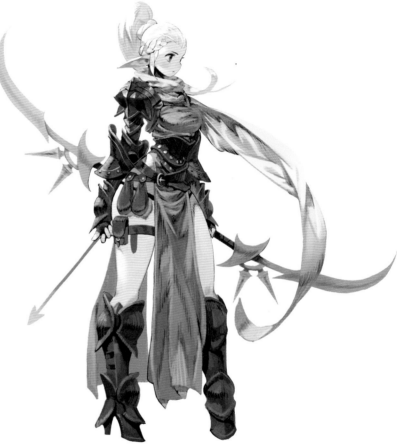

PROFILE
I was born in 1990 in Seoul. I work as a character designer. Nice to meet you!

		3	4
1	2		
		5	6

1. The Traveler/2020
2. Archer/ 2020
3. Knighterss/2020
4. Knight/2020
5. Queen/2020
6. Warrior/2020

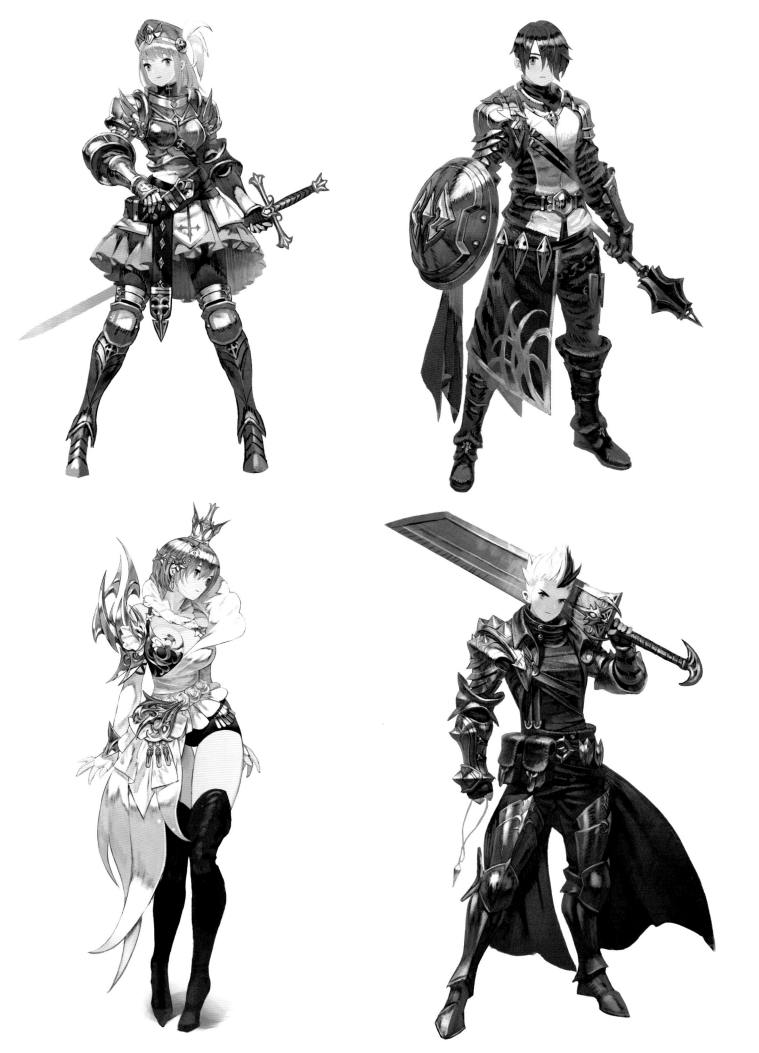

KONGYA

Language: Korean, English, Japanese

E-mail: mtae5579@gmail.com

twitter.com/Kong_sketch

pixiv ID : 7509825

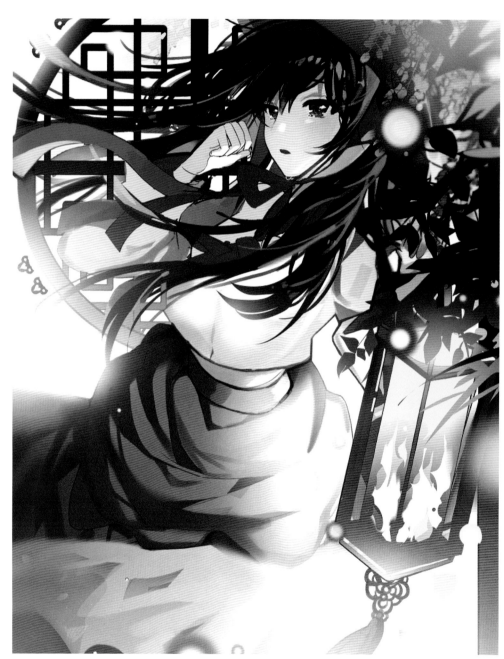

PROFILE

When I draw, I gain inspiration by looking at cute and pretty illustrations. I do a lot of work in manga and illustration.

1. Orient/2020
2. Asteroid Devil/2020
3. Blue Ball/2020
4. Black Cat Preparing for the Day/2020
5. JEJ/2020

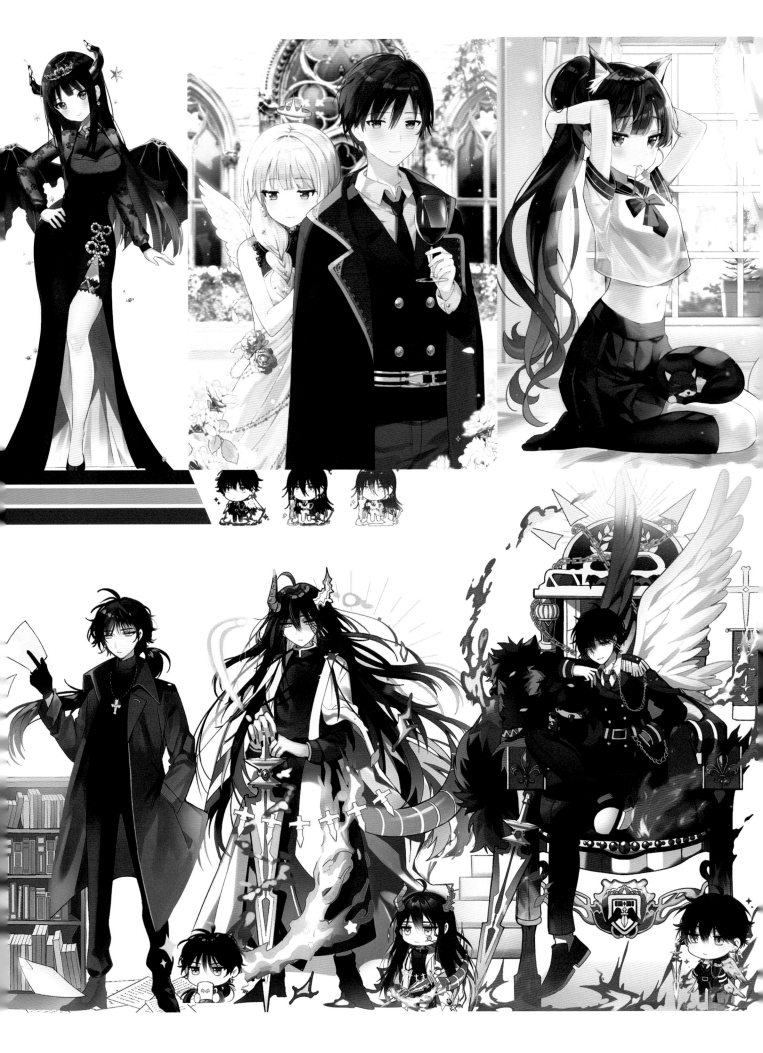

pine

Language: Korean, English, Japanese

E-mail: pine1230_@naver.com

twitter.com/pine1230_

pixiv ID : 3567819

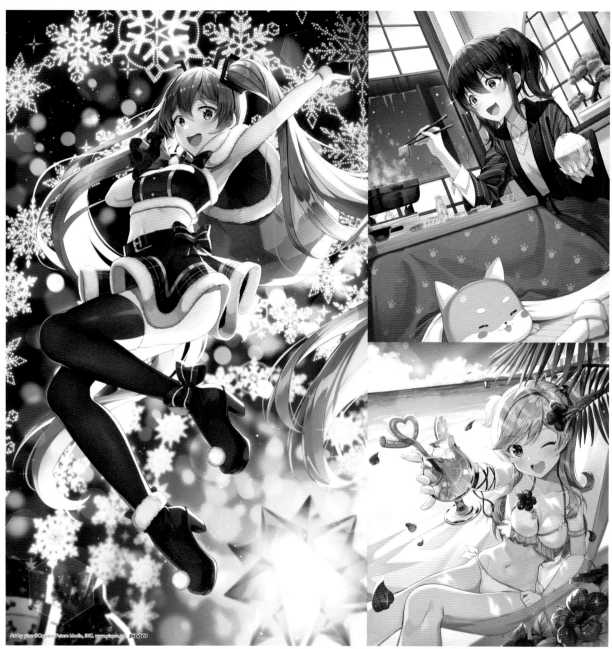

```
    | 2 |
 1  |---| 4
    | 3 |
```

PROFILE

I am an illustrator from Seoul who loves to draw lively and energetic characters. I love dog watching and my favorite thing is to take walks with my own dog.

1. Hatsune Miku fan art Christmas/2020
2. Shabu Shabu/2021
3. Summer Vacation/2020
4. China Panda/2021

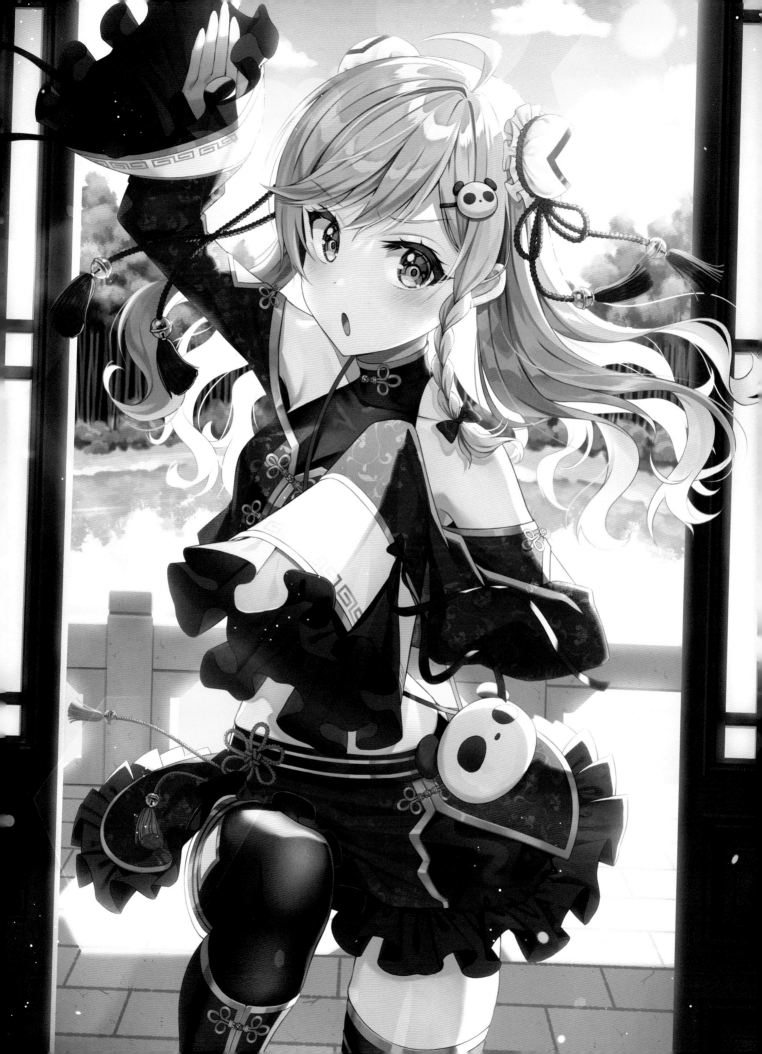

fajyobore

Language: Korean, English, Japanese

E-mail: fajyobore323@naver.com

twitter.com/fajyobore323

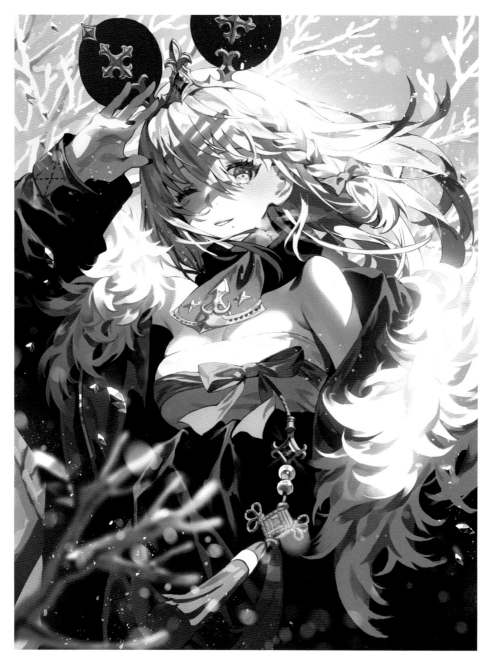

PROFILE
I have created illustrations for *Seven Knights* and *City of Forever 7 Days*. My drawings are full of shining, beautiful women.

1. 2020/2020
2. June/2020
3. Lemonade/2020
4. Honey/2021

150

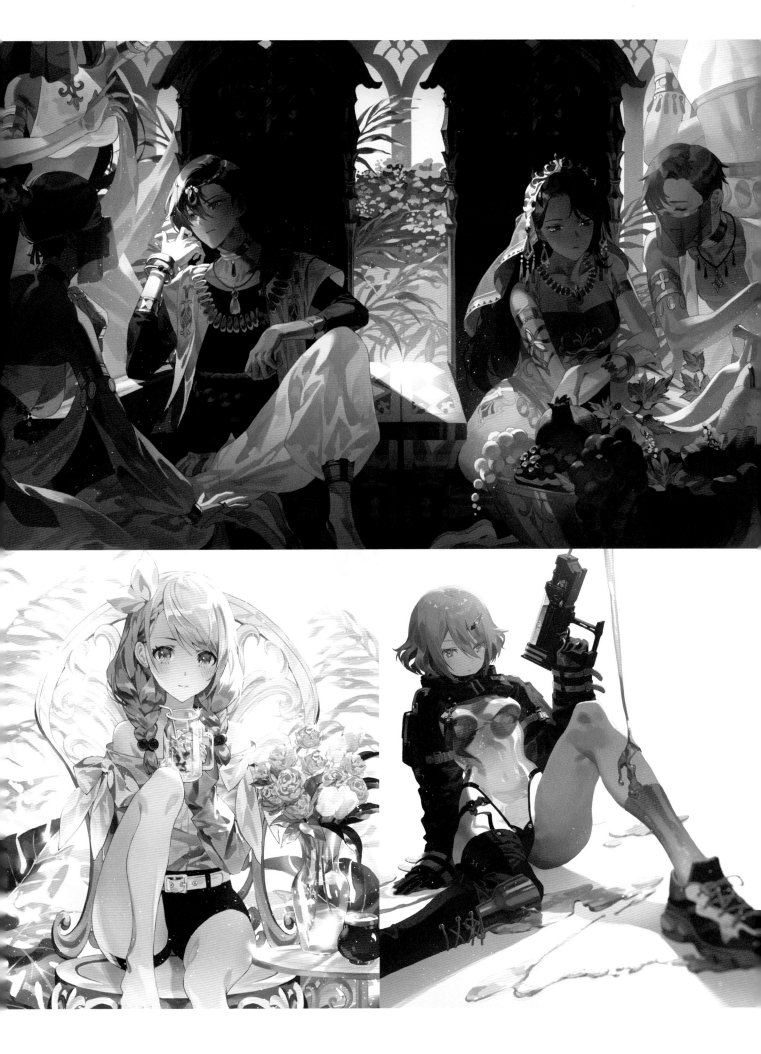

Patch

Language: Korean, English, Japanese

E-mail: patch.oxxo@gmail.com

twitter.com/patch_oxxo

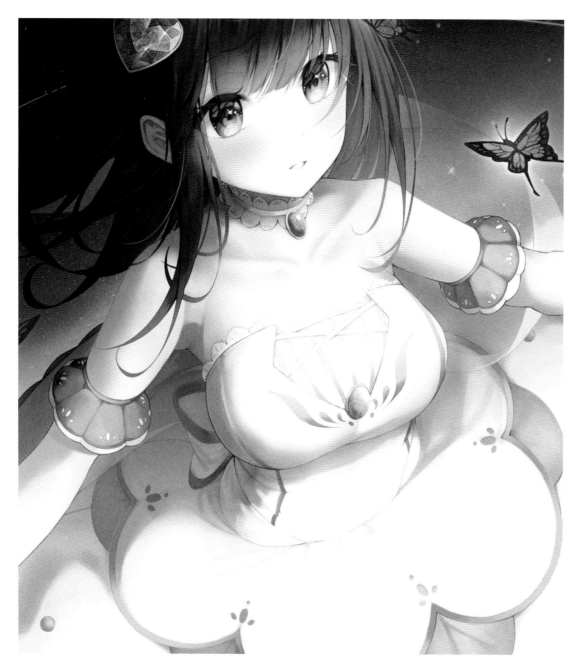

PROFILE
With the goal of creating lively illustrations like scenes out of a story, Patch uses nature, the sky and the universe in a variety of colors as motifs for their work.

1. Universe/2020
2. Spring/2020
3. Summer/2020

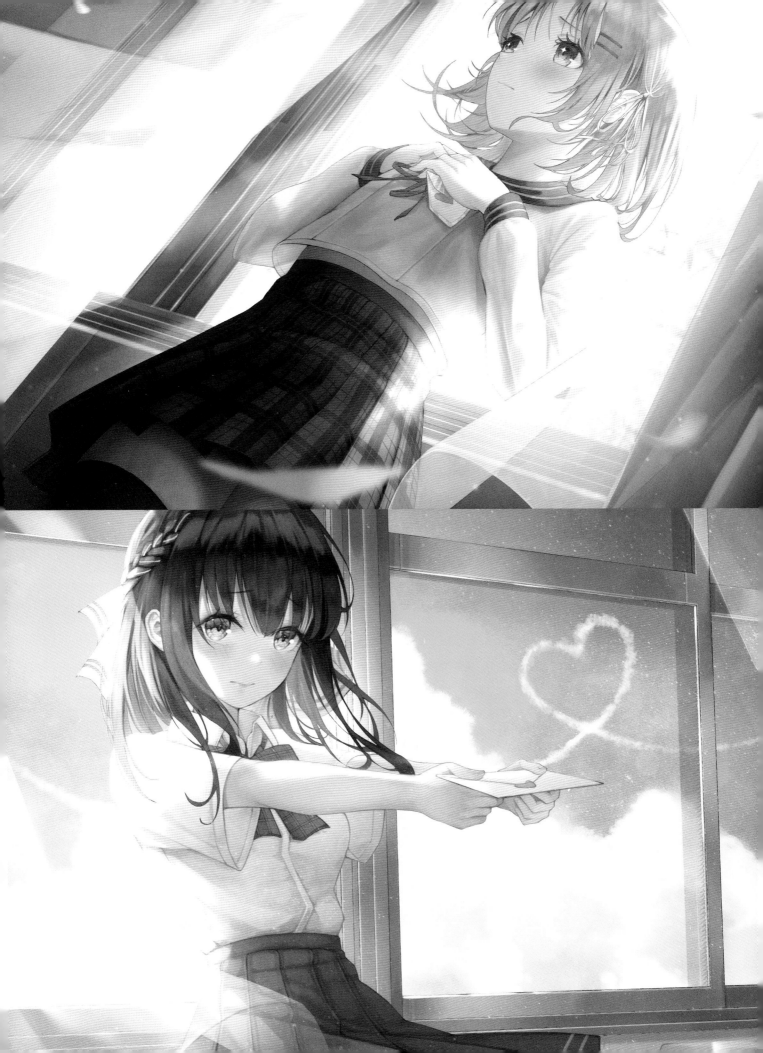

Puhang

Language: Korean, English, Japanese

E-mail: terry32243224@gmail.com

twitter.com/C_Puhang

pixiv ID : 71261019

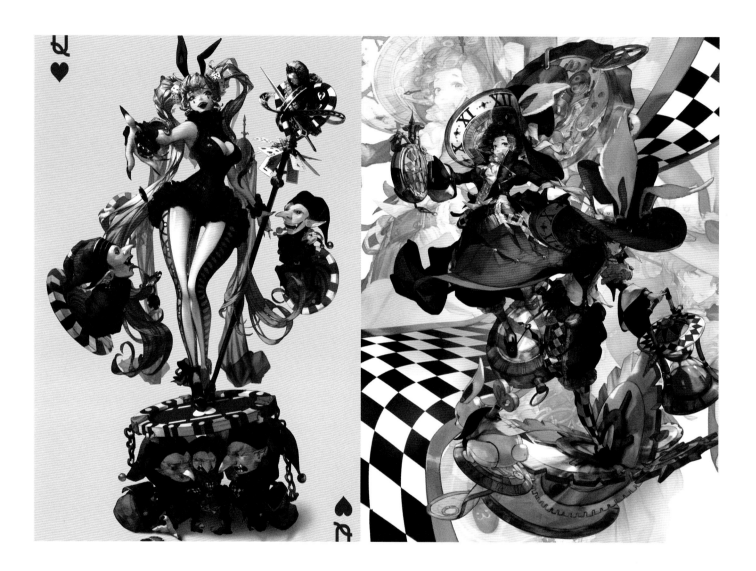

PROFILE
I am a painter with a long list of things I want to draw.

1. Q's Game/2021
2. Twin Chronomasters in Wonderland/2020
3. Lion Trainer/2020
4. Blossom/2021

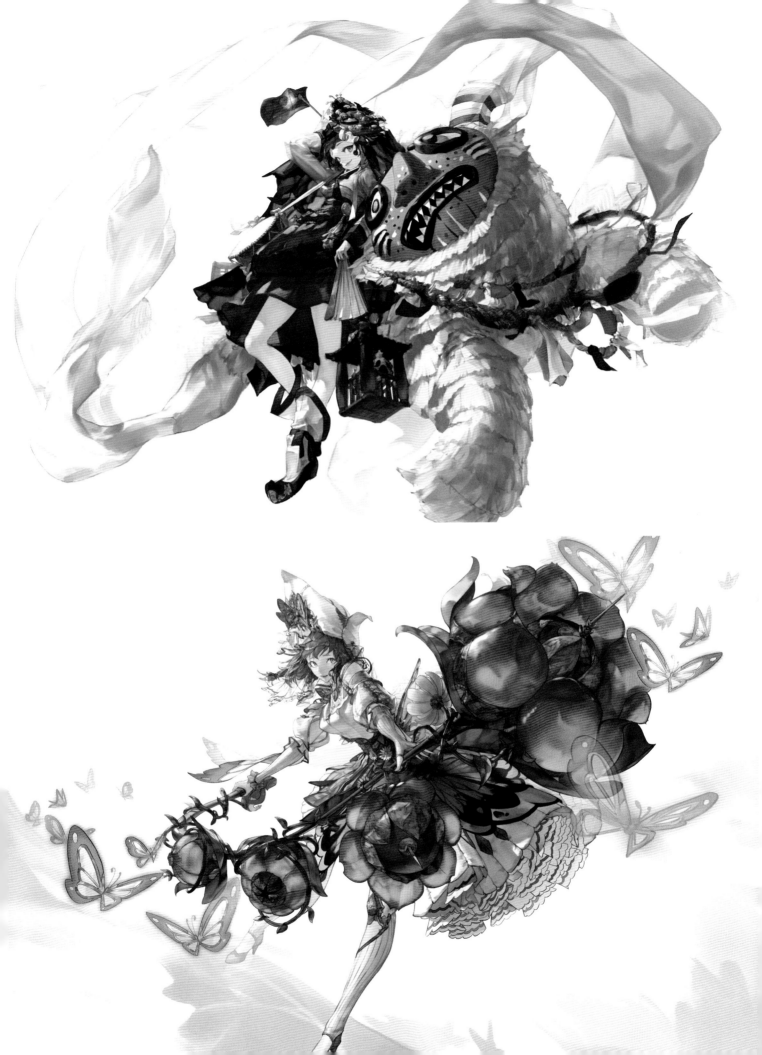

Pilyeon

Language: Korean, English, Japanese

E-mail: diffitud666@naver.com

twitter.com/vlfdus__0

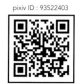

PROFILE
An illustrator living in South Korea, I work as a freelancer, creating cover art for various novels and games.

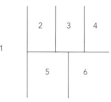

1. Original Illustration 6/2019
2. Original Illustration 1/2021
3. Original Illustration 4/2021
4. Original Illustration 7/2019
5. Original Illustration 3/2021
6. Original Illustration 5/2018

HAO

Language: Korean, English
E-mail: hjoesa15@gmail.com
instagram.com/where_hao

pixiv ID : 11155418

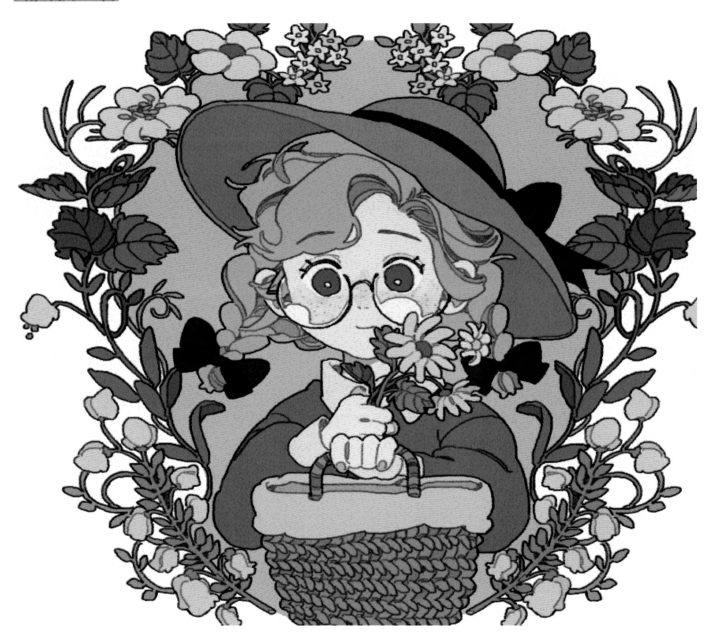

PROFILE
My name is Hao (HA0). I love to draw manga and illustrations in a vintage fairytale style. My goal is to create art that will be a strength and comfort to people.

1	2	3
	4	5
	6	7

1 to 7. Seed Sowers/2020

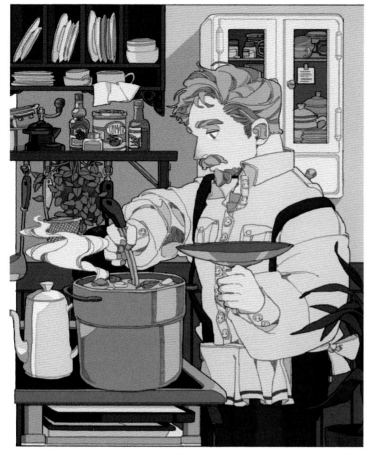

Sungmoo Heo

Language: Korean, English

E-mail: sungmoo95@naver.com

twitter.com/sungmoomoo

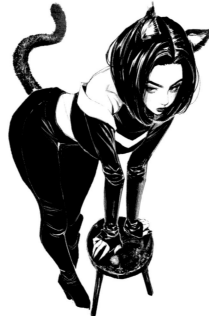

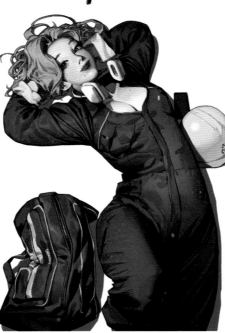

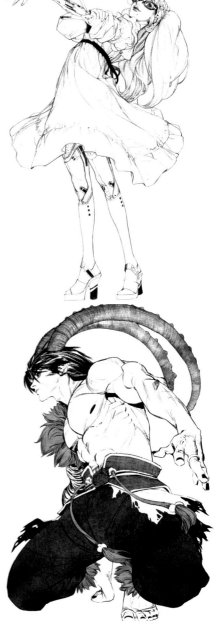

PROFILE

Born in 1995, living in Bucheon, Gyeonggi-do, Korea. Author of *Girls Drawing*; *The Live* on Webtoon; illustrator for *Legend of the Cryptids*.

1	2	3	
4	5	6	7

1. Drawing 1/2021
2. Drawing 2/2021
3. Drawing 3/2020
4. Stag Beetle Armor/2020
5. Break Time/2021
6. Drawing 4/2020
7. Winter Goddess/2019

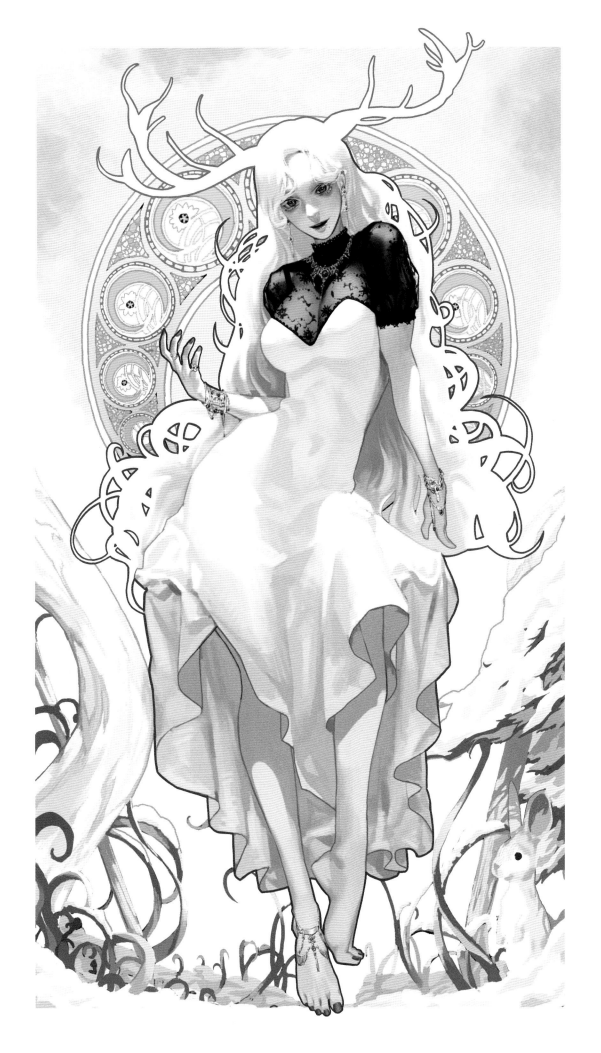

huni

Language: Korean, English, Japanese
E-mail: bhuni0822@gmail.com
twitter.com/b_huni_

pixiv ID : 8159347

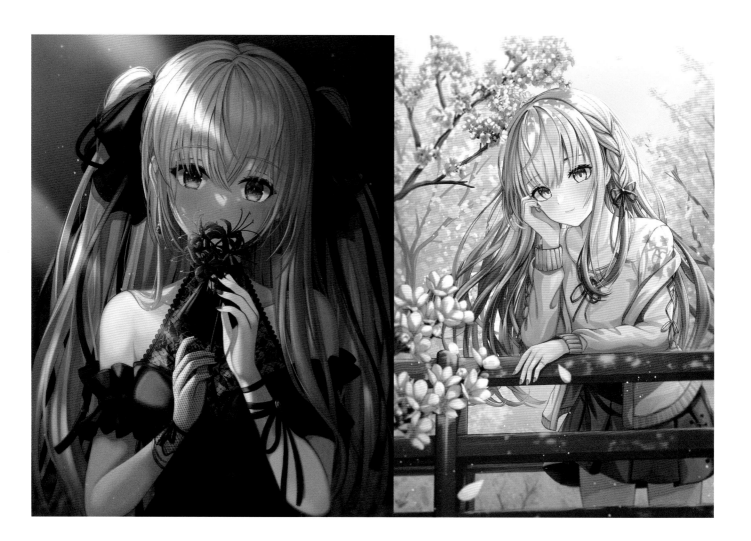

PROFILE
An otaku chick who loves Japanese anime and manga. A newbie illustrator who is working hard to draw pictures that touch people's hearts.

1 2 3

1. Lycoris/2021
2. Cherry Blossom/2021
3. Break Time/2021

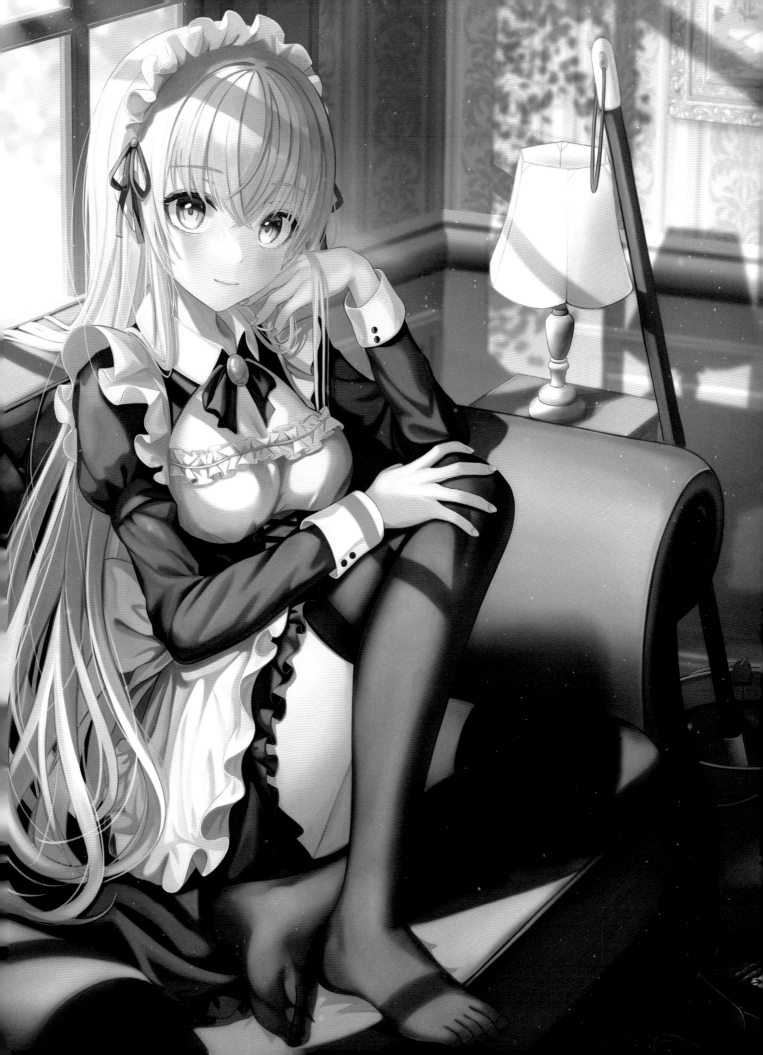

Tiv, a Korean manga artist and illustrator famous for *Masamune-kun's Revenge*, drew the cover of *Artists in Korea.*

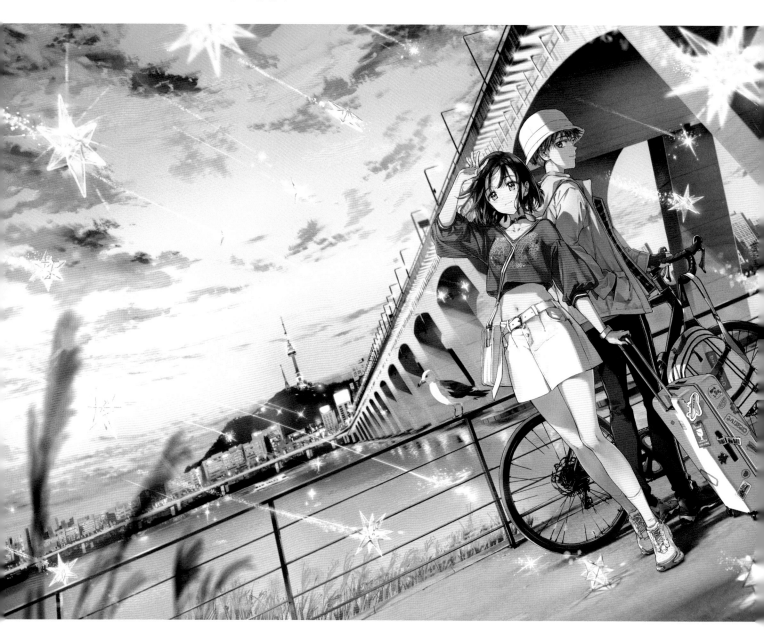

When did Tiv started drawing?

Since I was young, I loved manga and anime, and I scribbled and doodled in the margins of my notebook since then. When I was in high school, I joined the art club that met once a week, mainly painting landscapes. It wasn't until university that I started painting as a serious hobby.

When did you decide to become a professional illustrator?
When I was in my second year of university, I received a character design request from a company that saw an illustration I had drawn just for myself, and that inspired me to think of the possibility of an illustration career.

Are there artists or works that inspired you in the early days?
At the start, my art was heavily influenced by my favorite manga. I think the reason I wanted to create my own original art was seeing the work of manga artists Noriko Sasaki and Yoshihiro Togashi.

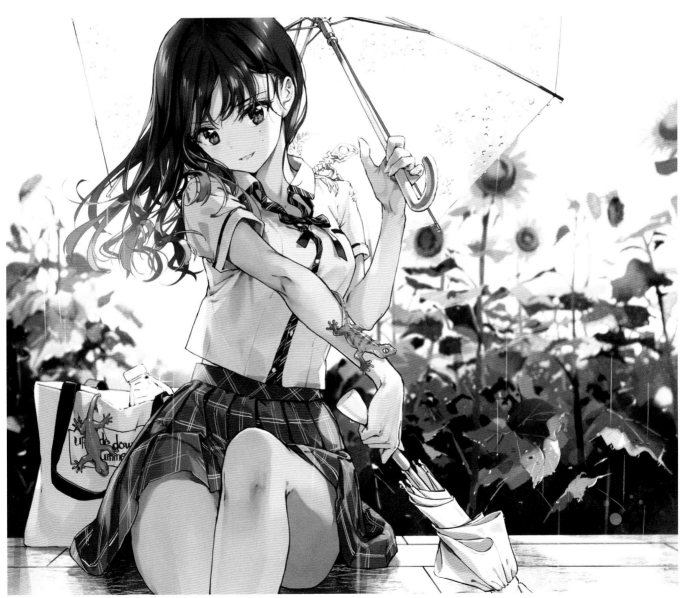

How did you come to establish your own style?
Maybe when I do a series or a project with the same themes
or characters? I didn't consciously create a style. It was only
after I saw my favorite expressions repeating over a period of
time that I realized, "this is my style."

When did you start using social media?
I've been using blogs to show off work-related art since I
became a professional illustrator. I've also been using Twitter
and pixiv since they both launched.

**What are your thoughts on managing social media like
Twitter and pixiv?**
I mainly use it as an announcement and promotional tool for
work projects, so I try to keep it short and sweet.

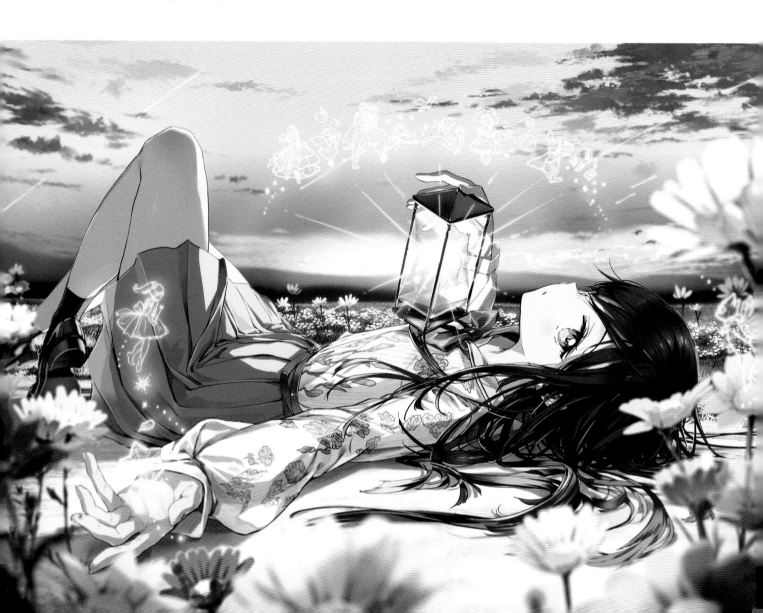

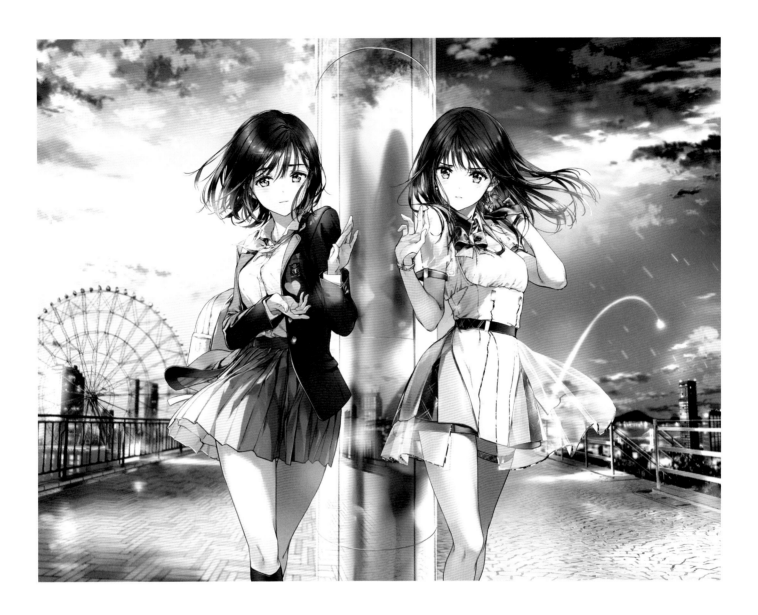

You have been living in Japan for a long time. Do you think that Japanese illustration has had a worldwide influence?

Yes, I think so. Like me, there are already many foreign artists working in Japan. I also think that Japanese artists are more open to trying new things, both in Japan and abroad. I think it's a big deal.

Is there a character or project you've always wanted to do?

I want to try character design for a science-fiction or mecha anime. Or maybe cute and shiny characters that also have a sense of realism. Something completely different than my usual fare.

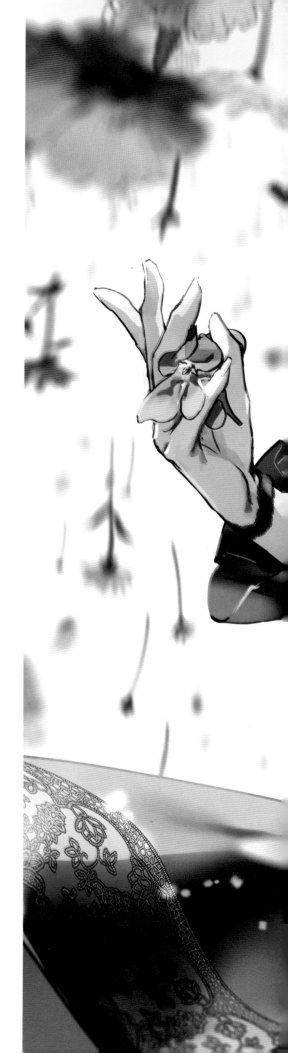

Did your style change after coming to Japan?
Yes, it did. Japan and Korea are close, but there are many differences in nature and weather that we see in our daily lives. My style changed as I was influenced by the color and people of the surrounding environment.

What do you tend to be influenced by as you draw? How does it affect your work? (For example, the music you listen to, the movies you watch, your living and working environment, etc.)
This is related to one of my previous answers, but the biggest impact is from my own life experience. Daily routine, travel, shopping. These simple events leave a strong and lasting impression on my work as I create.

How did you come up with the concept for this cover illustration?
Since this is a book dealing with Korean illustrations, I wanted to draw something symbolic of Korea on the cover. I thought it would be nice show where the changing landscape coexists with the part that never changes. I am very familiar with the Han River, and even though the color of the river is the same as the sky, I realized that the scenery on the riverside changed quite frequently. And there was my concept. As for the characters, I tried to create two people who you would typically see in a place like this.

Pink and blue are the main colors of not only this cover, but also in a lot of your illustrations. Do these two colors have a special meaning to you?
Pink is a color that leaves a strong impression on its own, but when combined with blue, it can create a very eye-catching image. But my history in print media is also part of the reason. I have always liked paintings that use a lot of blue, so originally, I tried using blue with a very high saturation.

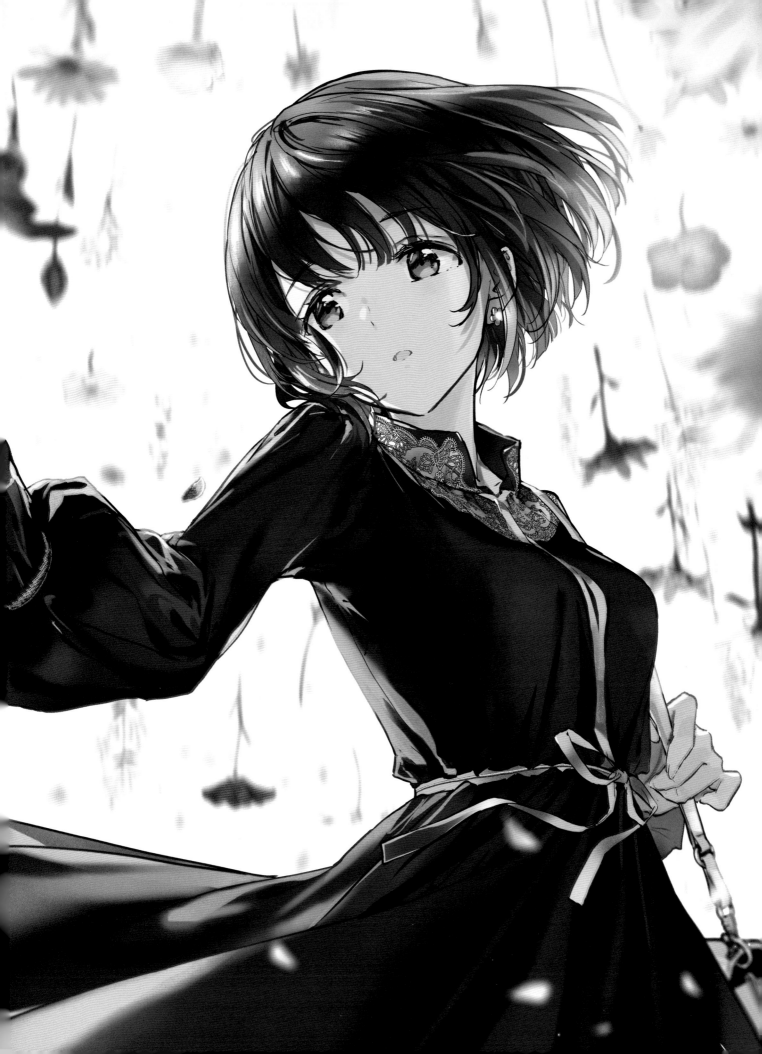

But there is a limit to the range of colors in CMYK (4 color) printing, so I often pair it with pink or yellow to compensate for the lack of saturation to make the blue stand out. Also, I sometimes use special features in the printing process. KP (special fluorescent pink) is a common one.

When drawing characters, where do you get inspiration for their clothes and fashion?
I love clothes shopping, and I'm always looking around the stores, studying reference material, and checking out the fashion of people on the street. Most of my inspiration is drawn from this.

Over time, the tastes of fans change. Tiv, do you adjust your style to fit current trends?
Just as the tastes of my fans change, my tastes also change, so there is a natural evolution that follows trends. There are other times when I get tired of my own style so I purposely seek out new things to try. I have to keep in mind that there is a balance between being swept away by what is going on around me and knowing when it is okay to go with the flow.

Are there any styles you would like to try in the future?
I would like to challenge myself with a style that creates more dramatic moments through expression and composition. A style that can tell a story more intensely.

Tiv is a manga artist and illustrator whose work emphasizes emotional expression. Credits include illustrator for Ichijinsha's manga series, Masamune-kun's Revenge, *and the* Girls Symphony *and* Plantonica/Luminoustar *art books.*

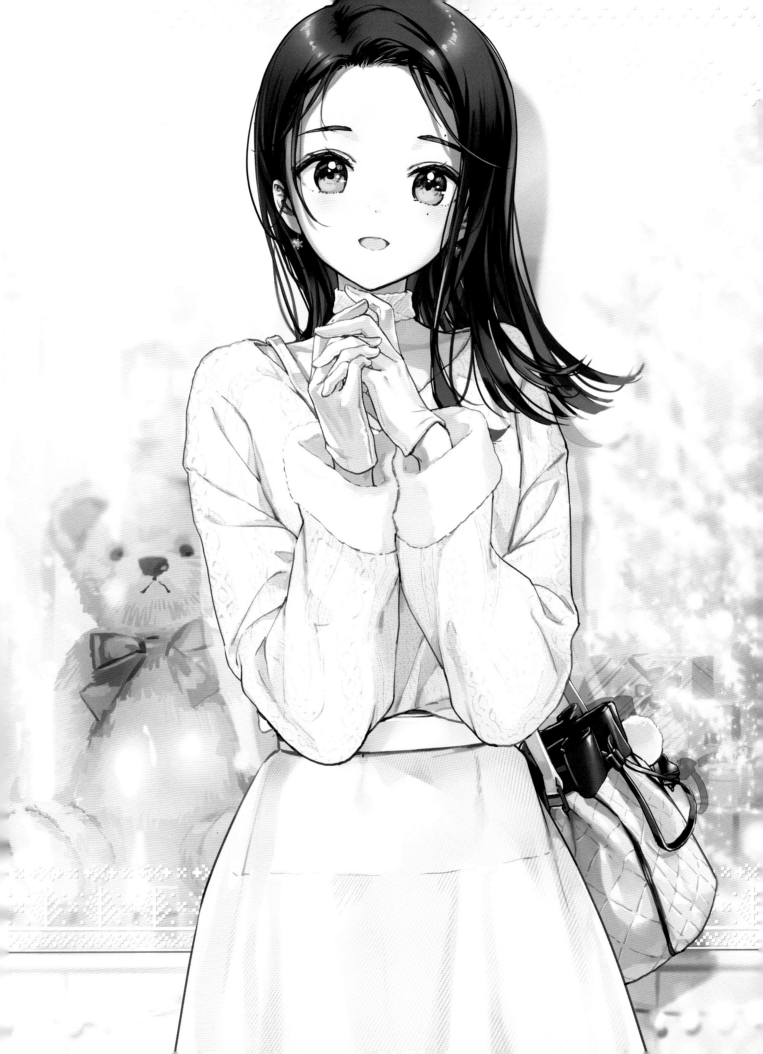

From roughs layouts to coloring, Modare discusses his illustration process.

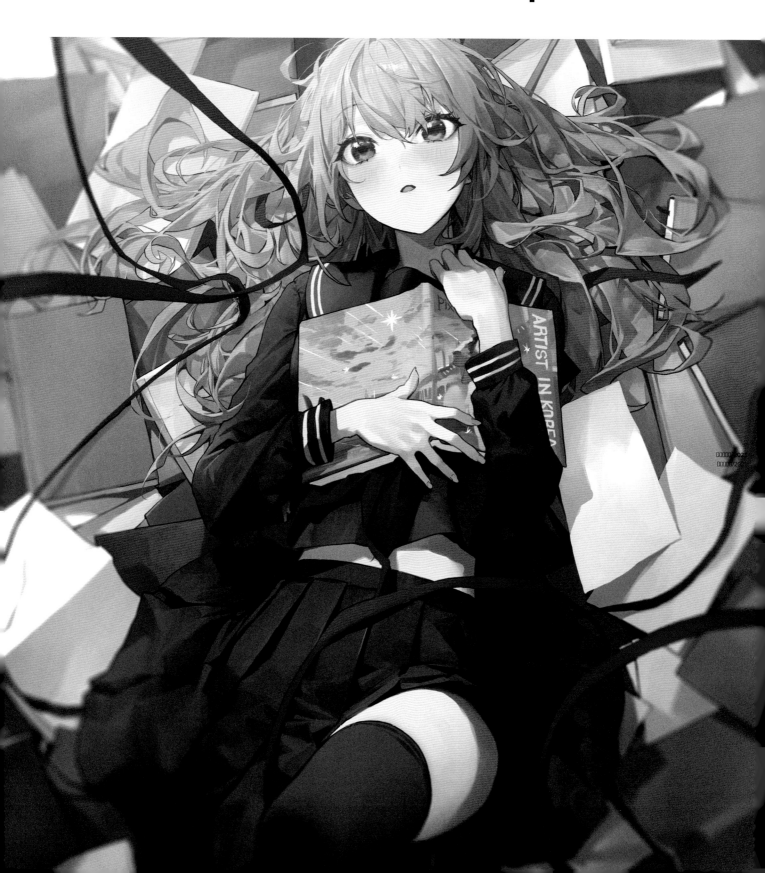

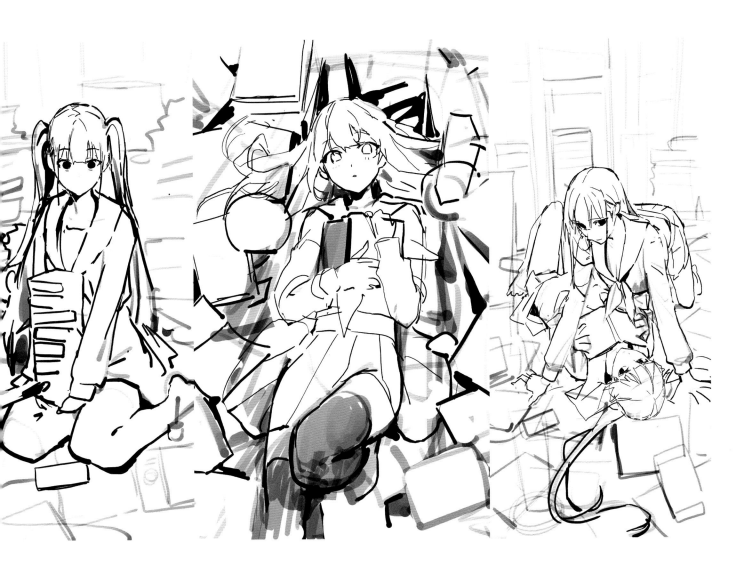

1) Rough Draft

Choose a theme and draw various rough sketches. I want to create something suitable for pixiv, so I think about objects or props related to it. Then I think about the placement of those objects with the characters on the canvas and imagining the overall composition in my head. It is important to try out several versions so that the final image doesn't look derivative. I try out different angles, and adjust the number of people, objects and composition. At this stage, the accuracy of the people or props in the image is not important. Concentrate more on the big picture. From those rough drafts, I proceed with the one I like the best and move to the next step.

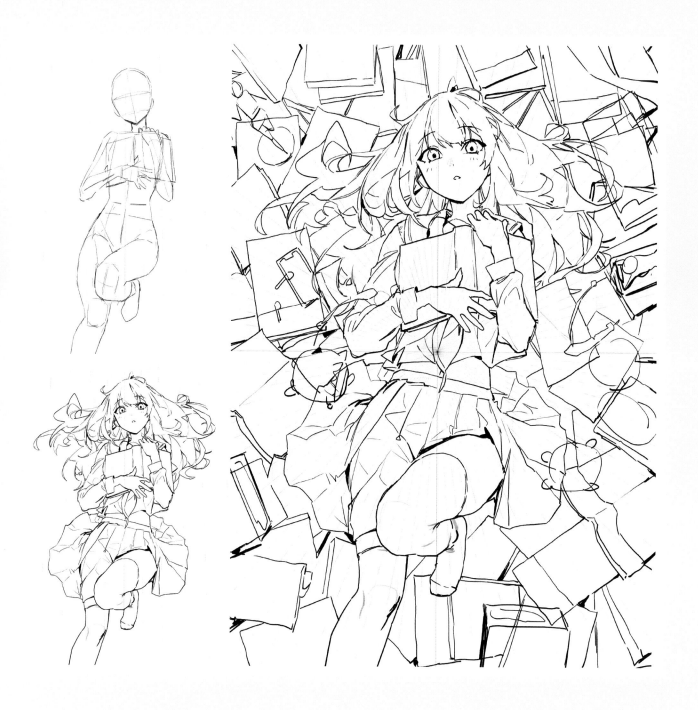

2) Rough Pencils

When fleshing out the roughs, I try to make the image more accurate. I focus on fixing the anatomy, incorrect perspective, and unrealistic facial expressions. I adjust the shape of the picture after I've fixed the character's pose so that it doesn't look unnatural.

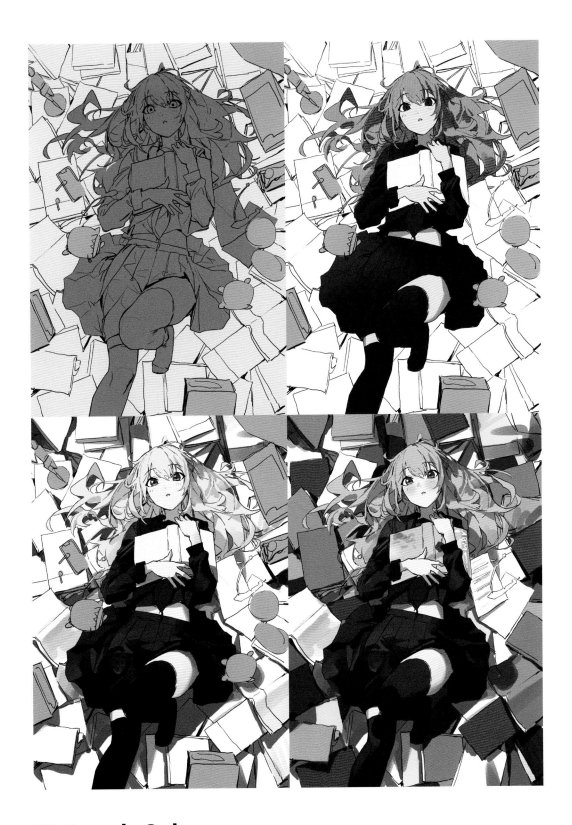

3) Rough Colors

The rough colors determine the direction of the entire look of the painting. This is an important part of the process because it determines the direction of light and the color palette. The same picture can have a completely different feel depending on the light, so I'm always thinking about the best lighting when I am drawing.

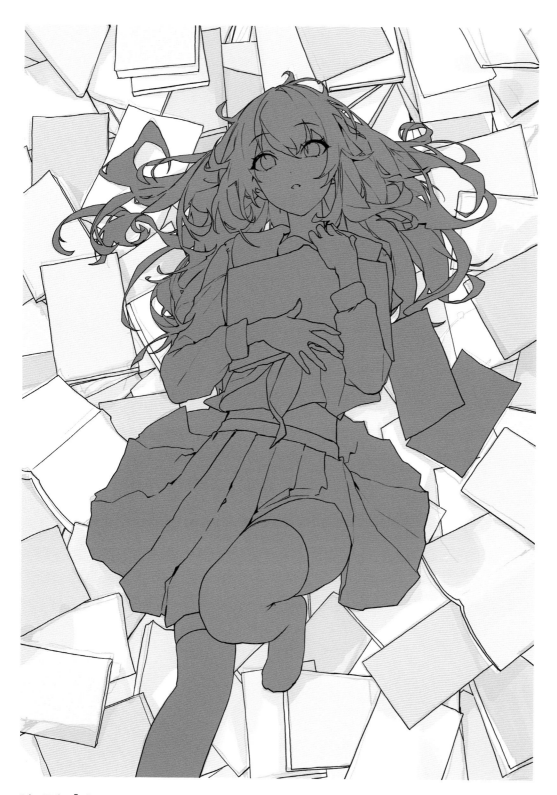

4) Picking Lines

Using the color roughs that I created as a reference, I finalize the shape of the picture. If you leave any mistakes now, it will be difficult to correct them later, so it is best to make sure everything is how you want it now. It isn't impossible to change later, so no need to worry. Be careful not to change the rough pencils too much. It is also very important to separate the image into different layers to make the work easier in the future. (I usually separate eyes, nose and other parts of the face from the body, and other objects from the background.)

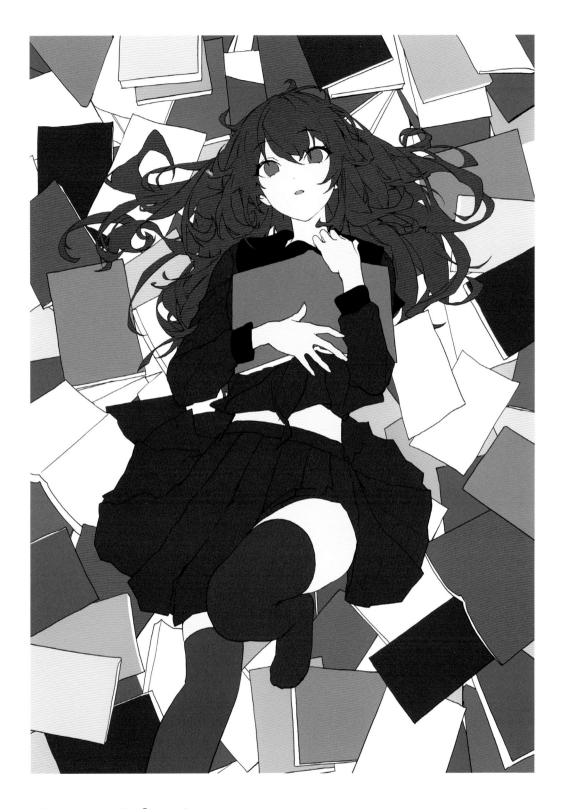

5) Area Selection

What I do here is fill in the gaps where the lines don't meet, so that I can properly select an area of the image.

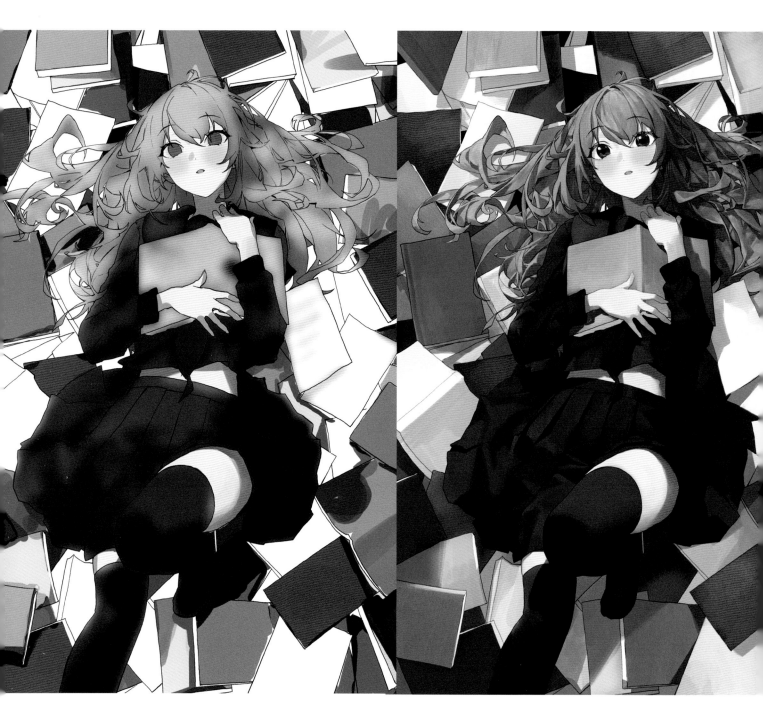

6) Colors

Copy the color of the coloring rough and blur it. This gives me a
natural neutral color that I will use to blend in with the painting.

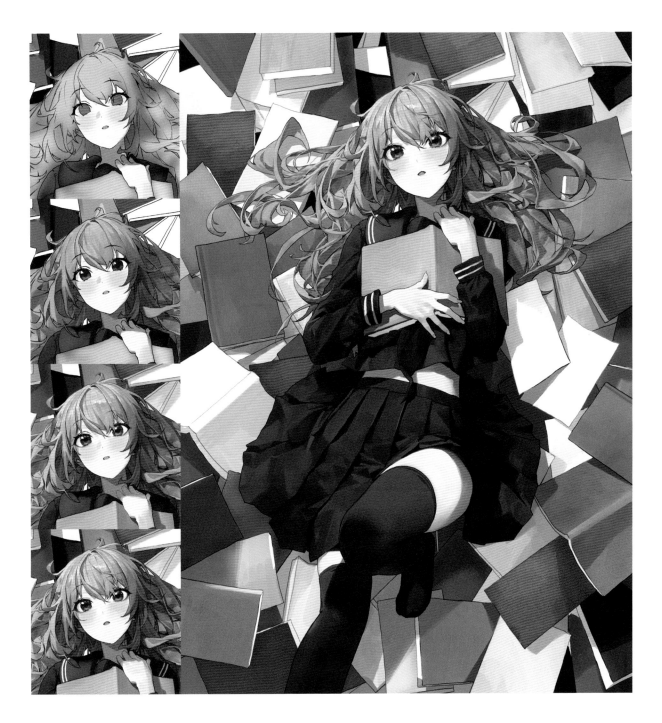

7) Detail

Start to apply more detailed shading to the rough colors. Pay close attention to the details you add to the face, in particular the eyes. You want to use this step to create a good expression.

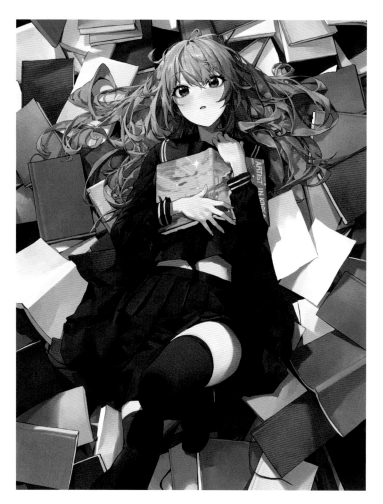

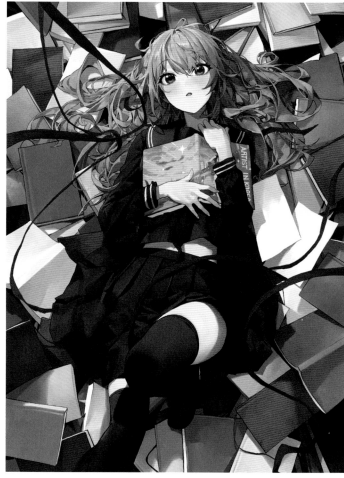

8) Background

Add shading to the background. It is important that the background shading doesn't ever overshadow the characters. The most important thing is the character.

9) Additions

The picture felt a little empty, so I added these ribbons.

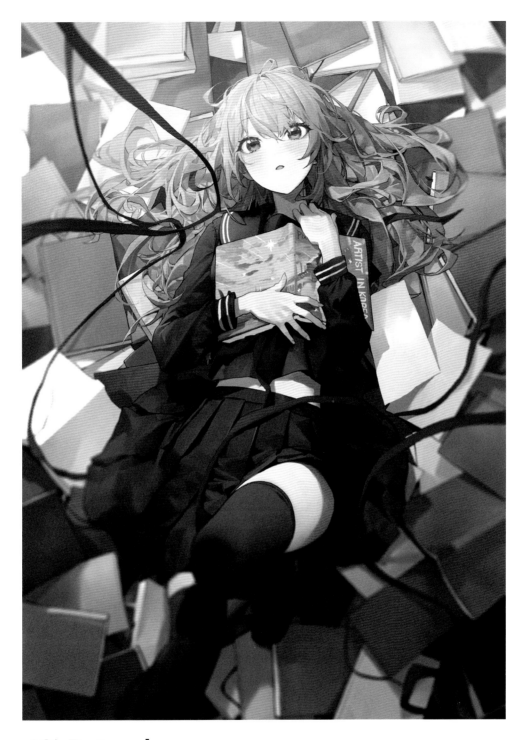

10) Retouch

Adjust the brightness, saturation, hue, etc. until it looks the way you want it. Make the characters stand out by adding more noise and blur. As for the tools themselves, there are many more powerful tools in Photoshop than Clip Studio Paint, so I recommend using that. It is a good idea to map out your plan for retouching, starting with the line drawing and working up.

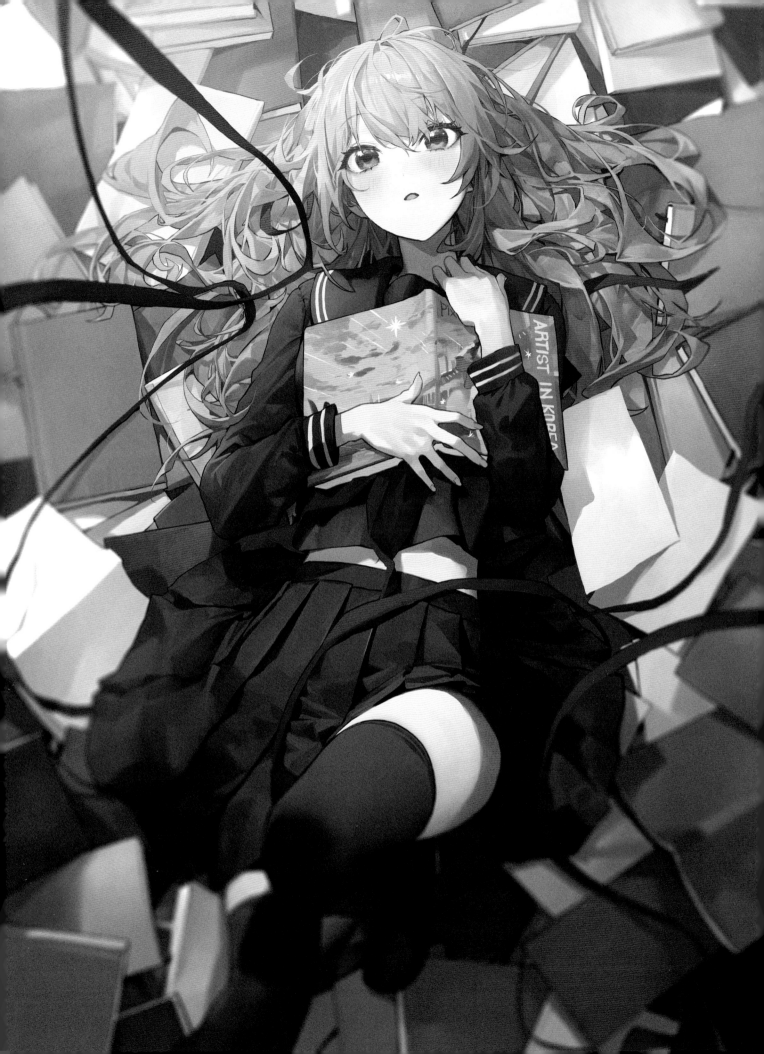

Please tell us about some current Korean illustrations that you have seen.

Korean illustration has a slightly different feel from Japanese illustration. Korean illustration aims for more realism in its presentation, with a high degree of perfection preferred over expressionism. It is different from Japanese illustration in that respect, but recently, expressionism has become more popular in Korea, and many Japanese-style illustrations have been created.

How does the general public in Korea view the average illustrator?

The word "illustrator" is still unfamiliar in Korea. There are many people who don't really understand when you tell them you are an illustrator. You have to say that you are a person who draws pictures for them to understand. And they will still look at you weird.

What is the difference between overseas illustrators and Korean artists?

As I said in the previous question, there is a clear difference in the degree of perfection and depiction of the paintings, as well as the individuality of the paintings. But these days it's getting harder and harder to tell them apart. Since they influence each other, I think it will become even more difficult to distinguish between them in the future.

Your paintings are loved all over Korea and beyond. What keeps you painting more?

I think I was lucky. I drew what I have loved since I was a child, and a lot of people took an interest in them. I will always be grateful.

MODARE is an illustrator from South Korea. He is good at drawing realistic expressions of light. He gained a lot of notoriety after posting anime and game illustrations on Twitter for 100 days in a row.

ARTISTS

IN KOREA

REPRESENTING
CREATORS OF
KOREA

Supervised by pixiv